EGYPTIAN PAINTING

EGYPTIAN PAINTING

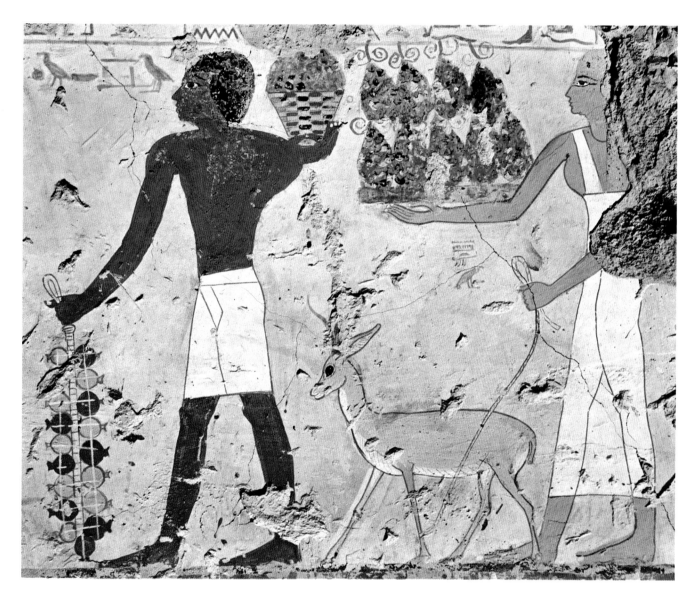

TEXT BY ARPAG MEKHITARIAN

Curator of Islamic Art, Musées Royaux d'Art et d'Histoire, Brussels

SKIRA

RIZZOLI
NEW YORK

Color plate on the title page:

Offering Bearers. Tomb of Amenemhet (No. 82), Thebes (1500-1450 B.C.).

*

© 1978 by Editions d'Art Albert Skira S.A., Geneva
First edition © 1954 by Editions d'Art Albert Skira, Geneva

This edition published in the United States of America in 1978 by

RIZZOLI INTERNATIONAL PUBLICATIONS, INC.
712 Fifth Avenue/New York 10019

Translated from the French by Stuart Gilbert

Library of Congress Catalog Card Number 54-11064
ISBN: 0-8478-0161-6 (hardcover)
ISBN: 0-8478-0159-4 (paperback)

PRINTED IN SWITZERLAND

UNTIL now Pharaonic art has been celebrated chiefly for its architectural monuments and sculptures, which have largely overshadowed the extant paintings. Located in hundreds, not to say thousands, of widely scattered tombs, these works had long been accessible to scholars and public only through sketches, watercolor copies and black-and-white reproductions. To meet the widely felt need for an illustrated study of Egyptian Painting, with each work faithfully reproduced in full color, we organized a field expedition whose task it was to " take " the pictures on the spot and—for the first time in the annals of Egyptology—to carry out the photographic separation of the colors by means of the direct color-separation process, i.e. in front of the paintings themselves. Only technicians and specialists who have actually worked in the field can appreciate the difficulties involved in bringing out the exact color and texture of these marvelous wall paintings from the funerary chapels erected by the ancient Egyptians to the memory of their honored dead.

★

We owe a considerable debt of gratitude to the Egyptian government and to a number of persons in authority for their good will and helpfulness, which so greatly facilitated our work. Our warmest thanks go in particular to Mr Mustafa Amer, Director General of the Egyptian Antiquities Department; Mr Abbas Bayoumi, Chief Curator, and Mr Maurice Raphaël, Curator, of Cairo Museum; Mr Zakaria Goneim, Curator of Monuments at Sakkara; Mr Labib Habachi, Chief Curator of Antiquities in Upper Egypt; Messrs Ibrahim Kamel and Mustafa Sobhy, Curator and Architect respectively at the Theban necropolis; Mr Ahmed Youssef, in charge of restorations in the Antiquities Department; Messrs George R. Hughes and Charles F. Nims, Field Director and Assistant Director respectively of the Oriental Institute of Chicago at Luxor, and the engineer Mr Healey, their collaborator. To these names we take pleasure in adding that of Mr D. B. Harden, Curator of the Ashmolean Museum and Secretary General of the Griffith Institute at Oxford.

★

Most of our photographs having been made at the Theban necropolis, we reserve a special word of thanks for Mr Labib Habachi, whose unfailing kindness and efficient, day-by-day collaboration cleared every obstacle from our path and made our stay a pleasant one indeed.

★

We would here express our gratitude for the zealous services, loyally rendered without exception, of the personnel placed at our disposal by the Antiquities Department. Our most grateful thanks also go to Sheik Abdel Maaboud, Chief Guardian of the Theban necropolis.

CONTENTS

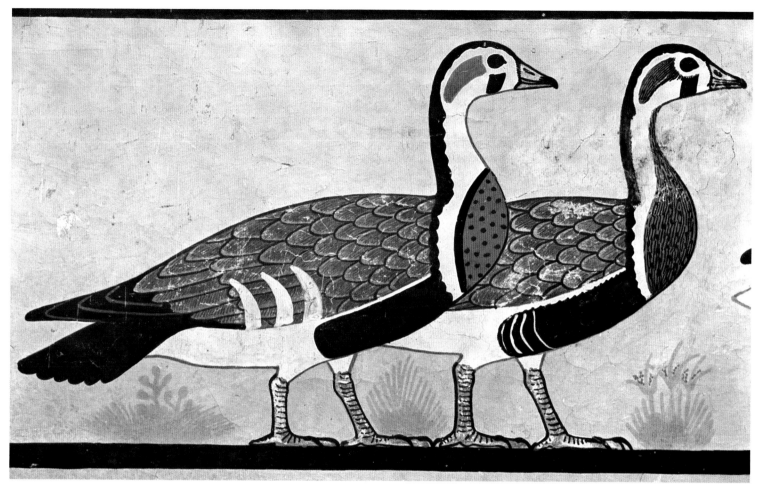

EGYPTIAN PAINTING

WHEN planning this study of Egyptian Painting we felt it needful to restrict its scope to some extent; so vast is the subject that otherwise our text would have been far too bulky and the effect of such a diversity of illustrations somewhat confusing. For, spanning as it did three thousand years, from the First to the Thirtieth Dynasty, the Pharaonic régime was one of the longest in Antiquity and throughout the period artists of the Nile Valley produced indisputable masterpieces. The pity is that relatively few have escaped intact the ravages of men and time. True, the dryness of the climate has done much for the preservation of Egyptian monuments; the trouble is that once they are uncovered by archaeologists and exposed to the vagaries of the weather, the wall paintings, often thin and fragile, rapidly deteriorate. How many exquisite details which as recently as twenty or thirty years ago delighted our eyes are now no

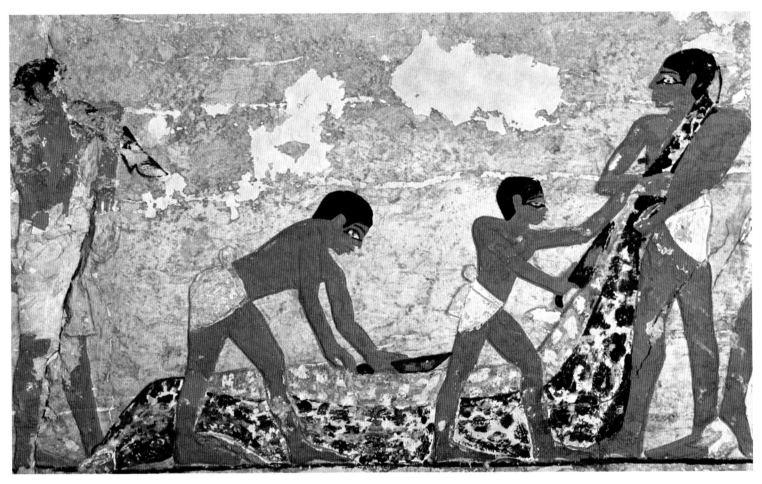

SCENE OF THE BUTCHER'S TRADE. TOMB OF PTAHIRUK, SAKKARA.

more than a handful of white dust! For the ground on which the pigment was applied —a thin coat of stucco—tends to develop cracks and gradually to flake away. Much gratitude is due to the Egyptian Government for having undertaken some years ago a systematic restoration of these eloquent memorials of an art whose rare alliance of majestic grandeur with delicate sensibility will become apparent to all who peruse this book. Much, unhappily, is lost beyond recall as a result of the activities of looters in the centuries preceding the Christian Era and, subsequently, of bigoted iconoclasts or that squalid tribe of petty pilferers who, with a view to extracting a few pounds or dollars from foreign pockets, make away with the precious vestiges of a culture that had aspired to be eternal. The amazing thing is that, notwithstanding twenty centuries of depredation, so many of the treasures of Ancient Egypt should have survived. There is in fact such a wealth of material that a rigorous selection had to be made, and it seems to us desirable in these opening pages to justify our choice.

If archaic Egyptian painting does not figure in this book the reason is that only one specimen—discovered in a tomb at Hierakonpolis at the beginning of this century and now in Cairo Museum—is extant, and it is in very poor condition.

Rich as it is in eye-filling monuments—pyramids, royal temples, sanctuaries of the gods and mastabas with sculptured walls—the Old Kingdom is much more scantily represented in the field of painting proper. True, during the period from the IVth to the VIth Dynasty, both in the Memphite necropolis (at Giza, Sakkara, Dahshur and Meidum) and in the provincial cemeteries (Deir el-Barsha, Meir, Deir el-Gabrawi, Asswan), some of the tombs of persons of high standing were adorned with mural paintings, but these are usually in a bad state of preservation. Any attempt to base on the surviving specimens an historical survey of Pharaonic painting from the reign of King Sneferu to that of Pepy II—i.e. from about 2700 to 2300 B.C.—would tend to present the facts in a false light.

All the same we have thought best to give two typical illustrations of the art of the Old Kingdom. The first is a fragment of the famous frieze, over five feet long and nine inches high, known as the "Geese of Meidum," which is painted on a coat of stucco covering the walls of unbaked bricks in the mastaba of Itet at Meidum. This frieze, now in Cairo Museum, dates to about 2700 B.C. and is the oldest extant Egyptian painting. The stylization of the animal forms, the symmetrical composition, the confidence of the drawing and the use of flat colors show that the canons and procedures of Egyptian art were stabilized at a very early date. This deliberate conformity gives the work a

HERD OF CATTLE FORDING A CANAL. MASTABA OF TI, SAKKARA.

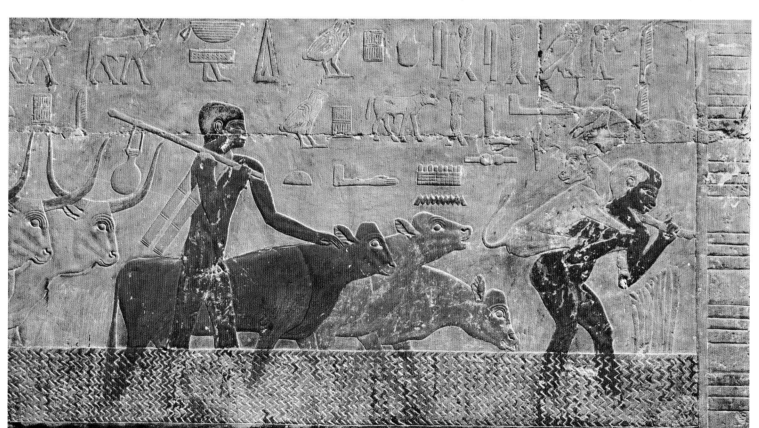

somewhat rigid aspect which, however, is not displeasing, provided we regard its function as purely decorative. Six geese are depicted, three walking to the right, three to the left, and the goose at each extremity is bending to peck at some plant or fallen seed. Landscape is suggested by small clumps of bushes. The two standing geese we illustrate belong to the right-hand sector of the frieze. Though in a way the most conventional, they are also the most individualized of the six birds. Whereas the four others are of the same species (with wavy, grey-brown plumage, long red beaks), those we reproduce are differentiated by the shape of the red patches on their throats, their short beaks and the drawing of the grey-black feathers, like fishes' scales. The formalism of the design, the strict parallelism of necks and feet, the meticulous filling-up of empty spaces with thin, pale green fronds interspersed with small flowers rendered in red dots—all are procedures smacking of that studied academicism from which, happily enough, great artists always try to break away.

We find in the so-called "Tomb of the Butchers" at Sakkara another example of the geometrically precise lay-out favored by Old Kingdom artists, but here it is compensated for by the painter's obvious feeling for rhythm and lively color contrasts. This tomb was hollowed out in the rocky plateau south of the causeway leading from the vestibule to the funerary chapel of King Unas (vth Dynasty, ca. 2450 B.C.). Discovered in 1944 by the Egyptian Antiquities Department, it bears the name of Ptahiruk, Superintendent of Slaughterhouses, and on the left wall are scenes illustrating the butcher's trade. That depicting the flaying of an ox is of exceptional interest; indulging in a realism rare in Egyptian art, the painter shows us the animal's gaping belly, with the pink entrails visible, after the skin, dappled white and black, has been stripped off. Enclosed in a sort of set-square, the scene is laid out in terms of an ascending curve; the gestures and proportions of the three men are determined by a line running parallel to that of the sacrificed animal, with the result that the stature of the central figure is reduced. This intellectualization, so to speak, of the composition is stressed by the omission of three of the ox's feet; only one is shown, disproportionately large and upheld by the most stalwart of the attendants. On the other hand, the careless, not to say clumsy execution apparent in the drawing of the figures, the way the four colors (red ocre, black, white and pink) are laid on, in masses without shading, and the imperfectly smoothed ground is camouflaged with a coat of bright yellow—all are symptomatic of the decline that set in with the close of the vith Dynasty and the provincial style of the "First Intermediary Period" (ca. 2300-2100 B.C.).

But we should be doing less than justice to the art of the Old Kingdom—which the Egyptians themselves came, in later times, to regard as their Golden Age—were we to draw any positive conclusions from the few works of pictorial art that have survived. A truer idea of it is given by the bas-reliefs in the mastabas, the most famous of which can now be seen at Sakkara. Noteworthy are the tombs of Ti, Ptahhotep, Mereruka and above all Mehu, in which the wall carvings are supplemented by paintings, well preserved in places. The "Herd of Cattle fording a Canal" (Mastaba of Ti) strikingly illustrates the closeness of the link between sculpture and painting, as the Egyptians

conceived them. The water is shown conventionally by vertical zigzags incised in the soft limestone, while, to suggest its translucency, only the men's limbs and the animal's hooves are painted. The artist has taken pains with the gradation of the colors; indeed, the composition, execution and expressive power of this picture are of no mean order. We reproduce a fragment. Two cowherds are driving their cattle to pasture across a canal; the man in front is carrying on his back a calf too young to swim the canal and it is looking back anxiously, tail in air, towards its mother. This cow is following with the others and lowing to reassure her calf. To the contrast between the bovine placidity of the other cows and this little "dialogue" between the mother and her nervous youngster is due the wonderful vitality of the scene, the work of an artist gifted with a very real sensibility. This is borne out by an hieroglyphic inscription telling us what the cowherd is saying to the mother-cow. Freely translated, it runs: "Don't be anxious, mother! Your babe won't come to harm." The only color that has weathered well is the red ochre, and it tells out, in two shades, upon the smooth stone ground. One of the highest achievements of Egyptian art, this work is dated to ca. 2500 B.C. With its balanced composition and sobriety, its strength and purity, it demonstrates the high artistic culture of Egypt in her "Golden Age."

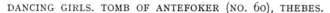

DANCING GIRLS. TOMB OF ANTEFOKER (NO. 60), THEBES.

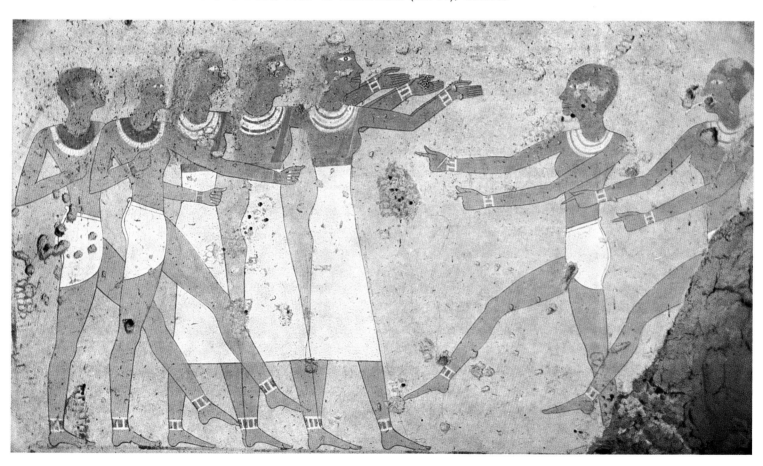

As regards Middle Kingdom art there has been more difficulty in providing a selection of representative paintings. The chief site where wall paintings of the xIth and xIIth Dynasties (ca. 2100-1800 B.C.) have been discovered is, unquestionably, Beni Hasan in Middle Egypt. Here several nomarchs excavated enormous burial chambers in the cliffs and decked the walls with paintings. Unfortunately most of these are now in such a condition that it would be wasted labor trying to photograph them; the best passages are hidden by an opaque film of dirt that has accumulated in the course of forty centuries. Under the supervision of M. Drioton, M. Stoppelaëre has attempted to remove this, and in one of the tombs approximately a square yard of painted surface has been cleaned. But experts agree that an analysis of the chemical reactions of the pigment employed will take time, and until this is done it would be rash to embark on any large-scale restorations.

It may perhaps be objected that the Tomb of Khnum-hetep (No. 3) at Beni Hasan contains a scene whose colors have kept their brightness—it has often been reproduced— and which should have figured in the present work; I refer to the picture of birds in an acacia. But charming though it be, this picture, which dates to about 1900 B.C. and is the only one capable of being photographed, gives a quite inadequate idea of the style prevailing during the three centuries of the Middle Kingdom. Moreover, since there are many pictures at once more typical and of more artistic merit in other tombs, the effect of singling out this one might be misleading. We can only hope that the next generation will be more favored and that once the walls of these funerary chapels have been cleaned, it will be possible to admire these masterpieces of ancient Egyptian art in all their pristine splendor.

However—so as not wholly to exclude, merely for technical reasons, the Middle Kingdom from this book—we reproduce a charming scene from the tomb of Antefoker, Vizier of King Senusret I (No. 60 in the necropolis of Thebes). Dated to about 1950 B.C., it represents four dancing girls in brief loincloths, each with a leg uplifted. Each of the two girls on the left has one arm extended, the fist clenched, and the other hand resting on her breast; those on the right have both arms outstretched and except for the thumb and index finger their hands too are closed. This is either a ritual gesture or a device for counting on the fingers the number of figures of the dance that have been performed. In the center three women in long, close-fitting white garments are stepping forward, beating time with their hands; they are, doubtless, the singers. Characteristic of Middle Kingdom art and a tradition that persisted until the xVIIIth Dynasty are the rigid attitudes of the figures, their symmetry, the parallelism of their movements, the cool, clear colors and even the style of dress.

As compared with earlier periods, the New Kingdom impresses us as being the great epoch of Egyptian painting, so many and so varied are the works belonging to it that have survived. From the reigns of Hatshepsut and Tuthmosis III up to the end of the xxth Dynasty (ca. 1500-1100 B.C.) Theban artists continuously produced works of a high order, and this continuity enables us to study, better than in any other period,

the evolution of a style from generation to generation. These New Kingdom painters tried their hand at all the genres practiced by their predecessors; moreover, these paintings have the advantage of being grouped together in a single locality, the necropolis of ancient Thebes, capital of the Pharaohs from the xith Dynasty on. (The numbers given in brackets after the names of tombs are those assigned them by the Egyptian Antiquities Department, and follow the order of their discovery.)

Several types of painting current in this period will, however, be excluded from our study: notably the papyri of the Book of the Dead, whose colored vignettes are in the nature of illustrations. Enlarged versions of them sometimes figure on the walls of tombs in which the after-life is depicted. Nor shall we deal with the *ostraca*, potsherds or flakes of limestone with paintings on them, which have been found in great numbers in the Theban necropolis. These were rough preliminary sketches made by the Egyptian painter before embarking on the full-size picture. The painted coffins will also be omitted; they are adorned with symbolical motifs and though some details are striking and finely wrought, they should, to our mind, be regarded as products of industrial art. Like the coffin paintings, the so-called mummy portraits will not be dealt with; made at a very late period, they fall into the categories of Hellenistic and Roman art, as do the vestiges of Alexandrian art still extant in the capital of the Ptolemies and at Hermopolis. Only exceptionally shall we refer to decorative Egyptian painting, the ornamental friezes and ceilings adorned with geometrical or stylized floral designs; and equally rarely to the royal tombs, whose deep subterranean passages suggest a descent into the netherworld, a suggestion borne out by the pictures and inscriptions on their carved and painted walls. As for works of the Late Period—those figuring, for example, in a chamber of the Saite tomb of Pedineith at Thebes (7th century B.C.) and in the Graeco-Egyptian tombs at Tuna—these belong to the decadence of Egyptian art and do not come within our program.

We propose, in short, to concentrate on those New Kingdom wall paintings which are to be found in private tombs at Thebes. And, even so, the field of study would exceed the compass of the present volume, were it not that our choice has been determined less by archaeological than by aesthetic considerations. Egyptologists will find nothing here with which they have not been familiarized by black-and-white reproductions or Mrs Davies' watercolor copies, photographic counterparts of several of which figure in this book. And since it is primarily addressed to art-lovers and students, we have aimed less at illustrating iconographically rare details than acknowledged masterpieces. These are presented in chronological order, so as to make our survey of the stylistic evolution that took place during the four centuries of the New Kingdom as revealing as possible.

Nothing could be further from our intention than to supplant the works of our predecessors and, still less, the magnificent sets of pictures made by Mrs Davies, fruit of a whole life's patient toil. The novel element in our venture is that here, for the first time in the annals of Egyptology, the Pharaonic paintings are reproduced by the direct color-separation process.

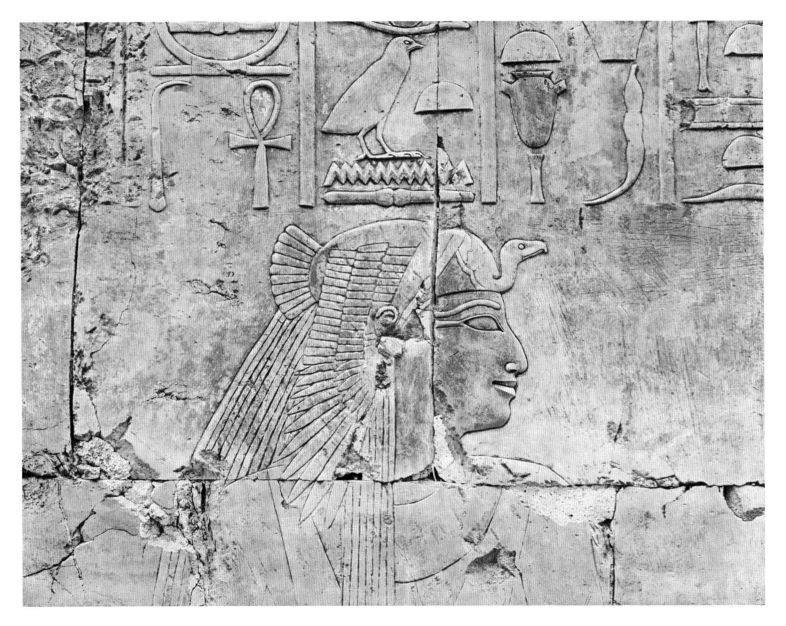

HEAD OF QUEEN AHMOSE. BAS-RELIEF IN THE TEMPLE OF QUEEN HATSHEPSUT
AT DEIR EL-BAHRI, THEBES.

No limit may be set to art, neither is there any craftsman that is fully master of his craft.

The Instruction of Ptahhotep

EGYPTIAN PICTORIAL ART
THE TOMBS AND THEIR DECORATION

Egyptian painting might well be described as primarily utilitarian, since its religious aim imposed on it a function of, so to speak, a "magical" order—provided we use the epithet in no derogatory sense. This accounts for the emplacement of the works with which we shall be dealing; all of them adorned the mortuary chapels which wealthy or important personages under the New Kingdom caused to be hollowed out in the rocky hills west of Thebes, the capital. Over four hundred of these "private" tombs (so designated to distinguish them from the royal hypogea) have been discovered, some carved, the others painted, and they are now accessible to the ordinary tourist as well as to the archaeologist. All keep to a more or less uniform plan, though there are many minor variations. The general lay-out is as follows: a small courtyard open to the sky, hewn in the rock and often in a ruinous state, leads to a door behind which is first a chamber whose width exceeds its length; then at right angles to it comes a long narrow chamber. A ground plan would take the form of an inverted T. In the tombs of exceptionally rich or eminent Egyptians this lay-out is amplified to include intermediate rooms or annexes, with make-believe columns engaged in the virgin rock and niches with statues inserted or carved in the wall. A vertical shaft or steeply descending passage leads down to the chamber in which were placed the sarcophagus and mortuary furniture, now lost for ever or dispersed in museums and private collections. These burial chambers were seldom decorated except, in some cases, with texts from the Book of the Dead, another exception being the group of tombs of workmen and artisans at Deir el-Medina to which our last chapter is devoted. Devoid of interest for the visitor, many of the underground chambers have been sealed off by the Antiquities Department to prevent the risk of fatal accidents.

The visible part of the tomb, i.e. the "chapel," is thus the only one which we shall study from the iconographical angle. Since this was regarded by the Egyptians as the dead man's future home, its walls were adorned not only with the most agreeable and varied scenes of earthly life but also with those of the life beyond the grave and, to perpetuate their efficacy, the rites performed over the dead body. There would be no point in enumerating here all the themes handled by Egyptian artists; lists will be found in the technical works cited in our bibliography. This book, in any case, does not set out to be a history of Pharaonic civilization, but to provide an over-all view of Theban painting. None the less we believe that it also gives the reader a vivid picture of Egyptian life during this period; moreover, he will find in our commentaries explanations of the scenes portrayed, whenever these seem called for.

It will be enough, at this stage, if we briefly describe the three main categories into which the works of the painters of Antiquity for the most part fall: mythological, ritual and biographical. Readers will notice that the world of the gods and that beyond

the grave is rather sparingly represented in this book; but it must be remembered that Egyptian artists, in this domain, slavishly followed the rules laid down by the priests and had little scope for originality. True, the religious symbols and divinities are flawlessly drawn and colored, but they do not come alive or move us—they are in fact over-academic. There is no denying the spirituality of the Egyptian religion; it is evidenced both by the sapiential texts and by stylized or hybrid forms whose hidden meaning was known only to initiates. All the same, our modern sensibility is allergic to these half-human, half-animal beings and those mummified Osirises whose greenish

VIEW OF THE SOUTH WALLS, TOMB OF NAKHT (NO. 52), THEBES.

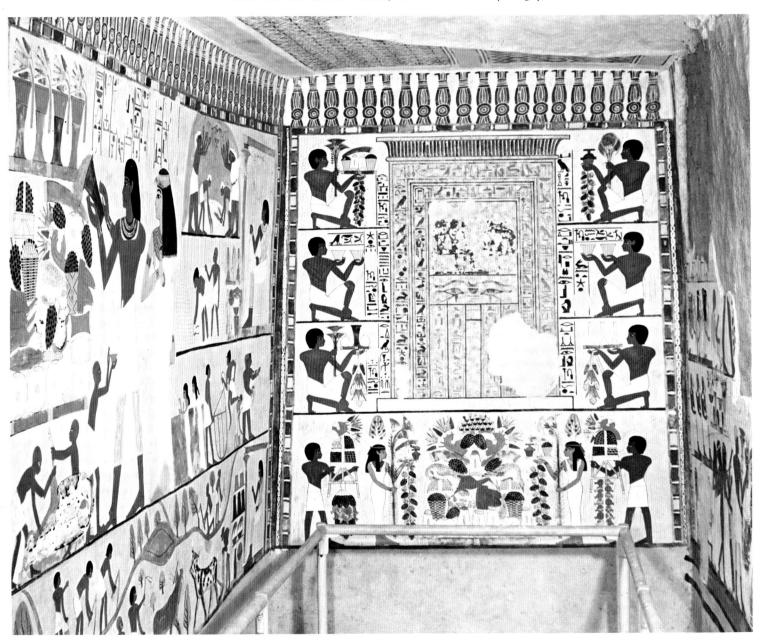

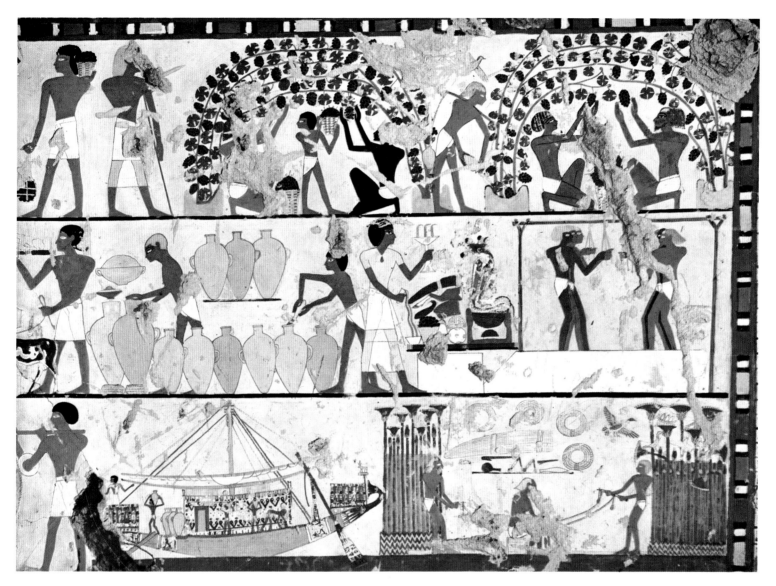

PAINTED WALL IN A NAMELESS TOMB (NO. 261), THEBES.

skins signify at once the decomposition of the corpse and the rebirth of vegetable life, and who supervise the ritual weighing in the Scales of Truth of the heart of the dead man humbly bowing before his divine Judge. The ceremonial scenes, on the other hand, are enacted on the earthly plane and concern the cult of the individual glorified in death. All the successive stages of the funeral rites, from the purification of the body to its entombment, are represented; sometimes indeed (during the Ramesside period) with considerable verve. But these scenes, also, are all too often stereotyped and one feels a lack of conviction on the artist's part; or else he left their execution to unskilled apprentices. Nevertheless these works are, as might be expected, the most numerous and merit more attention than is usually accorded them. Sometimes, in the midst of a quite commonplace picture sequence, we find charming details or vignettes in

which the artist has "let himself go" to the happiest effect. Our choice of illustrations in this exceptionally rich field of Egyptian art has been determined by the originality of the interpretation and the intrinsic beauty of the composition.

A brief explanation seems called for as regards the scenes we classify as "biographical." These are not so much biographies in the strict sense as idealized versions of the life of a "pasha" under the New Kingdom. However, this did not deter the owner of the tomb, if he was a member of the Court or an important functionary, from realistically presenting certain incidents of his career that he specially wished to commemorate. On the other hand, to the very impersonality of the scenes of everyday life is due the fascinating picture they provide of the Egyptian way of living. In depicting the recreations of the upper class—hunts and banquets—and the daily toil of workers in the fields, fens and workshops, the painter often displays not only subtle artistry but much human feeling. Breaking with hackneyed procedures and the "pattern-books," he gives rein to his fancy and enlivens the pictures he has been commissioned to make with touches of personal observation. Thus, across the gulf of time, such works as these make a direct and intimate appeal, and though their makers are anonymous —with one exception, that of the painter Amenwahsu, who decorated his own tomb (No. 111)—and were regarded by their contemporaries as mere artisans, we feel that the emotions and ideas behind their work are near akin to ours today. If we devote the greater part of this book to selected works of this order the reason is that, thanks to their fidelity to the originals, our colorplates will serve to illustrate the remarkable affinities, too long unnoticed, between the art-forms of the Egyptian past and modern taste.

COMPOSITION OF THE PICTURES

On entering a well-preserved Egyptian tomb we are no less struck by the vivacity of the colors than by the immense number of small scenes and figures on the walls, disposed in several registers one above the other and forming an unbroken sequence on each tier. Seldom does the Egyptian artist embark on a large-scale picture. Some exist, however, made to the scale of the massive tombs of the Viziers and Governors of Thebes, highest dignitaries of the Kingdom. Here, often enough, the carved or painted figures are life-size. Normally, however, the height of even the leading figures little exceeds four and a half feet. By "leading figures" we mean portrayals of the deceased at the entrances of their tombs making offerings to the Theban gods or declaiming a hymn to the sun; likenesses of the King in the tombs of Court favorites; of the gods and deified Pharaohs; and, exceptionally, certain figures in big scenes, of hunting and fishing for example. But usually the painter inscribes his picture in a rectangle or square located in a register whose height ranges from twelve to sixteen inches. Scenes are sometimes arranged in their logical order and sometimes (when the events form a series in time) in chronological sequence. We are invited, it seems, to "read" the

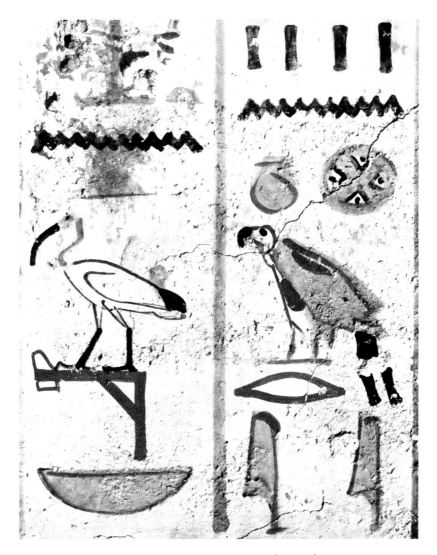

HIEROGLYPHICS. TOMB OF THANUNY (NO. 74), THEBES.

registers from the bottom of the wall upwards. This is best illustrated by the scenes of work in the fields; obviously the scene of sowing precedes that of reaping, and the latter that of treading out the grain. As regards those scenes which seem to be placed haphazard, we can either assume that the artist was allowed to take certain liberties in the arrangement of this theme, or else that he was guided by conventions or a symbolism whose meaning is unknown to us. In any case it would be a mistake to appraise Egyptian painting, aesthetically, in terms of the effect produced only by *ensembles* or groups of scenes. If we are to enter into the spirit of the Egyptian artist, we must study each picture, sometimes indeed each figure, independently, without regard to its context. It would seem that in a painting class under the New Kingdom the young "scribes of outlines" (as the Egyptians called their draftsmen) were taught their craft by means of rolls of papyrus, each "page" of which illustrated and gave details of one or more of the stock themes imposed on the apprentice tomb-painter. Thus the preference we

show for "close-ups" is quite in keeping with Egyptian ideas; all the same, we make a point of giving the dimensions of each subject reproduced (in our list of illustrations) so that the reader can better judge the general effect of the original.

With reference to this question of composition, the fact that some authorities have seen an analogy between Egyptian pictures and hieroglyphs should not be over-looked. Stress is often laid on the point that the Egyptian artist's handling of his subjects was intellectual or cerebral rather than naturalistic, and from this viewpoint the scenes on the walls of tombs and temples may be regarded as a sort of hieroglyphic text writ large. But the contrary view would seem better justified: that their feeling for decoration and simple, almost mathematical construction led the Egyptian scribes, generation after generation, to go on making hieroglyphic signs so finely executed and richly ornamental that they often vied with the best pictures of the day. In certain Theban tombs, in the royal hypogea and in the temples of the great periods, the inscriptions, whether written in columns or in horizontal lines, are works of art in their own right. Here, too, the draftsman groups his signs in carefully planned rectangles, following the procedure described above.

But surely there is no need today to justify the graphic conventions of the Egyptians; emancipated from the thrall of nature-imitation, modern art has trained our eyes to welcome the austere grandeur of Egyptian art on its own terms.

TECHNICAL PROCEDURES

Bringing out as they do the exact texture of the works we illustrate, our color-plates go far to reveal the pictorial technique of the Egyptian artists—all the more so because so many paintings in the Theban tombs were left unfinished and thus we can trace the various stages of the work, from the laying-on of the plaster ground to the application of the final coat of paint. Moreover the colors often seem so fresh that one almost has a fantastic impression that the painter will soon be returning to go on with his work. While helpful for the understanding of their methods, this tendency of Egyptian artists to leave their work half done is certainly surprising. Its explanation might be the notorious laziness of races dwelling in hot climates, or, in some cases, the premature death of the man commissioning the paintings of his tomb. Still the amazing fact remains that really finished works are the exception and that even in cases where the walls are fully decorated, one passage has often as not been left in the state of a rough sketch. Two typical examples may be cited: the tomb of Menna (No. 69), which we shall describe hereafter, and that of Païry (No. 139); the paintings in both of which—a relatively rare circumstance—seem to be partly by the same hand. In each case the single detail treated sketchwise by the artist is a boat; we might almost take it for a sort of "signature." One is almost tempted to read into this frequent failure to complete a given detail some esoteric meaning, a philosophy of incompletion.

We may begin by pointing out that the procedures followed at Thebes under the New Kingdom were already current at the beginning of the IVth Dynasty; we see them in "The Geese of Meidum." Yet in this same mastaba of Itet the artist initiated a technique that proved to be short-lived; the façade—which was of stone, whereas the rest of the tomb chapel is in sun-dried brick—was decorated with scenes executed in mock-painting, by the incrustation of color-pastes in cavities gouged out in the limestone. Various panels of this façade can be seen in the museums of Cairo, Copenhagen and Brussels; we give a fragment of the Cairo panel. It depicts a fowling scene; two kneeling figures are tugging at a rope fastened to a net in which some birds are trapped. The color-pastes are sufficiently well-preserved to produce the effect the painter was aiming at; in places where they have disappeared we can see the deep grooves in which they were inlaid. Though the curious technique invented by this artist had no sequel, this composition is of special interest, providing as it does a conspicuous example of the characteristics of Old Kingdom art as described above: geometrical and angular drawing combined with a rich over-all rhythm.

Since almost all the tombs at Thebes were hollowed out in the cliffs, the decorations were frequently made on a limestone ground. Unfortunately, the rock-face in these parts is highly friable. Where there happened to be a patch of good stone, the

FOWLING SCENE AND WORK IN THE FIELDS. FRAGMENT FROM THE MASTABA OF ITET AT MEIDUM. CAIRO MUSEUM.

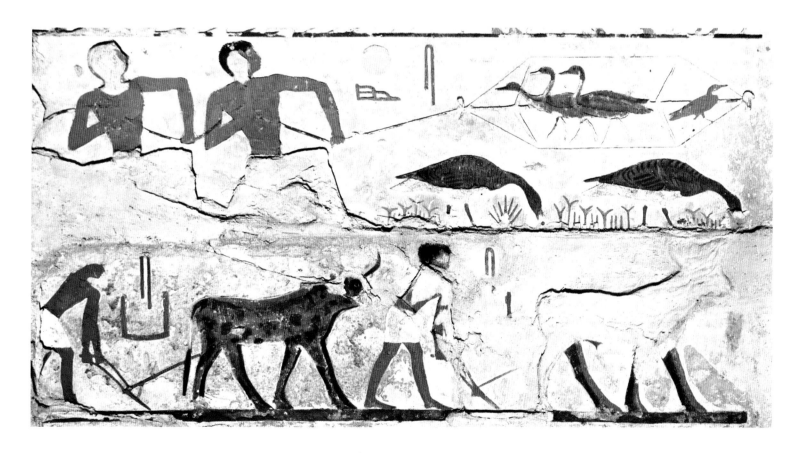

sculptor was usually called in first, and the painter's task was merely to color the reliefs. As in Greece, sculpture and painting went hand in hand, and it is no easy matter drawing the line between them. Should we regard a colored relief as being intrinsically sculpture painted over, or as a painting on a surface chiseled and modeled to give it fuller tactile values. For an understanding of this problem, the comparative study of specific cases is more rewarding than any general description. The Theban temples at Karnak, Luxor, the Ramesseum and Medinet-Habu (to cite only the most famous) were built in Nubian sandstone, a rough, coarse-grained stone. The walls were covered with a coat of white plaster, modeling the figures, and painted, down to the smallest details, in vivid colors. The effect must have been by modern standards unbearably garish, as garish as the original colors of the Parthenon, unless of course the blurring effect of the eastern sunlight allayed their virulence. Except in a very few places the plaster has gone and with it the colors, leaving the wall bare. And now that the lack of vigor of the bas-reliefs and sunk reliefs *per se*, not to mention the corrections made by the sculptors responsible for them, can be plainly seen, it is obvious that the painter had the last word in these creations. A similar, if less satisfactory, procedure was followed in several royal tombs in the Valley of the Kings and the Valley of the Queens, where the passages and tomb-chambers are situated in the depths of a calcareous mountain; here the walls were dressed with a more or less thick coat of gypsum which was lightly carved, then painted. Now that this coat has crumbled away, we might well suppose these tombs were left undecorated, were it not that here and there the sculptor's chisel struck through into the limestone. Thus dozens of square yards of inscriptions and depictions of scenes of the after-life which might have thrown much light on the Egyptian religion are irrevocably lost. Most tragic of all is the predicament of the tomb of Queen Nefertari, wife of that famous king Ramesses II (ca. 1298-1235 B.C.), which was discovered and opened up by the Italians fifty years ago. Here the superb paintings on modeled stucco which until the recent war delighted the eyes of archaeologists, art historians and tourists alike, are now in such a precarious state that their total loss may well be a matter of only a few years. For now that damp has got into the tomb the plaster is working loose from the walls, bulging, flaking away and, in places, has crumbled into dust. We find the same technique employed in private tombs of the Ramesside period, for example in the huge tomb (No. 148) of the priest Amenemope, who flourished under the xxth Dynasty (ca. 1160 B.C.). Fortunately some of the panels in this tomb are in an excellent state of preservation.

The bas-reliefs in the tombs of Thebes during the great period (i.e. the xviiith Dynasty) stand out as masterpieces of sculpture; the color on most of them has worn off—and anyhow was superfluous. None the less, when we examine the superb relief-work in the temple of Queen Hatshepsut at Deir el-Bahri, whose architecture is no less admirable, we get an idea of the happy alliance obtaining between the sculptors and painters of this period. This temple was built in terraces abutting on a bay of lofty cliffs, and some of the scenes behind the various porticos have kept their colors. Reproduced at the beginning of this chapter is the noble portrait of Hatshepsut's mother, Queen

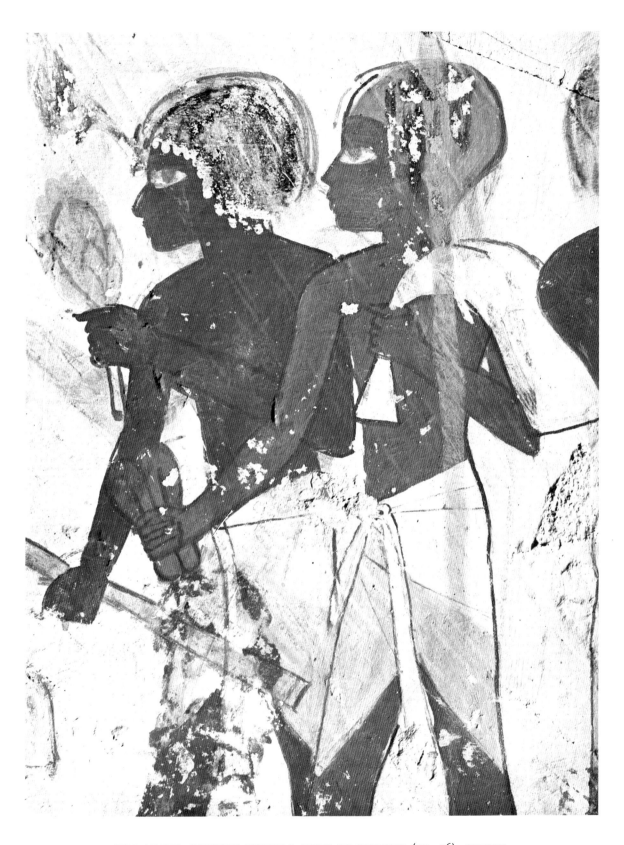

TWO YOUNG OFFERING-BEARERS. TOMB OF USERHET (NO. 56), THEBES.

Ahmose, and we can feel the loving care the artist has brought to carving the soft limestone, to which light and air have given a golden glow. There is a cameo-like precision in the work, but the profile is, so to speak, spiritualized by the purposeful omission of all non-essentials. True, this portrait relates to a "theogamy"; the queen has been visited by night by the god Amun, come down on earth in the guise of her spouse the king, and in due time she will be led to the birth chamber where her child, at once royal and divine, will see the day. Hence the smile of serene beatitude we see playing on her lips. Traces of two pigments still remain: a little red (much faded) on the cheek and eye, some pale blue on the wings of the stylized vulture of the head-dress, and the delicacy of these tones is in keeping with the exquisite modeling.

To return to the mural paintings properly so called, the surfaces to which they were applied were of three kinds, which we describe hereunder: smoothed limestone, a coat of stucco, or a loam-and-straw foundation.

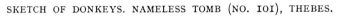

SKETCH OF DONKEYS. NAMELESS TOMB (NO. IOI), THEBES.

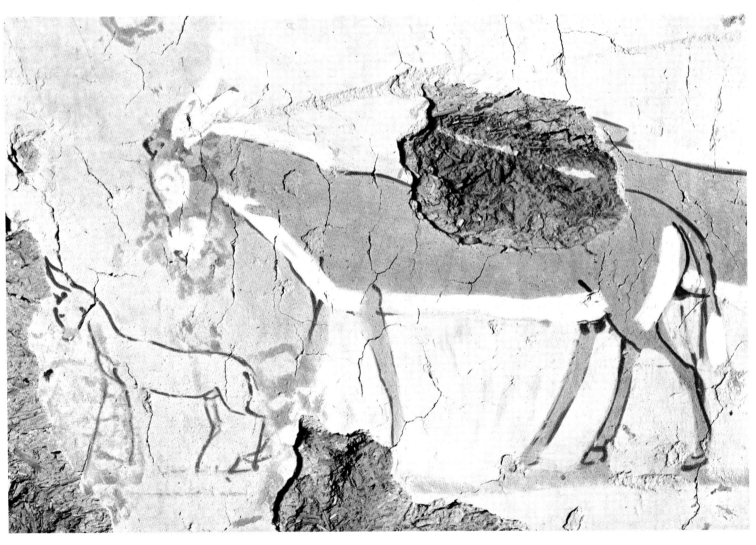

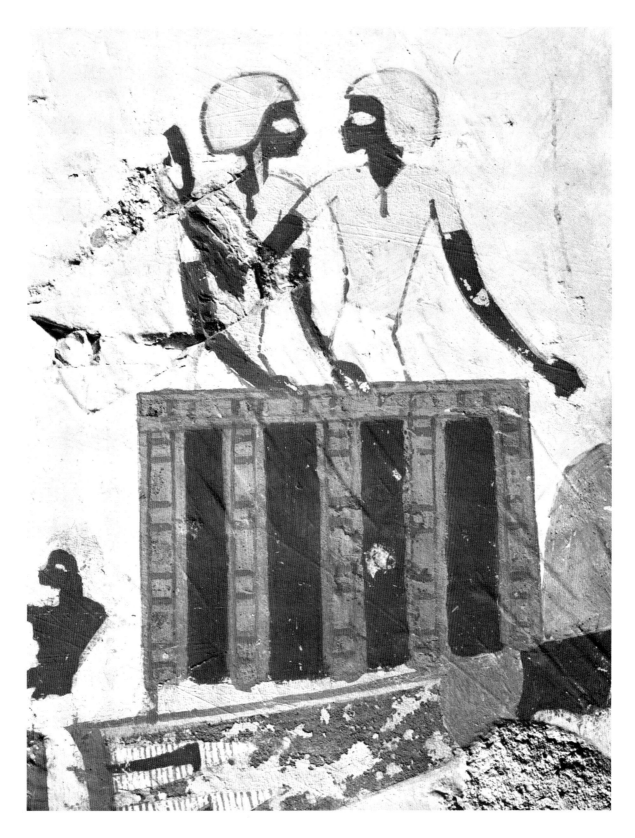

TWO SAILORS. DETAIL OF A BOATING SCENE. TOMB OF USERHET (NO. 56), THEBES.

When the rock in which the tomb was hewn was of good quality, the walls were carefully smoothed down, all holes and cracks being filled with plaster, and the artist painted directly on the surface of the rock-cut wall. Amongst the pictures we shall deal with the best examples of this technique are those from the tomb of Userhet (No. 56) and from that of Ramose (No. 55).

Two details from the former, which we reproduce, are revealing in this respect. The first shows two youths carrying offerings: a green lettuce and a white bag; one wearing a black wig, the other a close-fitting pink cap. The whole composition is sketch-like. The limestone wall, split above the second boy's head, can be clearly seen across the whitewash ground. The smear of mud upon the figure on the right is accounted for by the fact that this tomb, like so many others, was dwelt in by Christian hermits in later days (as can be seen by the crosses scrawled on the walls). To protect themselves from carnal desires, they tried to wash out the female figures painted by the ancient Egyptians and what we see here is a streak of water mixed with pigment that has run down from the tier above, where the "lascivious" images were painted.

Our second example, from the same tomb, shows how blemishes in the surface of the rock-wall were rectified with plaster. Two sailors are standing in the forward cabin of a boat on whose prow is a lion's head with a pink mane. This, too, is a sketch and treated summarily; the artist has left out the sounding-rod that one of the men in charge of the navigation of the boat is thrusting down into the water. The stylistic qualities of this work will be discussed later.

Most of the paintings at Thebes, anyhow those of the xviiith Dynasty, were done on stucco, not on the bare rock. In the charming group of donkeys in Tomb No. 101 the damaged portions show how the artists went about it. It is obvious that a thick coat of mud plaster was applied to the uneven rock-face, layer by layer, the wet loam being mixed with straw to reinforce it. Next, this foundation, rather like adobe, was overlaid with a film some two millimeters thick of a compound of plaster and powdered stone, constituting a smooth, fine-grained mortar enabling the utmost delicacy of line. According to the materials with which it is made, the stucco is in various shades of rather dingy grey, beige or brown; in any case it does not act as a ground to the pictures but is always given a coat of paint. This can be seen in the little scene we reproduce; though the young donkey with its ears pricked up and in the act of stepping forward has been merely sketched in, the artist has begun painting (in white) the underbelly, muzzle and tail of the she-ass, and laying in the background.

As already mentioned, there are so many sketches that it is easy to discover the various stages an Egyptian painting went through, from the artist's initial conception to the finished work, ready to hand over to the patron commissioning it. Without going into details we shall give a brief account of the way he went about composing human figures.

Once the wall surface was made ready, the artist began by drawing horizontal lines marking off the "registers" or tiers; next, for the scenes which called for elaborate treatment, whether because of their dimensions or their subject-matter, he subdivided

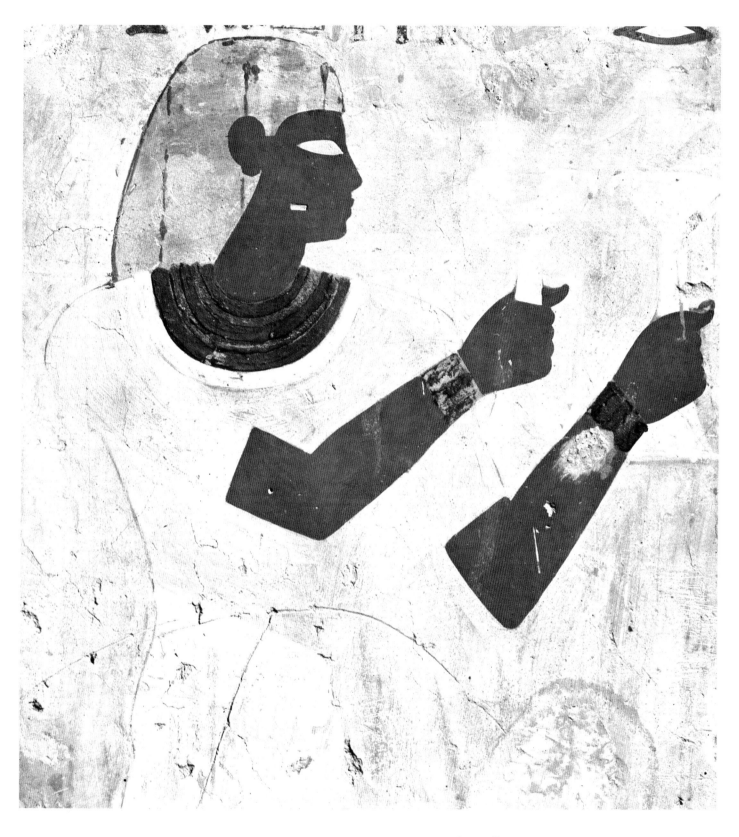

PORTRAIT OF A MAN. TOMB OF DESERKARASONB (NO. 38), THEBES.

the register into squares following an established canon and enabling him to locate each detail in its proper place. These guide-lines were made with cords soaked in red paint, splashes of which are sometimes visible along the lines. Once he had thus marked out his "canvas," the artist outlined his figures, and, laying in the background, caused them to stand out. This background was usually grey-blue during the early and middle periods of the xviiith Dynasty; exceptionally, in the tomb of Kenamun (No. 93), it is yellow. At the end of the xviiith and in the xixth Dynasty it became white. Yellow grounds were favored during the period of the Ramesses, notably at Deir el-Medina. When the artist started painting the figure he began, it seems, with the flesh-tints, using more or less vivid red ochre for the men and yellow, pink or pale suntan brown for women. For clothing, one or more coats of white were used, according to the degree of transparency or opaqueness called for. Multicolored jewels were depicted *en masse* before being given detailed treatment. The coiffures usually were done last. Meanwhile, in the course of these operations, the original sketch had gradually lost its sharpness of definition; the painter now remedied this by drawing with his brush a new outline in red (except at Deir el-Medina where it is black).

The procedure described above is illustrated by two of our reproductions. First we have the Deserkarasonb portrait (Tomb No. 38) in which the grey stucco is visible at the place where the wig was to be painted in, and so are the guide-lines of the preliminary graticulation. Since the final outlines were not added the general effect is rather blurred, but this is compensated for by gradations of the white, which develops broken tones where the intonaco shows through, with a pink sheen on the flesh, and becoming quite opaque at the waist, where there was already a first coat of white. The eye also has been left white, awaiting (like the hair) the addition of black lines to give it definition. Of the collar and bracelets we see enough to gather that they consist of the blue-green faience beads in fashion under the xviiith Dynasty.

The second portrait is that of a xixth Dynasty lady, wife or sister of the priest Userhet (Tomb No. 51). It, too, was left unfinished and we can still see the places where final details or outlines were yet to be inserted: the lotus-flower on the forehead, the bandeau round the top of the headdress, the eye, the earring. Under the blue of the ribbon can be seen, in red, an ornament of spiky leaves whose right edge has been retraced in black. This last brushstroke made by the unknown painter when round about 1300 B.C. he knocked off work—for the day, as he thought, but actually never to resume it—adds as it were a human touch to this wonderful composition, whose simplicity and sensitivity are already so appealing. Noteworthy, too, is the sleight of hand with which the artist has drawn the profile—in one continuous line without a single hesitation or revoke. Though omitting the nose-wing, it clearly indicates the shadow-line between the lips and that of the chin, and even a small dimple beside the rather imperious mouth.

From the purely technical viewpoint we may note that this picture illustrates the third of the three techniques described above, that is to say painting done on a loam-and-straw foundation. We can detect tiny shreds of the straw reinforcing the mud

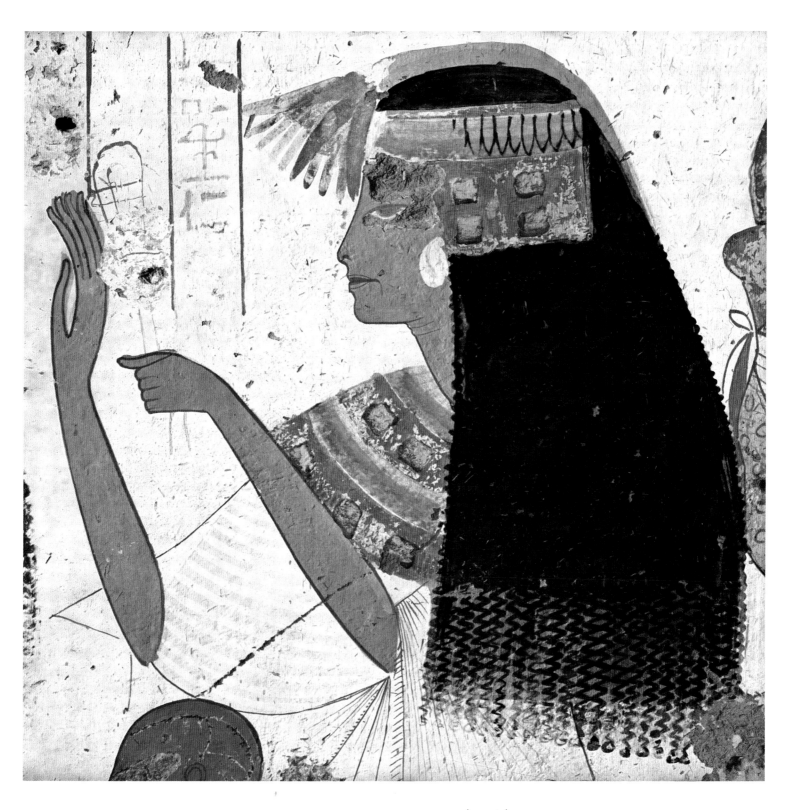

PORTRAIT OF A LADY. TOMB OF USERHET (NO. 51), THEBES.

plaster in several places; not only in the fissures of the forehead and eye but also behind the cheek, the wig and the white ground. If it seems strange that so precarious a foundation was used for pictures of such high excellence, it is still more wonderful that they should have survived so well. For on close inspection we realize that a mere breath of air would be enough to dislodge these gossamer films of pigment, frail as a butterfly's wing, from the wall of dried mud. Indeed the removal of the dust from certain scenes which we desired to photograph was a most exacting process; and in cases where a spider had set up house in a corner of one of the pictures, the risk of tearing off a fragment of the painting along with the web made things still worse. It is regrettable that, from the xixth Dynasty on, this technique became general; five of the tombs we shall deal with were treated in this way. The artist contented himself with covering the loam-and-straw foundation with a thin white or yellow undercoat and painted on this ground. Since he could no longer resort to the old method of squaring off the picture surface and making corrections which were subsequently masked by successive layers of pigment, much virtuosity was called for. Inevitably works of the Ramesside period show traces of this over-hasty execution.

We conclude our résumé of Egyptian pictorial technique with some account of the range of colors available and their composition. The color schemes of the Pharaonic painters were always very simple and they used the tempera process exclusively. The pigments consisted of natural substances ground to powder; the artist mixed them with water, adding a little gum so as to make them adhere to the surface, rock, plaster or puddled earth, on which he was to paint. Red, yellow and brown ochres predominate, their intensity diminishing the more they are diluted. These are mostly used for flesh-tints. Whitewash was used for garments and at the close of the xviiith Dynasty for backgrounds too. By applying a single coat or several, the artist could get effects of transparency or opacity, as desired. When mixed with or superimposed on red ochre, it served for the blush-pink of women's faces and certain kinds of fruit, animals or food in scenes of offerings. Blue and green are much employed; the base of both alike was copper frit and for this reason they are sometimes hard to distinguish. In the zigzags signifying water, the blue painted over the white ground acquires delicate translucencies. During the first half of the xviiith Dynasty all backgrounds were in blue; on lime-stone walls it became a little paler, tending towards azure, whereas on porous stucco it shaded off into a neutral, low-toned blue-grey. Green is reserved for leafage, thickets of papyrus, offerings of vegetables or flowers; also for certain elements in necklets, bracelets and girdles, where it is used to represent enameled beads. On these the color is often applied so thickly that it stands out in relief. It is difficult to say whether this was intentional, or a consequence of humidity. In any case, green is the color that has suffered most from exposure to the air; in many places it has developed a rusty hue which the original painter certainly did not desire. Sometimes, too, it has had an injurious effect on the plaster; to cite but one example, our readers will observe that the passages in the tomb of Menna (No. 69) which are painted green—notably the field of flax—have not only flaked away but have eaten into the coat of stucco and dragged

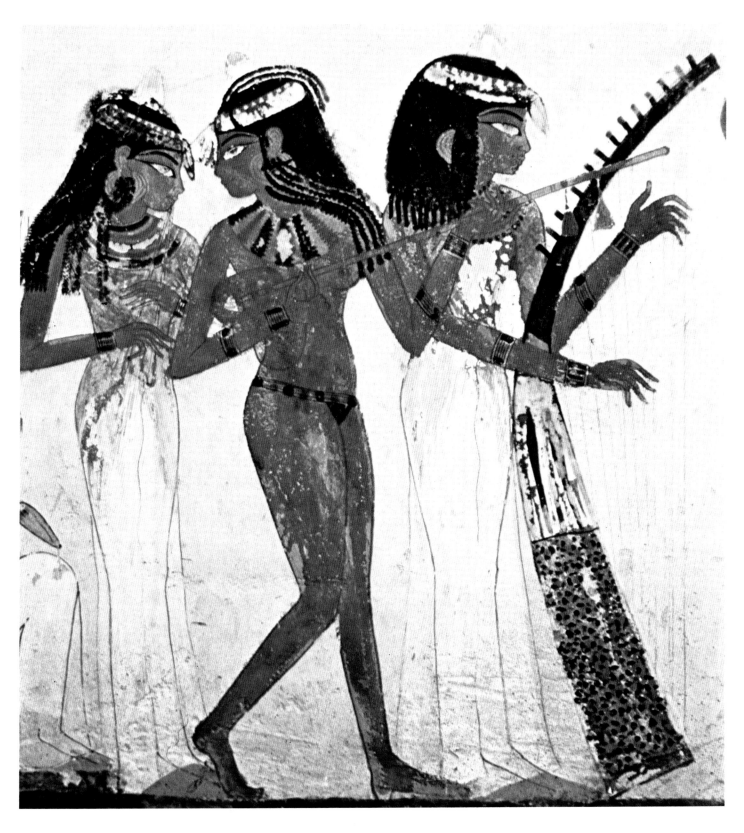

WOMEN MUSICIANS. TOMB OF NAKHT (NO. 52), THEBES.

it down with them. However, such chemical reactions are fairly rare. Black is still more impermanent; made of soot, it held badly on the wall, which is why in some cases the huge wigs worn by the women have disappeared, leaving the yellowish limestone or stucco bare—with the startling result that at first sight we might imagine that the Egyptian lady of the New Kingdom was usually a blonde! When mixed with other pigments black held better. Mixed with white, it was used for the grey of birds' wings or pleated dresses; with ochre, for producing a deep, rich red.

The Egyptian artist painted in flat tints, his choice of colors was conventional or arbitrary, but in his arrangement of them he showed a fine sense of decorative effect. He had little care for imitating nature, but, as if to prove that he was quite capable of doing so on occasion, he sometimes reproduced with meticulous precision the color, veins and texture of such objects as stone or earthenware vases, caskets or weapons. A skillful animal-painter, he had a wonderful knack of giving the "feel" of fur and plumage, but usually he disdained illusionist realism of this order and preferred to paint in pure colors, less lifelike than suggestive. Devoid of affectation, his work has a superb timelessness, and achieves, by dint of its aesthetic qualities rather than by any striving for spectacular effect, what for the Egyptian civilization of the Pharaonic age was the supreme aim: to stake an indefeasible claim on eternity.

In this connection we may mention that towards the middle of the xviiith Dynasty some painters tried to protect certain details by covering them with a thin coat of varnish. Unfortunately, this has become so brown or yellow with the years as to disfigure the picture. Flesh-tints in particular have suffered, and the drawing, too, has lost its sharpness under a film of opaque and brittle glaze. In fact these "protected" works were exposed to greater risks than the others, since the varnish tends to flake away, dragging off the pigment with it. These painters would have done better to trust to the Egyptian climate which, thanks to its extreme dryness, is the ideal preservative.

As an example of these varnished paintings we reproduce the famous group of three women playing instruments—a flute, a mandola and a harp—in the tomb of Nakht (No. 52). These young women are admirably individualized, each head (largely owing to its posture and the movement of the tresses of the hair) being quite unlike the others. The expressive "language" here is centered in the hands, notably those of the girls in long, straight-falling garments on either side of the dancer. This latter is naked but for a tiny girdle that is less a garment than an ornament and stresses the thickness of limb characteristic of the professional dancer. The suppleness of her body is conveyed by the curious transition from one plane to another so often found in Egyptian art; the face, seen in profile, is turned to the left, while the shoulders are shown front-view and here the left breast also is shown as if seen from in front, instead of in profile according to the Egyptian convention. The twist of her body at the waist is natural and accords with the position of the legs and feet moving, in profile, to the right, making thus a contrapposto with the face. This rhythmic arrangement of graceful curves is far more effective than would have been any dramatic gesturing. Indeed the whole composition is highly sophisticated; the light mass of the harpist and her instrument

balances the left half of the scene, while the animated "dialogue" between the two heads with flowing tresses contrasts with the placidity of the right-hand head with its thick, close-set wig. A linear counterpoint of parallels links up the two stationary figures each with each, and the dancer with the curve of the harp, while a diagonal movement is set up by the neck of the harp and the bent leg of the central figure.

An anthology, so to speak, of the colors employed by the Egyptians can be found in a small unfinished tomb in exceptionally good condition, that of Neferronpet (No. 43), who was the cook of Amenophis II. Indeed the four ladies (figuring in a banquet scene) illustrate almost the whole range of colors. Telling out against the blue-grey background are the red and yellow ochres of the flesh-tints, snow-white of dresses, black of wigs (paler in places because there is only one coat), the blue and green of necklaces, bracelets, diadems, lotus flowers and buds, and the mat on which the group is seated. The posture of the lady who is turning to hold out a lotus blossom for her brunette friend to sniff, is pleasantly realistic, as are the wisps of hair escaping from her coiffure.

BANQUETING SCENE WITH FOUR LADIES. TOMB OF NEFERRONPET (NO. 43), THEBES.

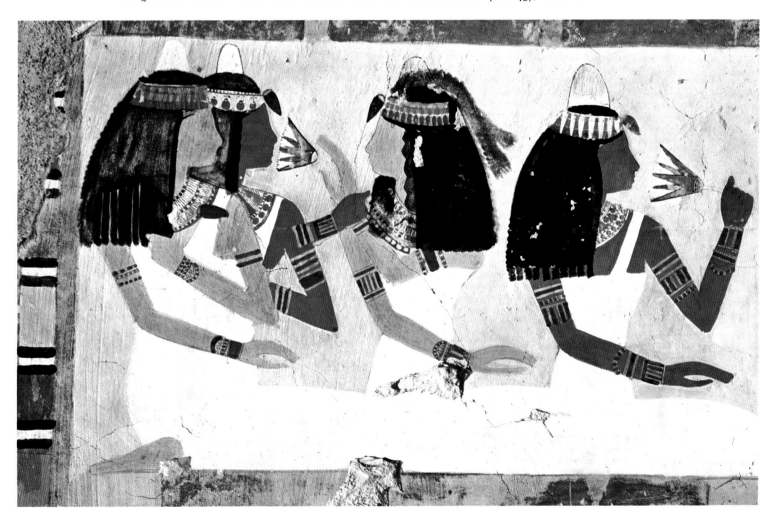

STYLISTIC EVOLUTION

In the chapters which follow we shall describe the evolution of Egyptian Painting from the xviiith Dynasty to the Ramesside period. A description, even an enumeration, of all surviving monuments being out of the question, we confine ourselves to what in our opinion are the best tombs, and the best murals or details in them. Readers will understand that reasons of space have obliged us reluctantly to omit not a few outstanding scenes. The order followed in our text is chronological; this seemed better than an arrangement according to themes, our approach being aesthetic rather than iconographical. Thus the sequence of our colorplates enables the reader to form a clear idea of the evolution of pictorial art under the New Kingdom, while in the accompanying text he will find critical analyses of the various pictures. Moreover, brief descriptions of works which could not here be reproduced will help him to form an idea of the vastness of the subject, of which such a book as this must perforce give but a partial view. Our aim, in short, has been to indicate and illustrate the changes that came over Egyptian art between 1500 and 1100 B.C.

There is some difficulty in assigning exact dates to the Theban tombs. Unless the name of a king figures in the inscriptions on the walls (and, even then, we have to make sure that the reference concerns a reigning king and is not a pious tribute to the memory of a dead ruler), the procedure usually followed is to compare its style and technique with those of other tombs whose date is positively known. By this means and also on the strength of philological and onomastic data, Egyptologists have drawn up a tentative chronology of the tombs at Thebes (there are approximately four hundred), which, though like all archaeological hypotheses somewhat speculative, seems by and large reliable. Specialists in the reigns of individual kings occasionally throw doubt on points of detail, but the general classification certainly holds good. Inevitably the dates of some of the works we shall discuss have been contested; we shall cite the experts' differences of opinion in respect of these, and set forth our reasons for the view we sponsor.

To make things simpler for our readers we append a brief description of each of the successive periods of Theban painting, but it must be understood that these definitions are purely schematic.

The art of the reign of Tuthmosis III (i.e. the first half of the 15th century B.C.), like that of the early xviiith Dynasty, had many affinities with the styles of the Old and Middle Kingdoms: extreme dignity, some stiffness in rendering movement, a penchant for symmetrical composition, vivid and opaque colors on sky-blue backgrounds.

Under Amenophis II (1448-1422 B.C.) and Tuthmosis IV (1422-1411 B.C.), gestures become suppler and more graceful, the artists show more freedom and fantasy in their compositions, colors are lighter, sometimes translucent, while backgrounds are in a neutral tint, blue-grey.

These diverse methods were combined during the reign of Amenophis III (1411-1375 B.C.), and the best works of this period have a sobriety and restraint that might

well be described as classical. We find a like refinement in the choice of colors, allied with a subtle gradation of tones more in keeping with the white backgrounds which now came more and more into favor.

The reign of Amenophis IV, also known as Akhenaten (1375-1358 B.C.), made a break whose full effects were felt only later, under the Ramessides. The artists of Tutankhamen's reign (ca. 1350 B.C.), seeking as they did to temper the excesses of the Amarna style, developed a mannered but highly attractive form of art, which, however, was short-lived. On the other hand, the transition period from the xviiith to the xixth Dynasty (covering approximately the second half of the 14th century B.C.), reveals two tendencies: one reactionary, i.e. academic, and the other so "advanced" as to anticipate the picturesque style of some Ramesside painters.

The epoch of the Ramesses—a very long one, spanning two centuries, the 13th and 12th B.C.—is, artistically speaking, under a cloud since it inaugurated the decadence of Egyptian art. In the best works there is often a curious mixture of virtuosity and carelessness. Alongside pieces in a still traditional style are figures with the long, shaven skulls of the type dear to Amenophis IV; with lean, gesticulating arms, thin, over-long legs, billowing garments, necklaces and jewelry gaudy to the point of flashiness. So as to give his pictures animation the xixth Dynasty painter cluttered them up with piquant details whose effect, if lively and original, lacks distinction. The hasty sketch now takes precedence of the finished work of art. Originality is cultivated at the expense of dignity. This lack of careful artistry and restraint is also to be seen in the way the walls are prepared; with a coat of white or yellow limewash on a plain loam-and-straw foundation. Meanwhile the ever-increasing popularity of yellow backgrounds led naturally enough to the use of vivid colors.

The tombs of workmen employed in the Theban necropolis and buried at Deir el-Medina form a group apart. Though the paintings in them are more summarily executed than those in the mortuary chapels of the rich and eminent personages of the same period—indeed they are sometimes done in monochrome—their freshness of inspiration, liveliness and informality are highly attractive.

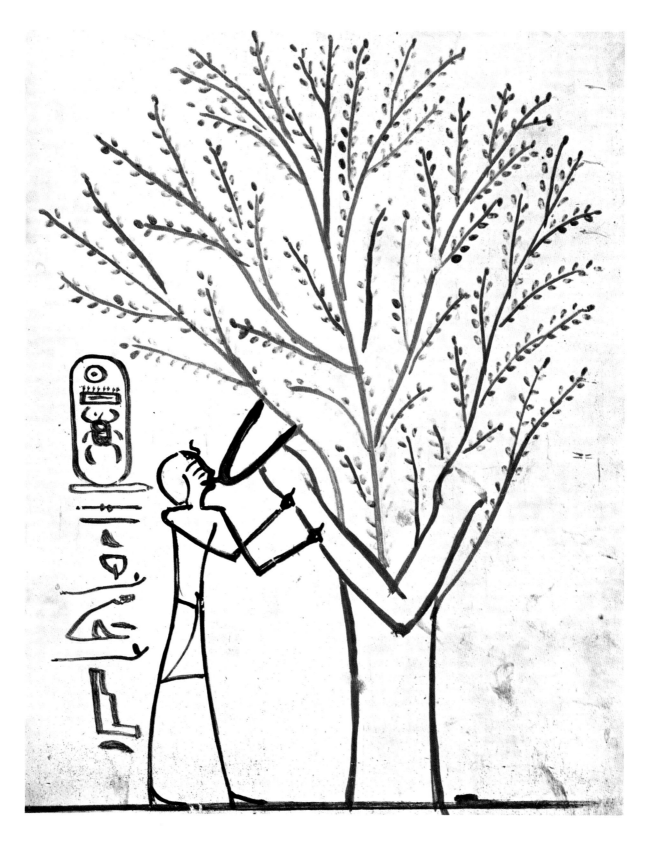

THE KING SUCKLED BY THE SYCAMORE GODDESS. BURIAL CHAMBER OF TUTHMOSIS III, THEBES.

EARLY PHASE OF THE NEW KINGDOM: ARCHAISM

About 1550 B.C. the Theban princes, aided by those of El Kab, succeeded in expelling the last of the Hyksos invaders, those warlike Shepherd Kings who, sweeping down from Asia, had subjugated Egypt for a while. Thus the city of the Mentuhoteps regained its position as capital of the kingdom, pending the day when it was to become capital of the Empire. A new dynasty was founded, the XVIIIth, and the kings belonging to it (who were called alternately Amenophis and Tuthmosis) consolidated both the independence of Egypt and her frontiers, extending the latter northwards to the Euphrates and on the south to the Fourth Cataract of the Nile. It was only to be expected that a race which had just shaken off a foreign yoke should embark on a revival of the national traditions. The form this took in the aesthetic field was a return to the canons of the Middle Kingdom and even to those of the Old Kingdom, which the Egyptians regarded as their golden age. Similar artistic revivals took place four or five times in the long course of their history, and this one coincided with the beginning of the XVIIIth Dynasty. To its achievement the fine reliefs in Queen Hatshepsut's temple at Deir el-Bahri, modeled on those in the temples and mastabas of Memphis, bear eloquent witness, and the same is true of the paintings discussed in this chapter.

It should, however, be noted that our illustrations of this revival are not taken from the royal tombs, which display, on the contrary, a cleavage with the past. The period of struggle and disorder from which the country had emerged brought home to the new Pharaohs of Thebes the risks of damage and looting to which deserted tombs were always exposed. So they decided to inter their bodies and treasures in the depths of the western mountains, at the end of long passages strewn with pitfalls, and to conceal the approaches to their burial chambers in the most inaccessible gullies of the desert Wadi now known as the Valley of the Kings. Thus the monarch, mundane avatar of Re, followed in the steps of the god, and traveled in the sunset of his life into that kingdom of the West where daily the Sun fulfilled his course. The pictures on the walls are presentations of this symbol; we see the god, with whom in death the Pharaoh is united, sailing in his "bark of millions of years" towards the netherworld. During the reign of Tuthmosis III (and, later, that of Amenophis II) these compositions took a form that may seem disconcerting at first sight. To give the illusion of an unfurled scroll of papyrus the artist painted the walls yellow and on this ground drew schematic figures in outline only, the effect being that of a mere diagram or preliminary sketch indicating merely the positions and attitudes of the various gods and spirits. The hieroglyphs, too, are done in a running hand so as to intensify our impression of a Book of the Dead writ large. One is reminded, incongruously enough, of an animated cartoon. The most striking example can be seen on a pillar in the burial chamber of Tuthmosis III

TUTHMOSIS III

on which we see the king being suckled by the "Sycamore Goddess" (identified with Isis). The branches and leafage of the sacred tree are suggested with a fine economy of means by a few red lines and blue-green dots respectively. From the trunk emerges a human arm holding forward a large breast which the young king is nuzzling. The artist's rendering of the tiny hands clutching the lower edge of the arm, too large to be encircled by them, has a finely poetic quality. Like the breast, the king's form is drawn in black; the line is spirited and cursive, and no essential has been omitted: neither the loincloth nor the uraeus-serpent in the headdress, prerogative of reigning monarchs.

But it is in private tombs that the true pictorial style of the period can best be seen. Among the most characteristic examples are the tomb of Ineni (No. 81), dated to the beginning of the XVIIIth Dynasty; the tombs of Senmut (No. 71) and Nebamun (No. 179), to the reign of Hatshepsut; and, for the reign of Tuthmosis III, the tombs of Wah (No. 22), Amenemhet (No. 82), Amenemheb (No. 85), Menkheperresonb (No. 86), Minnakht (No. 87), Rekhmire (No. 100), Amenuser (No. 131)—in which the paintings have been brought to light by a recent cleaning—and finally a nameless

THE SACRIFICIAL BULL. TOMB OF AMENEMHET (NO. 82), THEBES.

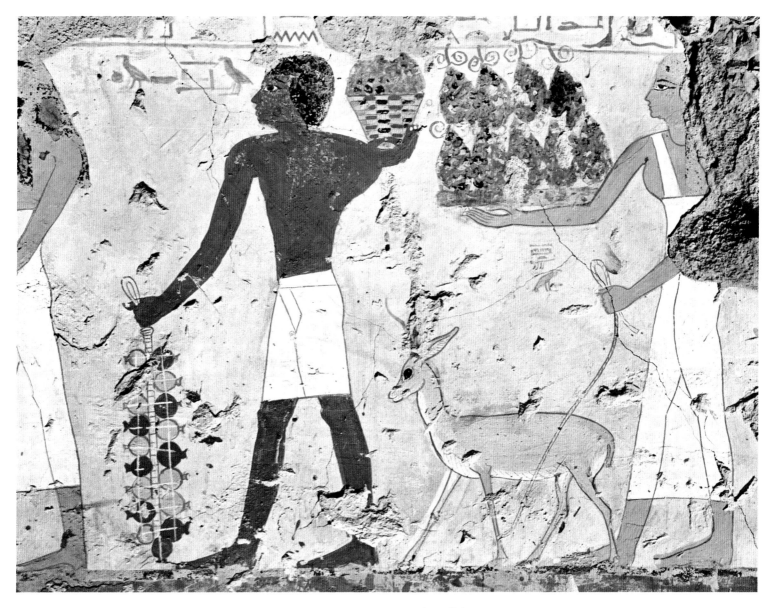

OFFERING-BEARERS. TOMB OF AMENEMHET (NO. 82), THEBES.

tomb (No. 261) which we ascribe to the same period. Though necessarily incomplete this list gives a good idea of our subject-matter. Obviously there can be no question of describing in detail all these tombs and the leading themes of the paintings figuring in them, descriptions of which can be found in monographs and specialist studies of the tombs at Thebes. Here we confine ourselves to the outstanding works.

The tomb of Amenemheb (No. 85), an officer who served under Tuthmosis III AMENEMHEB
and Amenophis II, sets a problem that will recur: that of its dating. Its archaizing style places it unmistakably in the period of Tuthmosis III. For we must bear in mind the fact that the Egyptians had their mortuary chapels built and fitted out during

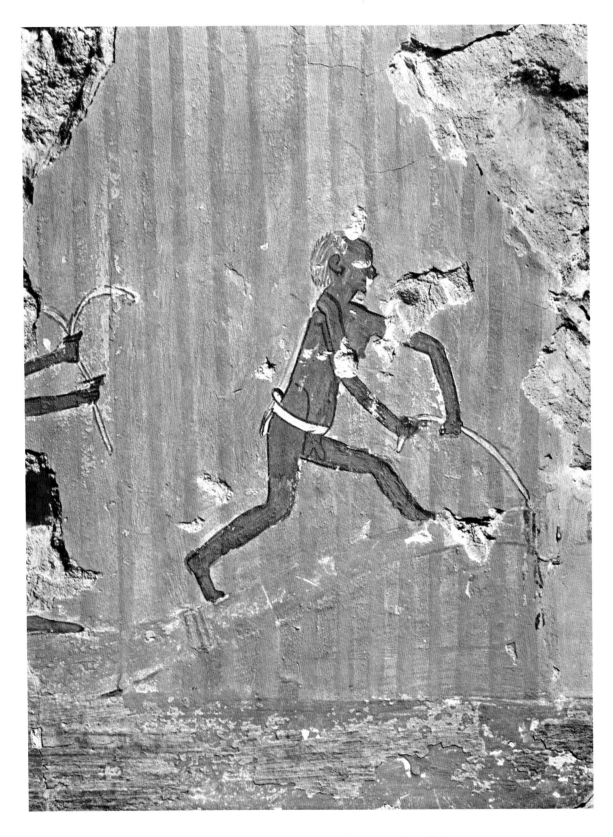

IN THE PAPYRUS THICKET. TOMB OF AMENEMHET (NO. 82), THEBES.

their lifetimes, and work on Amenemheb's was probably begun at the time when, under Tuthmosis III, he had attained sufficient eminence to entitle him to a tomb in the mountains of the West.

Most original of the scenes in the tomb of Amenemheb is beyond all doubt the hyena hunt on the inner side of the architrave between the two central pillars of the first chamber. Armed with a spear and a stick, a small but valiant hunter is advancing with long, springy strides on his quarry, a huge alarming-looking brute. (Unfortunately the animal's jaws are partially destroyed.) Intimidated, it seems, by the hunter's bold approach, the hyena, whose dugs show it to be a female, is on the defensive, at bay. No doubt the disproportion of the figures is due to the special nature of the setting; the architrave was not high enough to permit of a taller human figure. But what the painter chiefly aims at is the terrifying effect of an encounter with a hyena; which is why he has allotted most of the picture space to the animal. The presence of some charmingly depicted plants in so desolate a landscape strikes an agreeable, if unlikely note; these light touches of blue, studding the empty spaces, make an effective contrast with the monstrous bulk of the repulsive beast. Moreover, their stylization emphasizes the "cerebral" aspect of the composition without detriment to its decorative charm. This disdain of any servile imitation of nature, while characteristic of Egyptian painting in all periods, is particularly noticeable in this scene from the tomb of Amenemheb.

Unrivaled as an *animalier*, the Egyptian artist often applied his gift of keen observation and his consummate skill in outline-drawing to rendering with discreet fidelity animals of various kinds, for example the pink gazelle in the tomb of Amenemhet (No. 82), which is painted on the right wall of the inner chamber near the shaft leading down to the tomb chamber proper. Unknowing that it is being led forth to die, the little animal steps briskly forward in the procession of offering-bearers, accompanying a woman who guides it with a string tied to its foreleg. With a few deftly placed lines the artist has rendered to the life its characteristic gait, the way it carries its head, its fragile grace. The tenuous pink of its coat shows up but faintly against the grey-blue ground. So slender are the legs that to make them stand out the painter had, it seems, to whiten their immediate context. The muzzle and neck, too, are white and the blue of the horns has faded a little; but what above all holds our gaze is the eye, instinct with life and softly glowing. Despite its veracity this fragment, stripped as it is of all superfluous realism, has an almost ethereal lightness. The two figures on either side are less lifelike; conventionally colored (the man red and the woman yellow), they still keep to the canons of the past, the man being square-shouldered, the woman with narrow hips. They are dressed, too, in the ancient manner; the man wears only an abbreviated loincloth, the woman a rather short, tight-fitting dress with shoulder-straps. The indications of the limbs under the opaque white dress do not give the illusion of a transparent fabric—that was a device of a later period. On the other hand, the very stiffness and the studied symmetry of the movements build up a rhythm of parallels which, though seemingly static, creates as it were a synthesis of the act of walking. The warm flesh-

tints of the two offering-bearers and the vivid hues of the objects they are carrying (blue and black of grapes, red and yellow of the basket and pomegranates) help to throw into prominence the central, most skillfully pictured element of the ensemble: the gazelle, whose fluent, happily spontaneous drawing stresses the archaizing, hieratic rendering of the woman who is leading it.

On the opposite wall, as if the artist had in mind a diptych, are similar processions, and what catches our eye at once in these is the pink-white-grey young bull. Less delicately handled but no less lifelike than the gazelle, it has the discreet naturalism which the Egyptian painter could never bring himself to indulge in when depicting human beings. Moreover the artist has tried for a perspective effect, one of the bull's horns being shown in recession from the beholder. Gauche, perhaps, but interesting is the way the lefthand offering-bearer's basket is represented—in cross-section—so as to exhibit its contents. The colors of the figures—and their rigidity—resemble those of the figures on the other wall. Some vandal has tried to tear off the scene of a ritual dance on the upper wall, and it is badly mutilated.

By a happy chance the picture of a trio of musicians, in the long passage-way leading to the funerary chapel, has come down to us intact. It consists of a harpist and a flute-player (both women) on either side of a man playing the mandola. All are looking left, that is to say towards the end of the tomb whence the dead will emerge to greet their guests. The stiffness of the two standing figures, especially that of the woman, is characteristic; but the squatting harpist, though like the bodies of the others hers too is flat, is more alive. She is singing, accompanying herself on the harp. The half-closed eye and eyebrow are pushed up by the movement of her mouth—an attempt to render facial expression rare in paintings of the period. The colors are cool and pure, bright tones, pink, yellow and white predominating. In their midst the brown flesh-tints of the male musician make an emphatic contrast with the pearl-grey ground.

It was the first chamber of Amenemhet's tomb that contained the liveliest pictures; all have been wantonly defaced except for some small details: a bull-fight, a scene of hunting in the desert, a hippopotamus hunt and what seems to be a fowling scene. In the last-named scene, one of the finest in this tomb, stylized birds painted in quite incredible shades of green and blue are winging their way across an azure sky.

Under the hippopotamus a detail of an episode taking place in the fens has survived. In front of a papyrus thicket a man is binding together the stem of a canoe made out of reeds. Standing on the prow, his legs wide apart, he is tugging at the rope. Naked but for a diminutive belt, with a bald forehead and an untidy shock of hair straggling down his neck, this little man cuts a wonderfully lifelike figure.

MINNAKHT In much the same style is the large female mourner of the tomb of Minnakht (No. 87), where apart from a few sketches and, in the subterranean burial room, the funerary texts, practically only one painted wall, that on the left of the inmost chamber, has survived. Some scenes are unfinished. They depict the rites performed in front of the dead body: a procession of offering-bearers and mourners, the funerary "kiosk" and

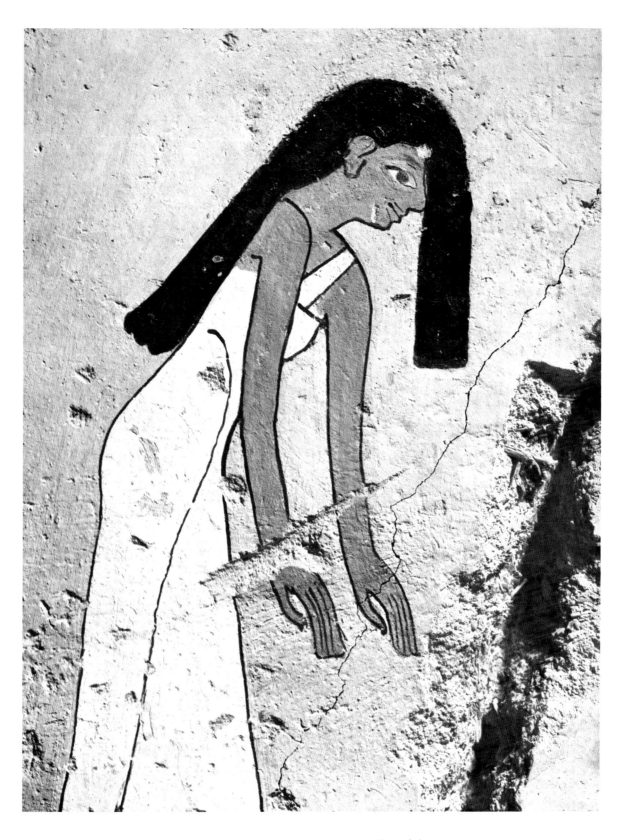

FEMALE MOURNER. TOMB OF MINNAKHT (NO. 87), THEBES.

garden and so forth. The group of weeping women is placed low down on the left; standing or squatting on the ground, they move their arms to a rhythm set by their leader, who alone figures in our colorplate. Bending slightly forward, her arms dangling, her hair straggling over her brows, an oddly cynical smile on her lips, she is "conducting" the lamentations and arm-wavings of her troupe of paid mourners. Three equally strong colors (yellow in the flesh-tints, the white of the dress, the black of the hair) tell out upon the pale blue ground, each color bound with a red contour-line—and the effect is wonderfully dramatic. Despite a certain awkwardness, or perhaps because of it, the rather clumsily drawn shoulders, hips placed too high, and constricted waists combine, strangely enough, to give an impression of intense vitality. If this artist's means were scanty, he used them to remarkable effect.

WAH The paintings in the Middle Kingdom style made in the reign of Tuthmosis III contain many fine details; especially in the tomb of Wah (No. 22), already mentioned. Wah, the king's butler, had his tomb decorated largely with banqueting scenes, showing pretty dancing-girls, harpists and mandola-players performing amongst the guests, who are waited on by slaves. A whole upper wall is devoted to a big twofold scene of fowling and fishing in the marshes; to this are appended in the lower register scenes of the wine harvest, wine-pressing, fowling (again) with nets, and offerings to the deceased. These paintings were made directly on the limestone and many of them have faded badly; early photographs prove that the colors must have been brighter fifty years ago. Were it not for this, Wah's tomb would have illustrated perhaps better than any other the characteristics of the archaic style. The personages, notably in the banquet scenes, are seated one behind the other with almost hieratic formalism, the dancing-girls are thin, the slaves small but with over-large heads, while the musicians, though their gestures are meaningful, are rather stiffly posed. The colors, too, have a certain harshness, partly due, it seems, to the non-absorbent texture of the limestone, but they also suggest an imitation of the Middle Kingdom style.

TOMB NO. 261 Another tomb, in excellent condition and stylistically resembling Wah's, is No. 261 (anonymous); we have already reproduced part of its only painted panel as illustrating the Egyptian method of composition in successive tiers. Offerings are heaped up in front of the dead man and his wife, seated on the left; then in three horizontal zones figure the following scenes, scanned from right to left. In the top register are two grape-harvesting scenes, a man carrying grapes, another laden with papyrus, two scribes, one writing while the other counts on his fingers. In the middle tier we see the winepress, the filling of the wine-jars, an offering being made to Renenutet (goddess of the soil), a man leading an ox, another carrying birds, another, fruit. In the bottom row we see ropes being made in a papyrus thicket, the unloading of a boat, four offering-bearers with birds, fruit and a large jar. The top of the wall is decorated with a frieze. Against the beige-grey background, the pictures stand out as colorfully as on the day when they were painted: red, brown or black figures, blue vines, jars of the same pink as the

dead man's tunic, green papyrus plants, the yellow boat, the black, white and pink coat of the ox, multicolored birds and offerings. From a close examination and comparison of these with other pictures we can infer that the paintings in Tomb No. 261 were contemporaneous with works that can be dated by the presence in their inscriptions of the royal cartouche of Tuthmosis III.

This comparison can be made with, for example, two notable tombs of this period, Menkheperresonb's (No. 86) and Rekhmire's (No. 100). Menkheperresonb was the high priest of Amun, and we see him inspecting the treasures and workshops of the god— in other words those of the temple. Conspicuous in this tomb are scenes of craftsmen at work, the transport of raw materials, processions of tributaries. The depiction of one of the Semites in a cortège of foreigners is admirably characterized; by the style to begin with, but no less by the man's features, garment and the objects he carries. He is tall, square-shouldered, with a triangular, massive torso and the profile is typically Asiatic: straight nose, slightly petulant mouth, peaked, ruddy beard. The flesh-tint, red ochre, has kept its brightness and effectively contrasts with the grey-brown stucco ground. Some vestimentary details are well observed, e.g. the long black necklet of elongated red and black beads interspersed with round red and yellow beads, which somewhat recalls a Muslim chaplet, and the fringed loincloth, tapering to a point between the man's legs and embroidered in spirals and a network pattern. The offerings brought by this typical Syrian are a gold vase, an elephant's tusk and a piece of white, blue-bordered cloth. The typically classical sobriety of the drawing, colors and proportions, and the dignity of the man's bearing and expression take us back to Old Kingdom art and rank this work beside the reliefs at Deir el-Bahri.

This essentially royal style and technique is, however, restricted to the tombs of the grandees of the realm; presumably, as a special favor, the Pharaoh lent them the services of his own artists. Amenuser, Governor of Thebes and Vizier of Tuthmosis III, made much use of this privilege in his two tombs. In the first of these (No. 61), situated at the highest point of the hill, the walls, which were faced with plaster before being painted, are now in a deplorable state. The decoration seems to have been completed up to the lintel of the niche for statues in the inner chamber. The burial chamber, located at the foot of a thirty-foot deep well, is exceptional, being lined with inscriptions copied from books dealing with the after-life. The few paintings in the mortuary chapel have the strong, uniform colors we associate with the beginning of the XVIIIth Dynasty. The second tomb (No. 131) is more monumental and the fact that it was left unfinished points to its being the later of the two. It was excavated lower down, at a place where it was possible to build, in front of the entrance, a vast terrace overlooking the valley. The limestone here was of good quality, well suited for carving, and the façade, entrance and a part of the first chamber, where the dead man is shown doing homage to his sovereign, are covered with low reliefs. The painted scenes may have been no more than sketches preparatory to carvings in relief. Unfortunately this tomb

was lived in for a long while and the pictures are hidden under a layer of soot, impervious even to infra-red rays. Attempts have been made to wash it off, and a trained eye can now detect some details, but such rough-and-ready cleanings not only involve a risk of damage to the pigment but are quite inadequate for any aesthetic evaluation of the paintings. However, we fare better in the case of a painting that was restored two years ago by the Antiquities Department; like the pictures in the tomb of Menkheperresonb, it consists of superimposed tiers of foreign tributaries: Cretans, Syrians and Semites. Though the colors are much faded, sometimes to the point of being indistinguishable from that of the rock-face, the delicate red contour-lines and the balanced lay-out are comparable to those found in a tomb of the period of Tuthmosis III, to which we now invite attention.

BRICKMAKERS. TOMB OF REKHMIRE (NO. IOO), THEBES.

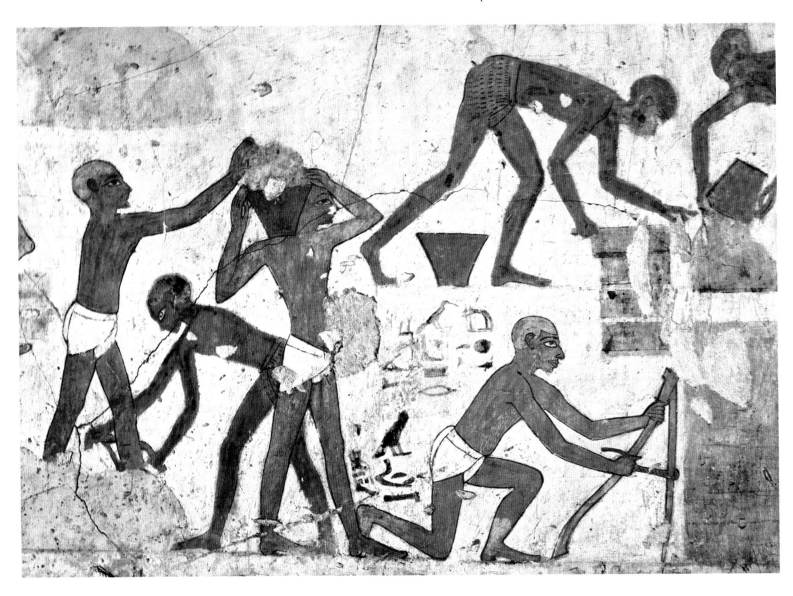

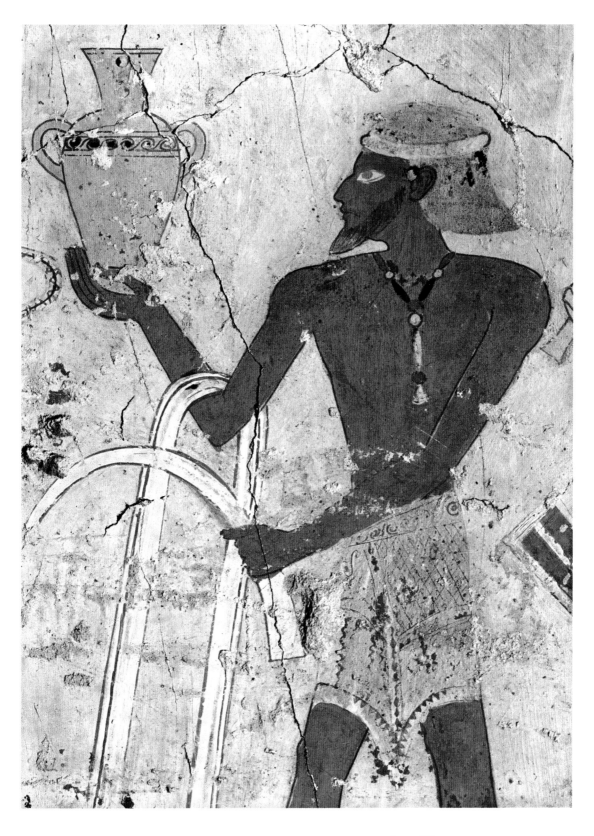

ASIATIC TRIBUTARY. TOMB OF MENKHEPERRESONB (NO. 86), THEBES.

This tomb (No. 100), that of Rekhmire, who succeeded Amenuser in the dual post of mayor and minister, is one of the most striking in all the Theban necropolis. Its lay-out is of the kind described in our opening pages. So as to increase the wall surface available for painting, the second chamber has been extended not only in depth but in height as well. The first, too, is unusually long—over sixty feet—while the second is over seventy-five; the ceiling, nine feet high at the entrance, rises thereafter to twenty-four feet. Thus in the tomb of Rekhmire alone there are over three hundred square yards of mural painting. Most of it is in good condition and there is an amazing variety of subjects, some not found in any other tomb. Alive to their high importance, the Antiquities Department has for several years been carrying on a careful restoration of these paintings. The work is now finished and we reproduce, for the first time under their original aspect, two successfully cleaned pictures. However, before discussing them in detail, we will give a brief summary of the most interesting iconographical features of this tomb, in the order in which they present themselves to the visitor. They comprise: the investiture of the Vizier, a procession of foreign tributaries bringing the produce and animals of their countries (Cretans, Asiatics, Africans with vases, chariots, skins of animals, ostrich feathers, ivory, gold, ebony, leopards, monkeys, a jaguar, a giraffe, a bear, an elephant, dogs, oxen, horses), an assembly of state officials, work in the fields, the temple storehouses, a distribution of food to workmen, various crafts (leather-work, carpentry, brickmaking, sculpture), the funeral ceremony (in nine tiers), religious rites, a banquet (in eight tiers).

It was no easy matter choosing amongst so many figures. We begin with a picture of the brickmakers. They are going actively about their various tasks, one digging, another mixing the mud, another loading a pot of it on to a fellow-worker's shoulder, and another shaping it in a rectangular mold. Once shaped, the bricks (for which Nile mud was used) were set out in rows to dry in the sun. The entire scene is longer than our reproduction and shows on the left two men drawing water (for mixing with the loam) from a square lotus pond with trees fanning out around it. To the right of the place where they are molded bricks are being carried to bricklayers who are building a ramp abutting on the temple wall. An inscription tells us that this work was, in fact, carried out in the reign of Tuthmosis III. The dating here has some importance since we learn from other inscriptions that Rekhmire was still living in the reign of Amenophis II. In such scenes as that of the brickmakers we find intimations of the freer style of the mid-XVIIIth Dynasty. The tall slender bodies are in the Middle Kingdom style, but they have more liveliness and, to avoid monotony, the painter uses for them two contrasting shades of red. True, we have here two quite distinct racial types; the skulls of the two dark-skinned men are differently shaped from those of the men with paler skins, also their loincloths and the way they wear their hair are different. Two of the pale-skins have beards and one can see that, unlike most Orientals, they have hair on their chests; even more distinctive are the blue eyes of the kneeling man. Clearly these three are Northerners, perhaps descendants of the Hebrews who had settled in the East of the Delta in the still recent days of Joseph and the Hyksos. The composition,

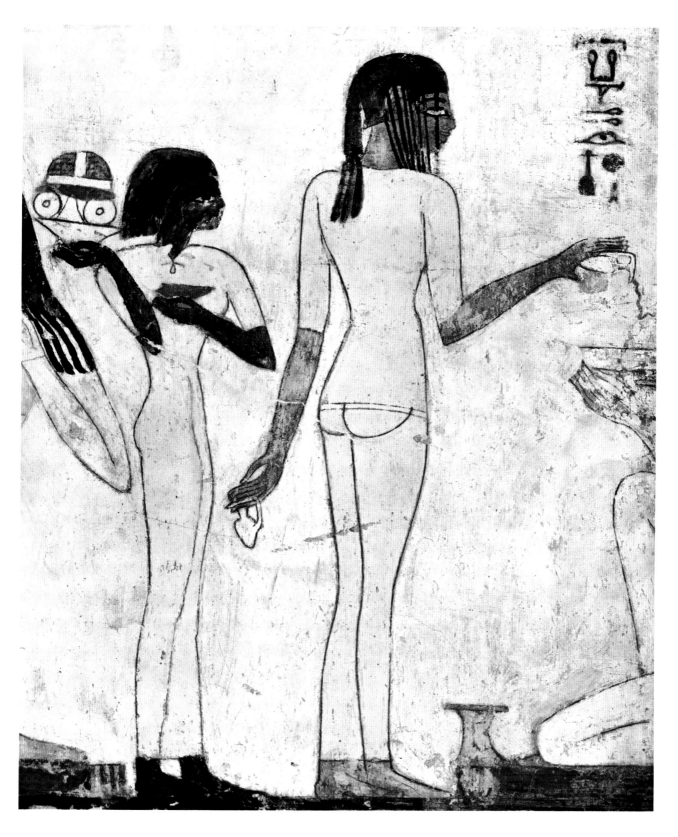

SERVING-MAIDS. TOMB OF REKHMIRE (NO. 100), THEBES.

too, is significant. The old conventions of symmetry and parallelism of gesture are abandoned, but there is no mistaking the skill with which one color is played off against another, and masses and movements are governed by an all-over rhythm. Another interesting point is that though the figures are depicted side-face, the artist has not given their shoulders the conventional twist. Here, in fact, we see the beginnings of a break with the archaic tradition of the age.

The same is true of a detail in the banquet scene facing the pictures of artisans at work. We see a bevy of ladies, seated singly or in couples, attended by serving-maids who are engaged in smartening them up. Here the line is everything, the white or light pink of the figures contrasts but slightly with the grey-blue background, indeed color plays a very minor part. The slave-girl in our illustration is slewing her body round in a curious manner; moreover, this back-view of a figure is exceptional, not to say unique, in Egyptian art. She is turning to her mistress to sprinkle her with aromatic oil, keeping the perfume bottle behind her, in her left hand. The position of the feet is odd, the left foot slipped behind the right. Much of the girl's face is hidden by the strands of hair falling on her right shoulder, as against three tresses on her left. Her slimness and the tenuity of her garment (across which details of her body and a belt under the dress are visible) make amends for some lingering traces of archaism in the profile, the clumsy drawing of her left hand and the unnatural thinness of her calf. So banal is the rendering of the small black slave-girl behind her that we feel this figure's only function is to serve as a foil to the beauty of her tall, fair companion.

We conclude this chapter by summing up the art tendencies at the beginning of the XVIIIth Dynasty, as revealed in the works dealt with above. The burst of patriotic fervor which followed the expulsion of the foreign rulers led naturally enough to a revival of the style of the XIth and XIIth Dynasties. Since no monument of the Hyksos interregnum has survived at Thebes, there is no evidence of the break in the course of native Egyptian art which must have been one of its consequences. In a general way it may be said that the tendency to imitate Middle Kingdom and even Old Kingdom art caused figures of the second Theban period to have a certain stiffness, yet this stiffness was more than sterile plagiarism. It was, rather, the normal development of an established school, whose evolution had been temporarily held up by the course of political events. There was a turn of the tide in Egypt's favor under Tuthmosis III, and Queen Hatshepsut's policy of "peaceful penetration" and trading expeditions soon led to military conquests. Having subdued the countries on their borders, the Pharaohs now enriched their capital with the spoils of victory and the tribute levied from their vassals. The wall paintings in private tombs bear witness to the taste for luxury that ensued: banqueting scenes, processions of foreigners, scenes of industry were favored subjects. Thus line became more supple, and painters took to using the more extensive range of colors called for by such themes and in particular the novel types of humanity and the exotic animals now to be seen in Egypt. The paintings in the tomb of Rekhmire, which point the way to the art of the next reign, show us this transition in active progress alongside a gradual relaxation of archaic disciplines.

CEILING DECORATION. BURIAL CHAMBER OF SENNUFER (NO. 96B), THEBES.

UNDER AMENOPHIS II AND TUTHMOSIS IV: GRACE AND CHARM

In the second half of the 15th century the liberation of the Egyptian painter from ancient prototypes became a *fait accompli*. Not that he abandoned the traditional themes—in this respect Pharaonic art was thoroughly conservative—but that he interpreted them on new lines and in terms of his personal sensibility. Thus the works of art produced in this period are more expressive and, gradually discarding their impersonal dignity, acquire the "human touch." We find a more imaginative handling of subjects and composition, while the more graceful poses of the figures, both male

YOUTHS CARRYING ARROWS. TOMB OF KENAMUN (NO. 93), THEBES.

and female, reflect the new refinement of the age, and artists take to using light, transparent glazes to suggest gossamer-thin tissues. These changes stemmed from the nation-wide taste for luxurious living which now developed in Egypt.

It was a period of political stability. Though we are told of "frontier troubles" these were never of a serious order; mere symptoms of the unrest that was apt to develop when a new king took over. During this period Egypt had two great rulers: Amenophis II from 1448 to about 1422, then his son Tuthmosis IV until 1411 B.C. Such was the continuity of the stylistic evolution that we group together the works of art produced in both reigns, beginning with the tombs dated to the reign of Amenophis II, and following with those ascribed, definitely or tentatively, to that of Tuthmosis IV.

The quite distinctive charm of the paintings made in the middle years of the XVIIIth Dynasty makes us regret all the more keenly the disappearance of its non-religious monuments—palaces, houses, shops and assembly rooms—and of the countless secular and decorative scenes that once adorned them. The mortuary chapels show us only one aspect of this art, a domain governed by more or less strict conventions.

It is generally thought that in the New Kingdom period the tombs, inasmuch as they were "houses of eternity," were so arranged as to recall to well-to-do Egyptians in the after-life the amenities of their earthly homes. This seems to be borne out by the lotus friezes on the walls and the imitations on the ceilings of polychrome mats woven in various designs. The stylization of forms enabled artists to vary *ad infinitum* the geometrical elements, based on floral or animal shapes, that figured in these decorations.

Exceptionally in the burial chamber of Sennufer (No. 96 B), Mayor of Thebes SENNUFER under Amenophis II, the painter has been directly inspired by nature. Starting from ground-level, a vine proliferates all over the ceiling, which has been left rough-hewn, perhaps so as the better to give the illusion of bunches of grapes hanging in a vine-arbor. The undercoat of pearl-grey stucco makes a delightful background to the patches of blue, studded with black spots, that represent the clusters. The artist has carried realism to the point of showing the tendrils sprouting on the sinuous reddish stems from which the grapes are hanging. Uniform green disks, light or dark green according as they have been painted with a single brushstroke or twice over, and broadly indented with white (three notches in each circle), represent the leaves. Clearly the work of a highly skillful and original artist, this ceiling decoration makes the scenes on the walls (religious rites, seated couples, the conveyance of the funerary furniture to the tomb) look relatively tame. We must bear in mind, however, that the burial chamber (decorations in such chambers are the exception) was sealed off. One detail in it calls for special mention: the scene of the dead man gazing at a sacred tree inhabited by a goddess who is peeping from the leafage. That this scene is symbolic is proved by the fact that the tree is placed, like an emblem, on a pedestal. The paintings in the mortuary chapel (No. 96 A)—now used for storing the objects found in the necropolis—need a thorough cleaning, but enough can be seen to show they are of a higher quality than the murals in the underground chamber.

It is from the Tomb of Kenamun (No. 93), Steward of the King, that we get the best idea of the artistic achievements of this period. One of the most spectacular monuments at Thebes, it is the only tomb in which, prior to the Ramesside period, yellow backgrounds are employed. The virtuosity of this artist is nothing short of amazing; with a fidelity unsurpassed by any other, he renders minutest details, the subtlest textural effects. The beads of necklaces and bracelets, the sheen of enamel on earthenware vases, the grain of granite, wood, porphyry and metal, the hair of an animal's pelt, scales of fishes, birds' feathers—all are depicted with loving care and prodigious skill; yet, by some miracle of artistry, the over-all effect is not impaired by this extreme attention to detail. Evidently some of these pictures were much appreciated by artists of a later age; for traces remain of the squaring lines drawn by some later painter with a view to copying them.

Unfortunately we can have only a very imperfect notion today of the pristine splendor of this enormous tomb; not only have many walls crumbled away, but Kenamun's personal enemies, once they no longer feared him, made haste to deface some of the scenes in which he figured. What remains is so badly mutilated or covered with so thick a layer of dirt as to be barely visible. In fact it is impossible to do justice in a photographic reproduction to such famous scenes as those of the woman playing a mandola and of Amenophis II in his youth.

Though technically nowise inferior, the scenes in fairly good condition have less of the vibrancy of life; indeed there is something cold and static in their very perfection. I have in mind the cortège of statues being taken to the tomb, the women's ritual dances, the New Year's gifts made to the King, the garden scene, the pictures of cattle, of hunting in the desert and the fens, offerings made to the gods and the dead and, lastly, the scenes of a kitchen, a bakery and of brewing. Were it not damaged, the hunting piece would rank as the peak-point of Egyptian art; it has all the subtle delicacy of a Japanese print. We see an ibex brought to bay by a hunting dog, an ostrich flapping its wings, a wild she-ass giving birth to a foal whose muzzle is promptly nipped by a jackal; and other animals crouching in their lairs. The ibex is given the place of honor and not only is there a striking dignity and elegance in its poise but in the treatment of the animal's coat, almost excessively meticulous though it is, the artist's feeling for tonal values gives an effect of volume rare in Pharaonic art. The head, unfortunately, has been ruined by some vandal.

Some fragments, however, on this wall are intact and here the colors have retained their brightness; for example, the picture of two boys carrying arrows, lotuses and fish. They are walking to the right, where originally the noble sportsman for whom they were "retrieving" was depicted, bow in hand. All the grace of youth is in these figures: lithe limbs, slim shoulders, small feet, chubby cheeks, big, inexpressive eyes; while the disproportion between their large heads and their stature emphasizes their tender age. One of their tasks is to hand his arrows to their master (perhaps their father) as quickly as they can, and the almost automatic precision of their gestures shows they are trained to it. The boy in front is holding out an arrow as he approaches,

while his brother is still pressing two arrows to his chest. The brilliancy of the dominant colors, red ochre in the flesh-tints and a luminous yellow for the background, is offset by the white of the short loincloths, the ivory-white of the arrows and the blue the painter lavishes, to such happy effect, on the necklaces and bracelets, the lotus flower, the string of fish.

Characteristic of the art of the reign of Amenophis II is its accent on youth, and we observe this not only in the tomb of Kenamun; the King himself, in his official stelae, took almost as much pleasure in demonstrating his prowess as a sportsman as in commemorating his victories in Asia and Nubia. Indeed, if we are to believe him, he was the champion archer of his day.

Like his sovereign, the royal scribe Userhet, who had been brought up in the palace, USERHET had himself depicted in his tomb (No. 56) as a hunter, scouring the desert in a chariot drawn by two horses, one red, one white, the reins being attached to the driver's body. He could thus direct his team by movements of his loins, while keeping his hands free for the bow and arrows. The animals he is hunting are in desperate flight, wounded, panting heavily—a struggling mass of antelopes and hyenas. But the man who painted this scene was an animal-lover and two details here reproduced bear eloquent witness to his sensibility. One of them shows a hare leaping wildly forward under the bellies of the horses and above a wounded hyena gasping its life out. The frantic movements of the hare are wonderfully conveyed by the red brushstrokes outlining the yellowish-brown body, while patches of white on the tail, belly and eye convey a suggestion of volume. The huge ears streaming back from a head with an oddly human profile and a snub nose intensify the effect of frenzied speed. The curve of the spine (in which the artist's pentamenti can still be seen) and the linework throughout show how accurate was his observation. The one exception, perhaps, is the animal's nose, squarer than it should be and more like a cat's than a hare's; but it has the spontaneity of a rapid sketch—the artist lacked time, maybe, to give the final touches. In fact one of the charms of the paintings in this tomb is that nothing seems quite finished.

There is the same freshness of inspiration in another detail from the hunting scene. Remote as is the age when it was painted, this picture of a wounded fox dying behind a bush has a direct appeal to modern sensibility. Crouching against the bush which shores it up, its back arched, its eye bloodshot, it poignantly expresses the horrified bewilderment of an animal whom death has taken unawares. The contrast between the tumultuous movement of the scene above and this silent tragedy enacted in a small corner of the composition is strangely moving. Rarely has an artist shown such self-restraint or conveyed so much with a minimum of means, and so overwhelming is the general effect that we overlook the single realistic detail that the painter has had the cruelty to add: the blood dripping from the animal's mouth and spirting from the left eye. The colors have an ethereal delicacy, pink and red prevailing in the fox's skin and the branches of the little bush, the leaves of which are rendered in a blue-green so delicate that they are only just perceptible. The ground is the natural limestone, painted white.

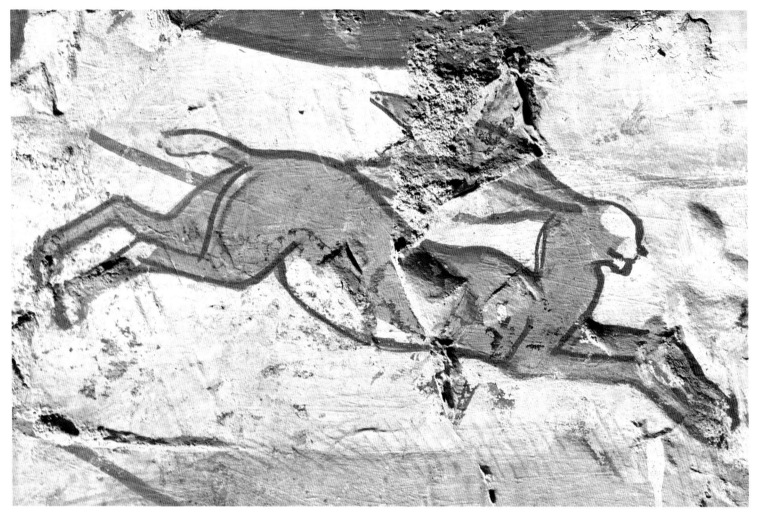

HARE FLEEING THE HUNTER. TOMB OF USERHET (NO. 56), THEBES.

One of the best preserved and most finely decorated in the Theban necropolis, Userhet's tomb abounds in picturesque and charming scenes. As for the technique employed, we have already noted that, along with the tomb of Ramose (No. 55), it is one of the best examples of the method of painting on a limestone wall smoothed down and given an undercoat of paint. In the first chamber we see the offerings made to Osiris, to King Amenophis II, to Userhet himself and to his wife. The two boys in the scene reproduced are Userhet's sons. Their sister originally appeared in this scene, but her figure was, for the usual reasons, expunged by chaste-minded hermits who subsequently occupied this tomb. Here, as against the adolescents in the tomb of Kenamun, the artist shows considerable freedom in handling the boys' forms, and has obviously departed from the models in the pattern-books. His originality shows itself in many, sometimes quite surprising ways. We have, for example, the blue monkeys (likewise defaced by the hermits) munching a pomegranate under their masters' couch. Or again, the scene of a meal in a vine-arbor, a lively counterpoint of blue-greens and

red on a white background. Or the herd of cattle, in colors that are almost imperceptible, with white calves scampering in all directions across a meadow, while oxen belly-upmost are being branded with red-hot irons. Or the scene of the royal fan-bearers bowing to the Pharaoh which is painted on a patch of rough plaster filling a cavity in the rock-face. Here we can see quite clearly the place where the painter's brush has "overflowed," where he has redressed his line, and the successive coats of paint applied: first, red for the flesh-tints; next, a glaze of white for the tunics (which thus become pink); and, similarly, touches of orange (yellow on red) for the handle of the fan. In the first chamber there is also an animated scene of an official inspection of army supplies, and the justly famous picture of barbers at work. As everywhere in the East, they ply their trade not in a shop but in the open, and the racy humor of the scene is heightened by the painter's treatment of his personages, like the shadow figures in a galanty-show—all in red ochre except for the white loincloths. These are work-men—one a Negro—who are taking advantage of an hour off to get their heads shaved.

DYING FOX. TOMB OF USERHET (NO. 56), THEBES.

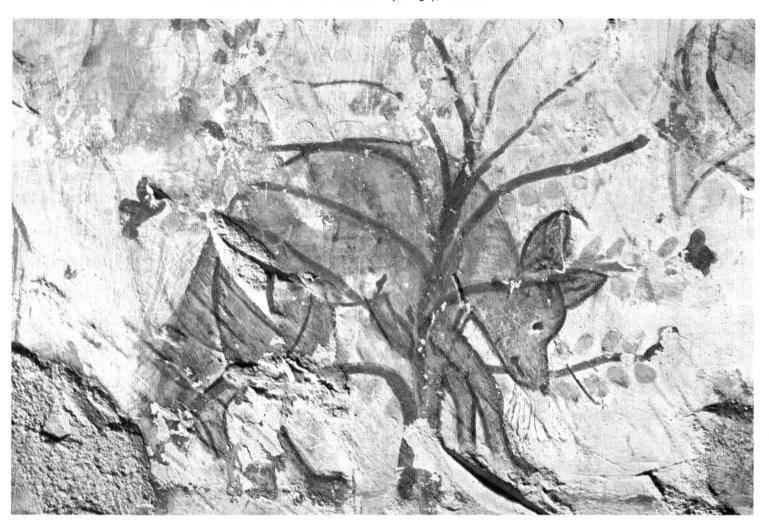

Two are being operated on while the others patiently wait their turn, squatting on the ground or sitting on stools. Some are gesticulating as they laugh and talk, some lounging in the shadow of a tree, while one enterprising customer has got hold of a big stool of which he has selfishly annexed the greater part, leaving no more than a few inches of it to his companion. In short, the whole scene is a vivid "slice of life" depicted by an artist with a lively sense of humor.

In the second chamber—here the tomb chapel—the contrast between the excitements of the hunt described above and the serenity of the funeral rites on the opposite wall is clearly intended to symbolize the difference between the pleasures of man's earthly existence and the beatitude of the after-life. This is one of the rare cases where the arrangement of the pictures has a philosophical idea behind it. Thus on the left wall we see Userhet in his chariot racing across the desert in the fervor of the hunt; on the righthand wall we see the same chariot and the unyoked horses being led to their master's tomb. Even more striking, and certainly intended, is the contrast between the plebeian characters figuring in the scenes of active, everyday life (fishing and fowling in the marshes, grape gathering and pressing) and the little group of female mourners walking with measured steps.

In the winepress scene we have a wonderfully complete depiction of an annual event on the estate of an Egyptian nobleman. Six men, well differentiated from each other, are treading out the grapes heaped in a tank, and to keep themselves from stumbling are clinging to branches that dangle from the roof of the shelter under which they work. All the elements of the picture are arranged in parallel vertical lines; the slender, pale-green columns, leafy branches with red or blue-green clusters, and likewise the figures—of whom the two at the back especially have the vacant look one associates with drunkenness. They seem to be singing as they work; perhaps the fumes of the wine have gone to their heads. In an adjoining scene we see the jars filled with wine being counted up by a scribe who is noting the numbers on a tablet.

But we soon forget the gay vulgarity, quite in the Brueghel manner, of this scene when we turn to that on the opposite wall, the stately group of female mourners. The gestures expressive of grief—folded arms, hands pressed to their foreheads—are biblical in their simple dignity. There is no straining after rhetorical effect, the artist has succeeded in conveying with a fine economy of line discreet but heartfelt grief. This scene is obviously by the same man who painted the "Dying Fox," and he shows here the predilection for a slightly mawkish pink which we find in other pictures in this tomb. But this color serves its purpose; it creates that restful atmosphere which so effectively distinguishes the funeral scene from its more highly colored pendants, the scenes of hunting and vintaging.

Let us now revert to a detail (of two sailors) already cited as illustrating the Egyptian practice of filling up "faults" with plaster when the painting was done directly on the rock-face. This scene comes from the "last voyage" which formed part of the funeral rites; of common occurrence in tombs, it depicts either the conveyance of the body across the river from the east bank (where was the city of the living, Thebes),

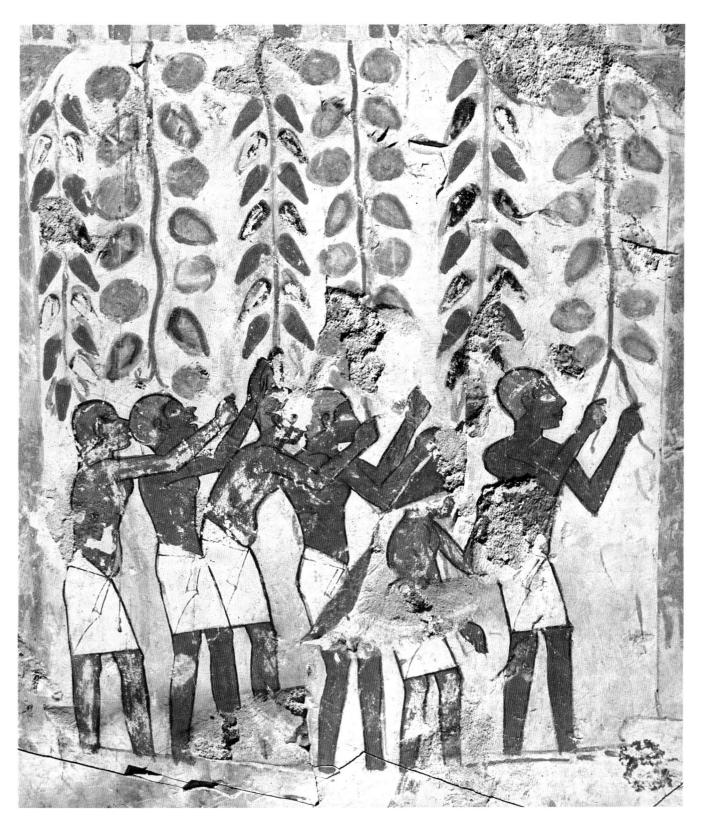

WINEPRESSING SCENE. TOMB OF USERHET (NO. 56), THEBES.

or else the *post mortem* journey of the dead to Abydos, headquarters of the cult of Osiris, lord of the Other World. The merit of this work, despite its unfinished state, lies in the balanced composition and its color orchestration. Admirable, too, is the contrast—we would wish to think it is intentional—between the square mass of the cabin, decorated in red, yellow and blue-green, and the airy lightness of the two figures whose torsos rise above this "box." Only faces, arms and loincloths have been colored; the hair would have been black and the tunics probably of the same pink as the prow, but, as it is, the yellow limestone showing at the places left uncolored has the happiest effect. It would be pleasant to surmise that the artist was so well satisfied with his sketch that he decided not to finish it, for fear of weakening its direct appeal; in any case so eloquent are the gestures that even the absence of the sounding-rod does not disturb us in the least.

DEHUTI Amongst the other tombs of this period that of Dehuti (No. 45), steward of the High Priest of Amun, calls for special mention. Though this tomb was later occupied by a notability of the time of Ramesses II, some of the wall paintings were made under Amenophis II. Thus the panels in the decorated chamber display, confronting each other, the styles of the mid-xviiith and xixth Dynasties and we can measure at a glance the stylistic evolution that took place during a century and a half. Actually three successive styles can be distinguished. The wall on which Dehuti and his mother are shown receiving offerings is painted in vivid colors and displays the studied archaism and sharp definition characteristic of the early xviiith Dynasty. Is this the work of an artist who lagged behind his time or a genuinely older work on which Dehuti had his name inscribed? A plausible explanation would be that the tomb was made ready during the lifetime of his parents, contemporaries of Tuthmosis III. As for the funeral scenes, these belong to the period of the "usurper" Dehutemheb and present no problem—they are obviously Ramesside, and we shall deal with them later. Only one picture, the banqueting scene on the panel corresponding to the archaizing portraits, raises serious difficulties regarding its dating. Somewhat careless execution and the depiction on the lower register of the second owner of the tomb (Dehutemheb) suggests that it is a xixth Dynasty work. On the other hand the confident drawing of the outlines and the supple movement of the figures seem to warrant our assigning it to the mid-xviiith Dynasty. Moreover it differs altogether from the other Ramesside paintings in this tomb and we have little doubt that it belongs to the period of Dehuti and Amenophis II. But it evidently underwent retouchings at a later date.

The detail (in the upper register) of a slave girl pouring a drink into the cupped hands of a lady is an elegant example of the eye-pleasing style of an art that now was tending towards mannerism. Though the painter's treatment of what should, hierarchically speaking, be the leading figures is perfunctory, he has put the best of himself into the likeness of the serving-girl and admirably rendered the supple grace of the young body, the charming movement of the girl's arms, the shy smile on her lips. Here the flesh-tints are no longer the conventional pink obtaining in the Userhet tomb, but

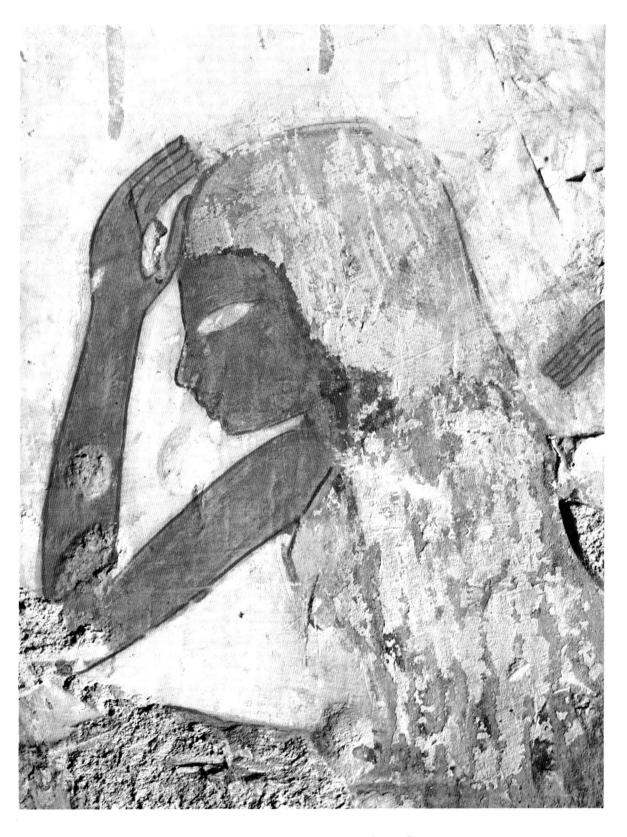

WEEPING WOMAN. TOMB OF USERHET (NO. 56), THEBES.

have the natural hue of sunburnt skin, the hue which was henceforth to be generally adopted. Strangely enough, to make it stand out better, the left arm was painted red. The grey-blue ground used here was favored by XVIIIth Dynasty artists. The hastily written inscriptions above the figures were undoubtedly added later, when this tomb was "usurped." There are traces of other retouchings; for example the diaphanous garment on the girl's body, originally naked. It was Dehutemheb, the second owner of the tomb who dressed her thus—out of prudery one might have supposed, were it not that the inscription shows him to have been a manufacturer of fine linen.

At the beginning of this chapter we mentioned that the art of Amenophis II and that of Tuthmosis IV should be regarded as a single unit; it is only for chronological

BANQUET, DETAIL. TOMB OF DEHUTI (NO. 45), THEBES.

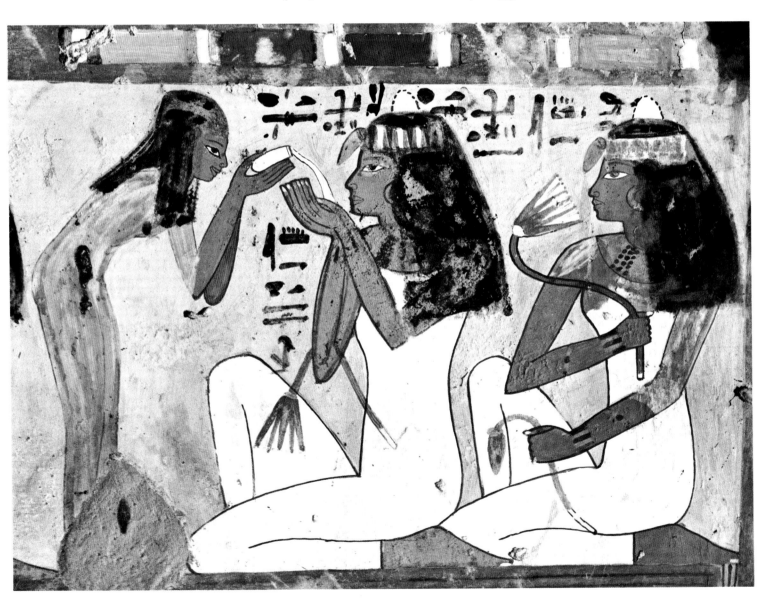

reasons that we deal with them separately. The works now to be described belong to the second of these reigns. Nor need we go into the question of the dates of individual monuments; the tombs we illustrate are for the most part ascribed by general consent to the period of Tuthmosis IV.

The naturalness of movements, reference to which was made above, is apparent also in a small tomb, that of Deserkarasonb (No. 38), in which are foretastes of the livelier style that came in with the second half of the xviiith Dynasty. Most typical in this respect is the scene of the butcher at work, which it is interesting to compare with the similar Old Kingdom scene discussed at the beginning of this work. Here the butcher, bent double, is hacking off the animal's head, while his assistant is holding the bull's leg which likewise will be severed and offered to the gods. Obviously this beast has been fattened for the sacrifice. Its tail describes a long curve above the butcher's body, whose supple movement it reiterates. Upon the pale grey ground the only notes of color are red and white for the men, soft green and yellow in the papyrus mat, grey-black in the animal's coat. The effectiveness of this composition is largely due to the curiously gyratory rhythm the artist has imparted to it.

Though unfinished and diminutive, Deserkarasonb's tomb contains many delightful details; all are in the first chamber, the second having been left undecorated. The butchers are in the lower register of the lefthand wall. In the register above we see the deceased, his wife and children making offerings to the gods. The youngest of the girls is carrying a bunch of dates. Her rather stiff attitude contrasts with that of her brother (in the register above) who is hurrying forward, a heavy jar on his shoulder, as fast as his legs can carry him. Her profile is rendered with a charmingly ingenuous simplicity; the painter has sketched in the features in a slightly ochreous pink, then outlined them with a single, rapid stroke, without lingering over details, eye and mouth being omitted. As a result of this hasty drawing the chest protrudes in a manner that certainly was not intended. The space reserved for the girl's hair is only partially painted in and instead of being concealed by the usual massive wig, her hair is rippling over her shoulder, while a pigtail starting from the top of her head hangs down her back. Thus the stucco ground shows through the hair in places.

A whole wall is devoted to scenes of work in the fields; another to a banquet presided over by the dead man and his wife (whose figure has been obliterated). They are seated and two young girls are handing them offerings of necklaces. The banquet is accompanied by music and dances, the performers occupying the middle of the picture, with the male guests on one side, the women on the other. Despite their solemn airs the gentlemen are behaving rather badly; one has drunk too much and, supported by a friend, is vomiting into a bucket someone has provided in the nick of time. This type of scene, at once realistic and discreetly handled, though rare in Egyptian art, is quite in the spirit of the so-called "harpists' songs." For they were jovial folk, these ancient Egyptians (as Herodotus observed), and despite an obsession with the here-after, believed in enjoying life.

At the top of the wall on which the banqueting scene figures there is a particularly charming detail. Seated on a low chair, a lady is being waited on by two little slave girls. One is bending shyly but with infinite grace towards her mistress, to put in place a vagrant lock of hair. Nothing could be more natural than the way her plaits and necklace droop over her back and round her breast. The other serving-maid is holding out a lotus and a collar-necklace whose flower-shaped beads give it the look of a garland. Both are naked. The little girl with a slightly sulky expression who is adjusting a lock of her mistress's hair is the high spot of the picture and given the central place. The folds of flesh above her waist as she leans forward show that for all her seeming litheness, she is reasonably plump. The slightly awkward gesture is essentially symbolic, and as a single arm sufficed to convey its meaning, the painter has thought it needless to put in the other. The posture of her mistress is amusing, the chair being

BUTCHERS AT WORK. TOMB OF DESERKARASONB (NO. 38), THEBES.

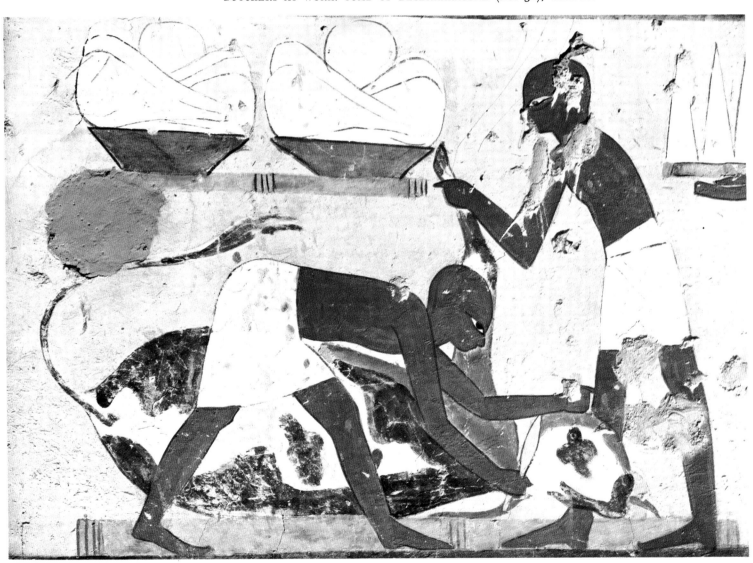

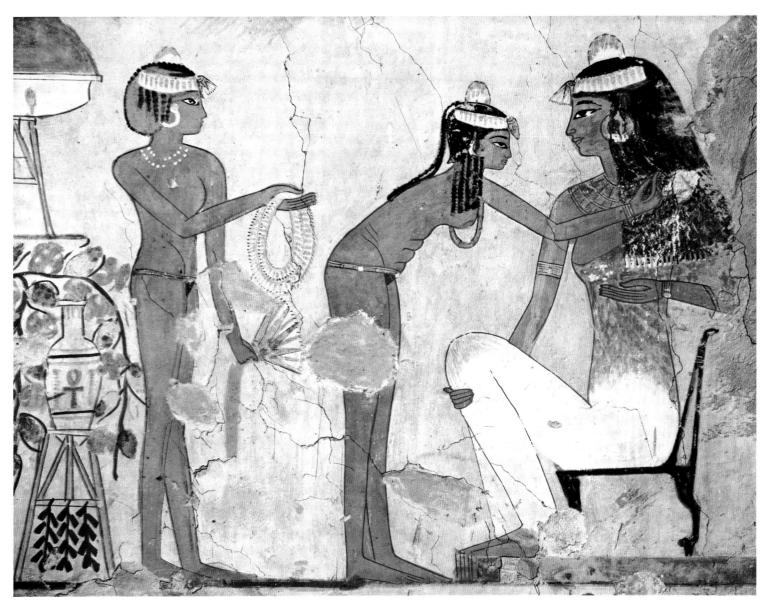

WOMAN AT HER TOILET. TOMB OF DESERKARASONB (NO. 38), THEBES.

much too low and small for so tall a lady; she is not so much sitting as squatting on it, with her knees drawn up, clasped by her right hand, and she seems to be trying to rest her left elbow on the back of the chair to steady herself. Here as elsewhere in this tomb, the colors are subdued: brownish pink for flesh-tints and for flowers a blue-green which shows up hardly at all on the uniform grey ground.

Very different are the bright, fresh colors in the tomb of the Scribe Nakht (No. 52), NAKHT which, though as small as that of Deserkarasonb, is a great favorite with visitors owing to its exceptionally good state of preservation. The blind harper is justly famous. He is placed above the group of three musicians described in our chapter on Egyptian

pictorial technique. Throughout the East blind men earn their livings as ballad singers or chanters of religious hymns. It is believed that in Egypt they enjoyed a special privilege; whereas ordinary persons were not allowed to enter the "Holy of Holies," since it was thought fitting that the god should remain invisible to human eyes, an exception was made in favor of the blind. In any case the inner rooms of the temples where the divine mysteries were enacted were as dark as could be desired.

The harp-player is in attendance at a banquet. Squatting tailor-wise, he is shown wholly in profile like Deserkarasonb's girl slave; indeed the stylistic affinities of the two pictures are striking. He, too, is plump, and the folds of fat at the back of his neck and at the bottom of his chest are realistically rendered. On his shaven head is one of those odd-looking cones of scented ointment worn by all the members of banqueting parties. The sad expression on his face is admirably conveyed by two brushstrokes, that of the tight-shut eye and the contour of the parted lips. The painter has skillfully differentiated the hands; the hooked fingers of the left hand show that the palm is turned towards us, while the back of the other is indicated by its downturned fingers. (The same applies to the woman playing the harp in the lower register.) Another realistic touch is the squatting man's foot protruding from beneath his thigh. Exquisite in itself, the color-scheme gains by the fact that the greyish white ground has worn away in places, with the result that the beige stucco adds a note of warmth to the composition. There is more red than usual in the flesh-tints and the long white tunic being transparent above the waist where the man wears nothing below it, the pink skin underneath shows through, while specks of blue and yellow in the ornaments of the harp and the necklace add notes of brightness.

On another wall of this tomb we see the dead man hunting birds and harpooning fish in the papyrus marsh. In the lower registers are scenes of the wine harvest, grape-pressing, hunting with nets, fowls being plucked, offerings made to the dead. The birds are delightfully rendered; indeed the five geese bunched together, and in their midst a gosling with his head on his mother's back, nestling up to her as if seeking warmth and protection, compose a charming "family group." Above the papyrus thickets where Nakht is indulging in the Egyptian nobleman's favorite sport, we see startled birds in flight. With their stylized wings and plumage conventionally painted red and blue, the duck streaking across the whiteness of the sky look like so many flying St Andrew's-crosses. Meanwhile, disdaining flight, a duck and a pink bird perched on a papyrus shoot stand guard over their nests and eggs. The striking contrast between the light tones in the upper part of the picture and the mass of greenery below was certainly intended by the artist. It not only emphasizes the pearly shimmer of the Eastern sky into which all colors melt away, but incites the beholder to come nearer for a close-up view of the animals, which were obviously more congenial to the painter than his human figures.

The persons of high rank figuring in Nakht's tomb are often rendered rather stiffly; on the other hand, when dealing with members of the lower orders, the artist handles his subject more vivaciously and seems more at ease. The grape-gatherers working in

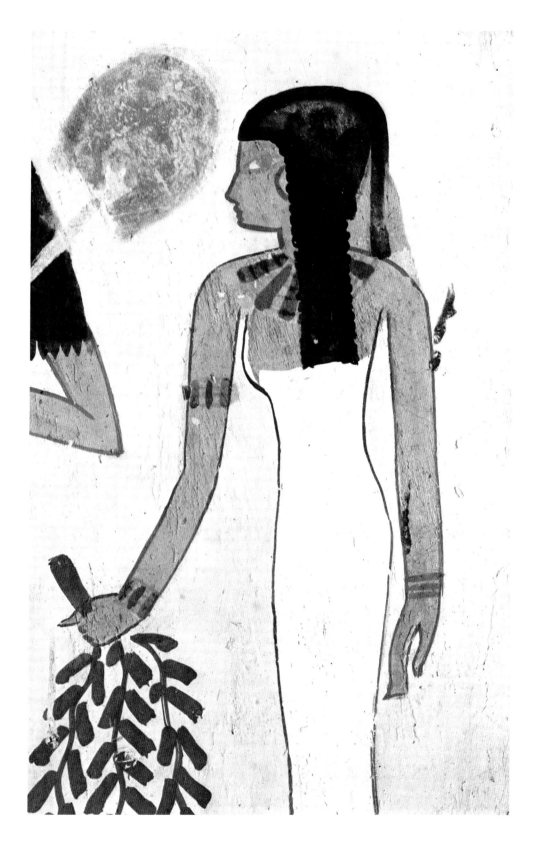

GIRL WITH A BUNCH OF DATES. TOMB OF DESERKARASONB (NO. 38), THEBES.

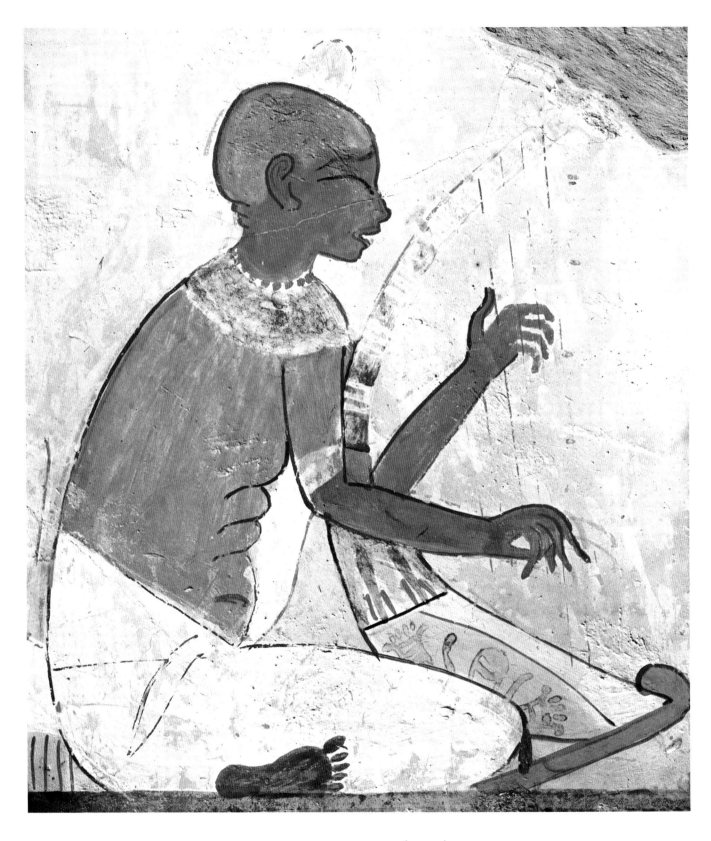

BLIND HARPIST. TOMB OF NAKHT (NO. 52), THEBES.

the vine-arbor and the cooks plucking geese (below the scene of fishing and fowling) have that air of rather loutish amiability which still characterizes the fellahs of Upper Egypt. The wall on the left as we enter the tomb is devoted to scenes of agricultural labor: ploughing, sowing, reaping, treading out the wheat, winnowing and so forth. Behind the reapers two men have filled to overflowing a bin-like receptacle used to carry the wheat, and are trying to press down the lid, which they then will tie down with a rope. The lid is wider than the diameter of the container, whose rim is made, it seems, of wood or some other hard material, and it is traversed by a long pole which, as we learn from similar scenes, the men will place on their shoulders when the bin is closed and they carry it away. One of the men has placed the pole under his shoulder and leapt into the air so as to use his full weight to press into the bin the overflowing mass of grain. He has the rope between his hands ready to tie the cover down. His agile leap strikes an effective contrast with the immobility of his mate, who is gripping the other

FOWLING SCENE, DETAIL. TOMB OF NAKHT (NO. 52), THEBES.

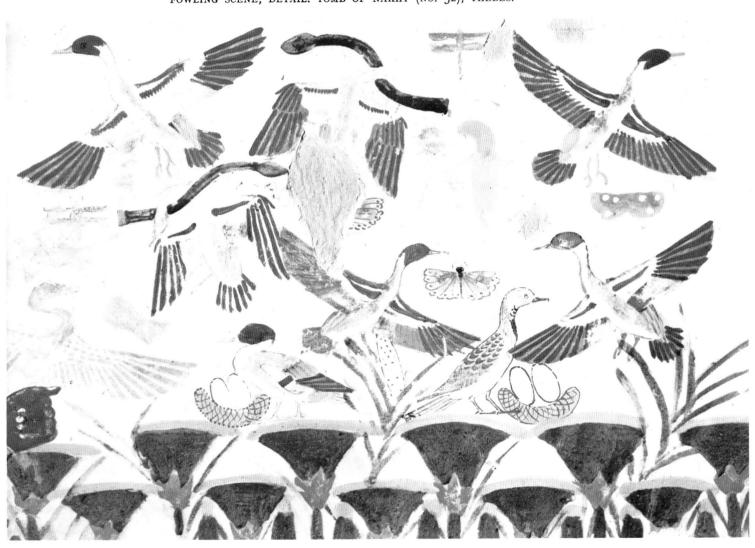

end of the pole. Under the legs of the leaping man poised in air like a ballet dancer, there was an empty space, at the righthand bottom corner, and here, as a foil to his display of energy, the artist has inserted a tranquil figure, a gleaner stooping to pick up some fallen ears of wheat that she will presently carry off in the basket placed beside her. The setting is suggested by a cornfield on the extreme right, where we see harvesters at work, cutting the wheat near the top of the stalk and leaving a high stubble after the Egyptian fashion. The composition of the scene is simple, but perfectly balanced: a big triangle on a background of vertical parallel lines, and the dominant color—red ochre in slightly varying tones—makes an effective contrast with the pale-grey of the wall.

On the left of the same line of scenes, with her back to the unmoving man, a girl is plucking flax—as we infer from her gesture, details of the plants having been left unpainted. The difference of the color-schemes shows that the artist wished to make a clean-cut division between the two scenes. Here the background is a big patch of green against which the pretty peasant-girl's white dress falls in graceful curves. Her profile is charming: a rounded, slightly tip-tilted nose, fleshy lips, a thick chin suggestive of plump cheeks. Despite a strong contrast between the huge eye and black hair and the delicate pink of the skin, the general effect is one of gentle grace, tinged with sensuality.

In a corner of the lefthand wall we see a worker kneeling at the foot of a tree and drinking from a waterskin hung half way up the trunk. What gives this glimpse of real life its piquancy is the way the artist has conveyed by the look on the man's face and his whole attitude his appreciation of a brief respite from labor in the hot Egyptian fields. Actually this scene was an afterthought; the painter wanted to fill up with some anecdotal detail the triangle left vacant after his depiction of the undulating ground on which Nakht's laborers were working. Another of this artist's caprices was to paint the leafage not green but blue; whereas the sugar-loaf form of the tree is conventional enough, being taken from the hieroglyphic sign that means "benignity"—perhaps owing to an association of ideas; in a sun-scorched land like Egypt the shadow of a tree is as welcome as a drink of water.

MENNA We shall not linger on the other, more commonplace scenes, mostly of offering-bearers, in the tomb of Nakht, but move on to another equally famous tomb, that of Menna (No. 69). Here, too, the wall on the left of the entrance is decorated with scenes of work in the fields—as was fit and proper, since Menna was the Pharaoh's "Field Scribe." His duty was to supervise both the field-laborers' work and that of the officials carrying out the cadastral survey. This is one of the most complete of the many picture sequences on this subject found in Egyptian tombs. Unfortunately the green pigment used in the flax harvesting scene (at the extreme right of the lower register) has disintegrated. Next, the various operations in the cultivation of wheat, staple produce of dynastic Egypt, are depicted in logical order, from the bottom upwards: ploughing (with the primitive Egyptian plough), sowing, reaping, carting, threshing, treading out the wheat on the threshing-floor, measuring it in bushels. On the upper register are land surveyors at work; attended by menials carrying their writing materials,

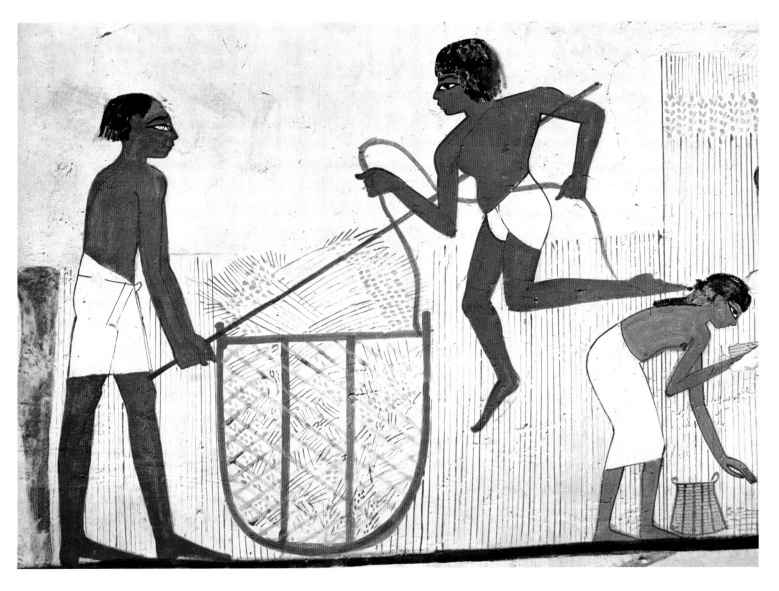

HARVESTING SCENE, DETAIL. TOMB OF NAKHT (NO. 52), THEBES.

revenue officials are manipulating lengths of rope whose purpose is clearly indicated by knots spaced out at equal distances. They are greeted by a peasant, his wife and son, all carrying gifts—can it be that the honorable representatives of the tax-office are amenable to bribes? The man presents the firstfruits of his crop in the guise of a doll made of ears of grain, the so-called "bride of the wheat." This custom has persisted to the present day; every Easter Monday the whole population of Egypt comes out of doors "to sniff the breeze" (the name given to this rite of spring), and everyone sports bouquets got up in various designs; in particular, dolls made of wheat stalks. It is amusing or regrettable—according to our views of "progress"—to note that nowadays the age-old "bride of the wheat", once associated with fertility rites, with the chthonian gods who fertilize mother earth, with Osiris and cobra-headed Renenutet,

is often to be seen dangling in the back windows of cars at Cairo and Alexandria. Thus across scores of centuries the "bride" has retained her function as a mascot. As in the past, we see this effigy nailed to housefronts in Egyptian villages; indeed the practice is not confined to Egypt, but prevails in other lands, especially in the Balkans. To return to the land-surveying scene in Menna's tomb—we are shown the peasant's wife following her husband, carrying some food, no doubt her culinary masterpiece, while the small boy is reluctantly offering the government official what he loves best in the world, a baby donkey (vandal hands, alas, have effaced it) and a kid. One can guess from the way he holds the tiny animal how much the sacrifice of his pet costs the little boy and this is emphasized by the way he is pursing his lips, as if trying to keep back a sob. (Perhaps this particular brushstroke was accidental, but, however that may be, there is no denying the emotion it conveys.) On the right some misdoers have been haled before the lord and master and are being given a beating. The artist has treated this scene with much humor, but not unsympathetically. One of the master's servants is mustering the other culprits; his hands are outspread and in the absence of an explanatory text we may assume he is trying to allay the fears of the poor wretches who meekly advance, arms dangling, towards the place of punishment. Another servant has started belaboring with a stick the back of a man lying face downwards, while the next for punishment kneels before the master, begging to be let off. Gestures and attitudes are quite simply rendered and there is nothing in the least "abstract" in this little scene; it is completely lifelike. On the fourth register four laborers are measuring the grain in bushels while eight scribes note the figures on their tablets. As if this array of bureaucrats were not enough, a thirteenth man—another accountant or perhaps an overseer—has been outlined in the center, but his figure left unpainted. An amusing detail: one of these representatives of the powers-that-be, seated on the top of a heap of grain, is counting on his fingers! In the scene of the transport of the grain there are equally picturesque touches. Two little girls are having a set-to over some ears of wheat lying on the ground, while, in pleasant contrast, a somewhat older girl is coming to the rescue of a friend who has a thorn in her foot. Meanwhile a slacker is drowsing under a tree, his head resting on his knees, beside a man playing the flute. Next comes the scene of treading out the wheat. Two laborers are preparing the threshing floor, pulling down shocks of wheat-sheaves with three-pronged forks and spreading the wheat on the ground, while another man is driving four oxen round and round, flicking them with a branch to keep them on the move. The driver and a man on the right have covered their heads with strips of white cloth to protect them from the dust rising from the threshing floor. The man precariously perched on a heap of wheat on the left cuts an amusing figure. He has an expression of such bovine stupidity that we can understand why his opposite number on the right is watching him with obvious anxiety. He is the sort of man who is always having accidents. Next we see a foreman supervising the work of two fellahs strewing wheat on the threshing-floor. Elegantly leaning on a long stick, he is telling off his men, who have swung their heads round and are vigorously protesting. The expression on the face of the man on the left, with the thick

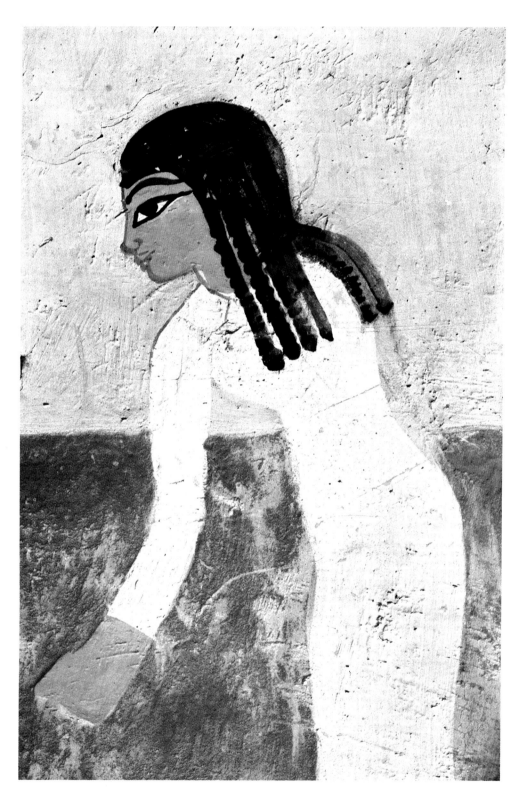

GIRL PICKING FLAX, DETAIL. TOMB OF NAKHT (NO. 52), THEBES.

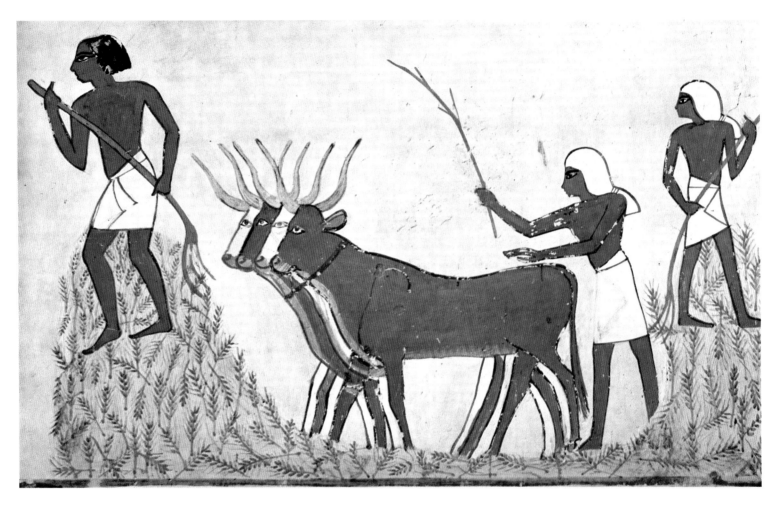

TREADING OUT THE WHEAT. TOMB OF MENNA (NO. 69), THEBES.

lips and bulbous nose conveys his sense of outrage; no doubt the two men reprimanded by the supercilious jack-in-office are suggesting he would do better to vent his indignation on the two loafers taking it easy behind him under the same tree—the flute-player and the sleeping man. Further to the left in the same row is another scene connected with the tree. A young mother, wife of one of the laborers, has brought a dish of food, presumably for her husband. Sitting on a low stool, she has taken off her garment and is using it as a sort of pouch to hold her baby, and the child is raising its hand to stroke her hair. Tiny as the scene is, compared with the others, there is nothing finicking in its execution. Far from aiming at any captious appeal, the xviiith Dynasty artist exercised a fine restraint that lent dignity to even his smallest works. Though often overlooked, this little picture plays an important part in the sequence of scenes of work in the fields. Without undue effusion it adds the human touch, reminding us that these serfs, mere drudges though they seem, have home lives of their own, wives and families to whom they return when the day's work is done. It links up diagonally with the scene on the top register of the boy carrying a kid. We have intentionally

placed the "motherhood" scene in Menna's tomb facing that of the thirsty man in Nakht's: the sentimental and the humorous confronting each other—to the detriment of neither.

The painter of Menna's tomb was no less discreet in his choice of colors than in his handling of themes. In the picture sequence of work in the fields the yellow of the wheat predominates, reappearing in many scenes, while figures are painted uniformly in red ochre. So pale is the grey ground that it would seem white, were not the men's loincloths still whiter. A few touches of pink are added, chiefly to indicate the transparency of the dresses of the naughty little girls and the good ones. The green of the flax field has perished (as already noted) owing to corrosion; but the blue-green of the small trees on the lower stretch of wall has stood up well. The black of the hair is less opaque than in other tombs, either because some of the pigment has worn off, or because the artist purposely diluted it; in any case the greyish, delicately modulated tones soften the emphatic contrasts usually found in Egyptian painting.

SCENE OF WORK IN THE FIELDS. TOMB OF MENNA (NO. 69), THEBES.

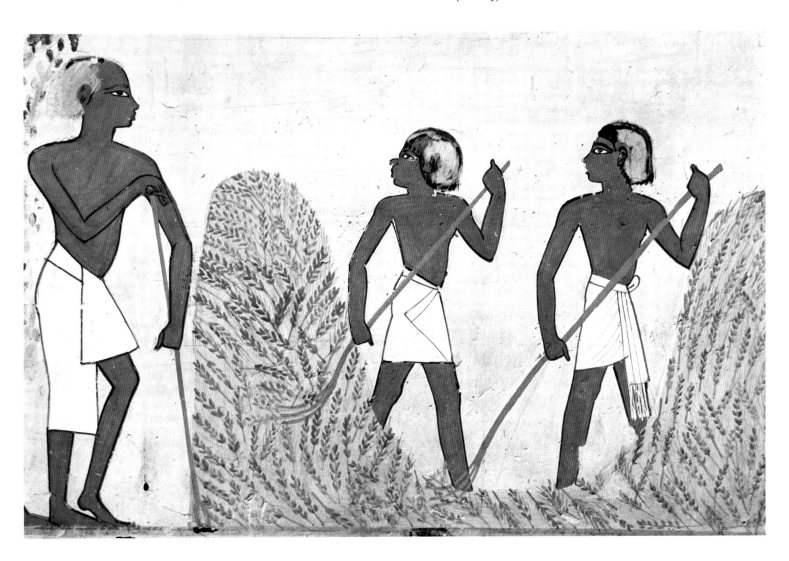

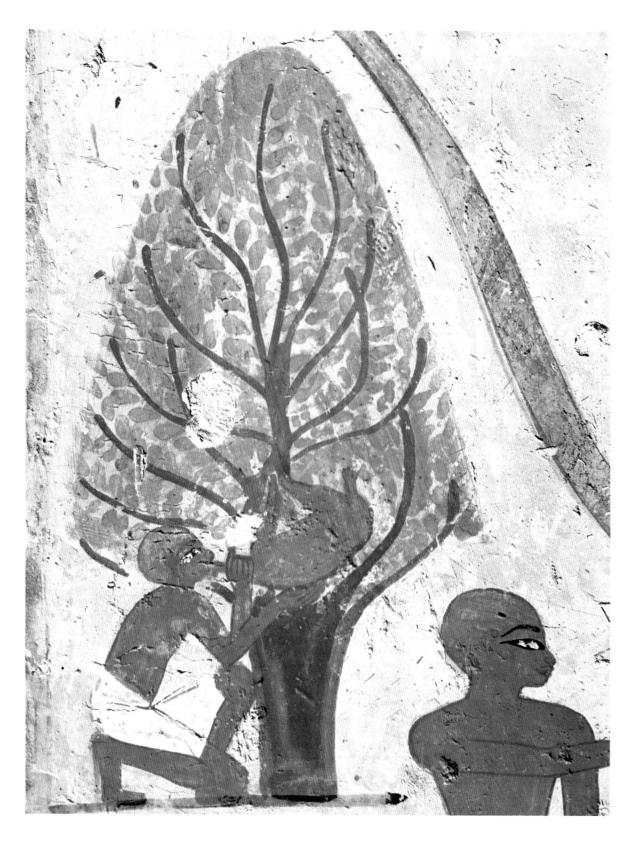

MAN DRINKING FROM A WATERSKIN. TOMB OF NAKHT (NO. 52), THEBES.

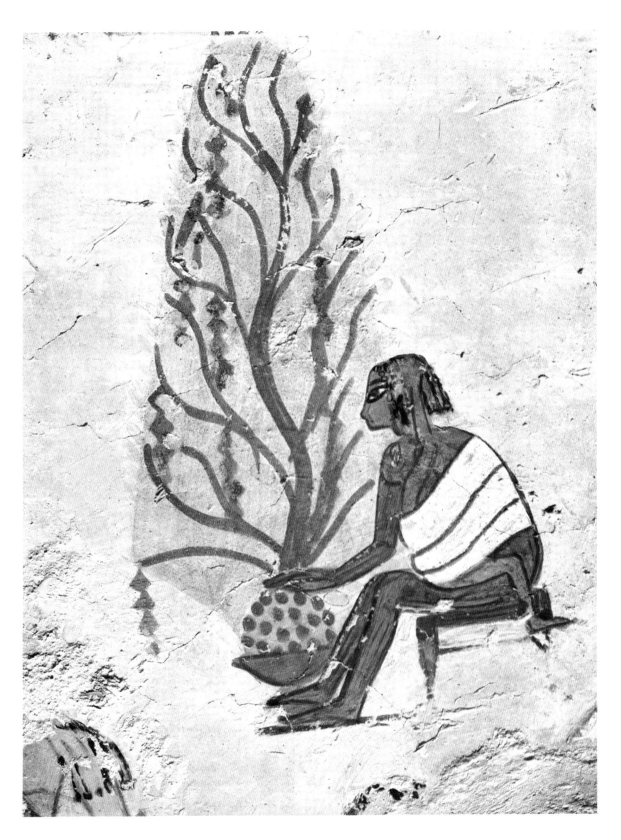

MOTHER AND CHILD. TOMB OF MENNA (NO. 69), THEBES.

The poetic touches found occasionally in the scenes of rural life in the first chamber of this tomb recur in the mortuary chapel. However, most of these pictures are of an inferior order; so much so that we can be fairly certain they are the work of other artists, and that we have here an instance of the team work so often evident in the decoration of Egyptian tombs. Presumably a gifted master-painter took charge of the chief scenes or those which interested him most and left to underlings the task of painting those which called for less inventiveness and originality of style. Processions of offering-bearers, funeral rites, the judgment before Osiris—such set themes had nothing to lose by being impersonal; indeed, given their symbolic intent, they gained by being treated in this manner. Nevertheless, it was these ceremonial scenes, far less striking than those of Menna's life, that the painter of the tomb of Païry (No. 139) seems to have copied. True, such subjects obviously lent themselves better to imitation; but the case is rare and there is all the more reason for drawing attention to it since archaeologists have not so far applied themselves to making detailed comparisons between similar paintings in different tombs with a view to deciding whether or not they are by the same hand. To prove the point (one of considerable interest to Egyptologists) we should need to

THE FUNERARY VOYAGE OF THE DEAD. TOMB OF MENNA (NO. 69), THEBES.

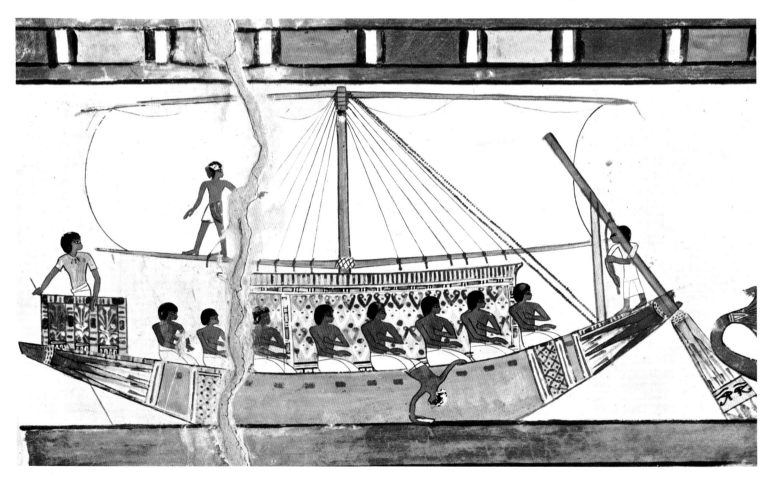

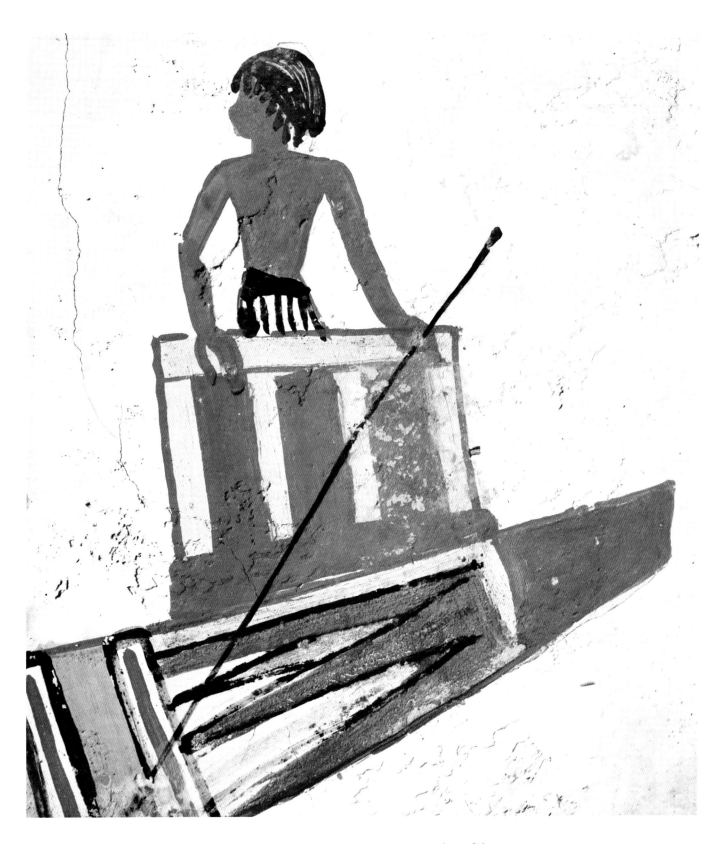

SAILOR TAKING SOUNDINGS. TOMB OF MENNA (NO. 69), THEBES.

incorporate a number of illustrations bearing on the problem, but these being in many cases of a rather commonplace order, would be unsuitable for inclusion in the present volume. So we merely mention this theory, in passing, and reserve it for discussion in a more technical work.

Menna's chapel is a narrow corridor ending in a niche for statues. The left wall is the one of which we spoke above with qualified approval, though it contains several picturesque details such as the women mourners in the funerary boat and some furniture-carriers. The right wall, however—anyhow in its best portions—, was clearly dealt with by the master-painter. Though the scenes of the so-called "opening of the mouth" and offering-bearers have less artistic merit, that of the pilgrimage to Abydos (on the upper register) is a work of real beauty. Its theme is the *post mortem* voyage of the dead man to the holy city of the god Osiris, so that on its return the body might be worthy of interment in the Theban mountainside.

With its immense white sail bellying in the wind, the ship on board which Menna and his wife are journeying from North to South is grandly rendered. Standing at the bows in a small box-like cabin decorated with a stylized floral pattern, the captain is taking soundings as the ship advances up the Nile. Perched on the lower yard-arm, a sailor-boy is shouting instructions to the man who works the rudder-oar, which is

HUNTING AND FISHING, DETAIL: WILD DUCK. TOMB OF MENNA (NO. 69), THEBES.

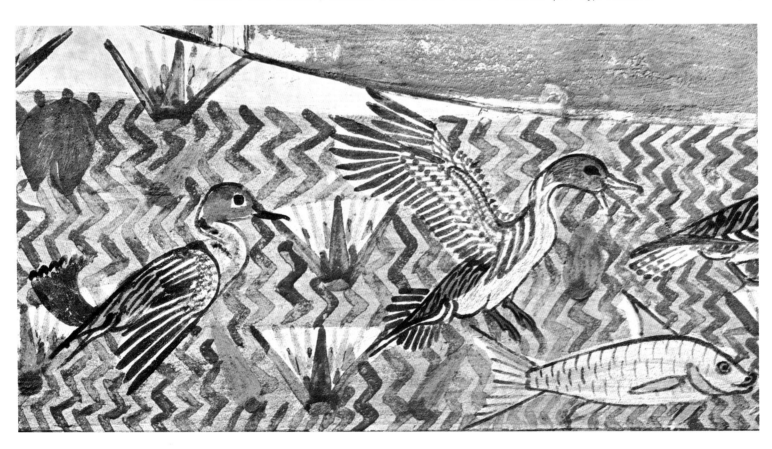

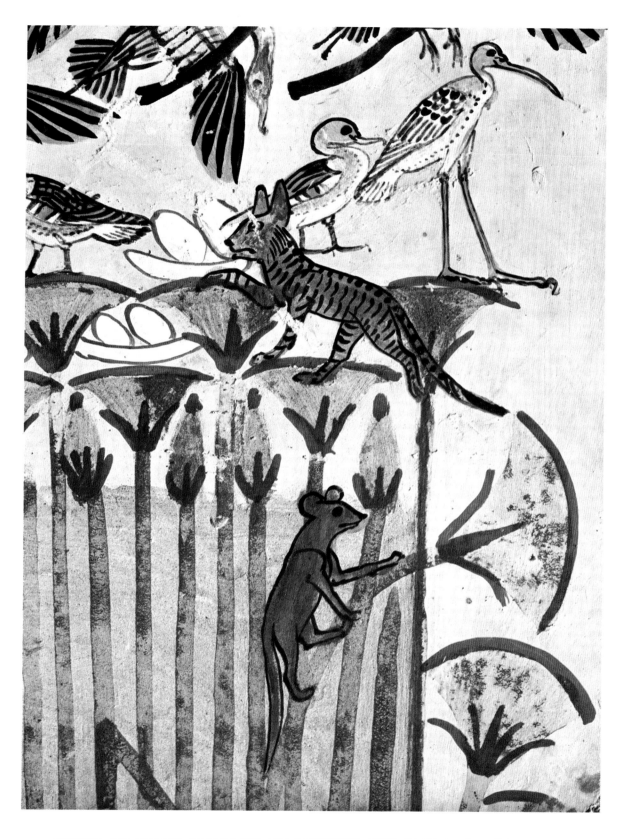

HUNTING AND FISHING, DETAIL: CAT AND ICHNEUMON. TOMB OF MENNA (NO. 69), THEBES.

adorned with "magic eyes" and a lotus flower, this latter motif being repeated on the stern and bows of the ship. As the wind is favorable the rowers have laid down their oars and crossed their arms in the Egyptian manner, one hand on the chest, the other resting on the knees. Evidently the painter, while aware of the hieratic quality of this attitude, saw that the effect of its eight-fold repetition would be monotonous; so, as a variant, he has depicted one of the crew hanging, head downward, over the side of the boat and scooping up water from the river in a basin. The man's awkward position, as he clings precariously to the bulwarks to keep himself from tumbling into the water, adds a touch of comic relief. It is interesting to note that the painter has had to make two versions of the profile to get an effect of foreshortening—unique in Egyptian pictorial art. He had another amusing inspiration when he made the man's torso start off from the knees of the rower next to him, suggesting a jointed puppet that at a touch flops forward from the seated to the bending position.

On the right are three more boats: two containing the mummies of the dead couple and only the third, which tows the others, being manned by rowers. Seemingly it was a recognized practice to use rowers for going down the Nile and sails for traveling upstream, since the prevailing winds in Egypt blow from the north. A curious point (already noted) is that the tug-boat was left unfinished by the painter, setting and figures being merely sketched in. The detail we reproduce shows the captain with the sounding-rod in the prow; he is turning to his crew to tell them how to shape their course. For navigation of the Nile has always been a tricky business, the river being full of hidden sand-banks only a few inches beneath the surface which, under the influence of the current, constantly change their position and are a serious menace to navigation, especially during the low-water season. Even today you always see a man standing at the prow of the Nile boats, shallow-draught vessels though they are, making the immemorial gesture of Menna's sailor and singing out directions to the steersman. Here the sureness of the brushwork in the rendering of the man at the prow is noteworthy. The artist has not lingered over details; eye, mouth and even the definitive contour-line of the face are omitted. This sketch-like handling of features is complemented by the almost impressionist rendering of the hair. And here, too, as in the similar instance of this technique described above, we feel that the artist consciously aimed at this effect.

In all these scenes the color orchestration is superb: deep blue for the strip of water, yellow for the woodwork of the boats and the drapery amidships, green for the floral or geometric designs, red ochre for the figures, pure white for the vast rectangle of the sail spanning the full length of the boat.

The fowling scene, too—it is one of the masterpieces of Egyptian painting—, bears the imprint of the "Master of Menna." Notable in the fragments we reproduce are the glorious wealth of colors, well-balanced composition, delicately clean-cut linework and the artist's gift of observation. The theme is frequent in Egyptian art. On the left the fowler is launching a throw-stick at the birds; on the right we see him in a papyrus boat, harpooning fish, accompanied by his wife and children. The wife has placed her arm round her husband's waist to steady him. One of the girls, already in her teens

but represented in the prevailing fashion as a naked child, is kneeling at her parents' feet and, with a charmingly graceful gesture, bending to pick a blue lotus-bud peeping from its sheath of vivid green.

Wild duck that have escaped the carnage are alighting on the Nile amongst the lotuses, and fish are placidly swimming just beneath the surface of the river. One of the ducks, quacking in alarm, beak wide open and tongue thrust out, is still in flight; another is folding his wings, keeping his tail up; a third (not shown in our plate), who has quickly recovered from his fright, is starting to peck at flowers in the water. The treatment of the water, represented by the usual zigzag wave lines placed vertically in a narrow strip, creates a vivid impression of depth. Various shades of blue, ranging from the dullest to the most intense produce the effect of a watercolor so exactly that we almost forget the painting has a stucco ground; while touches of white, green, red and black break what might else be the monotony of this symphony in blue.

The hunter's son, a rather vacant-looking youth, is turning to his father and pointing to a papyrus clump in which a little drama is being enacted: birds being chased out of their nests by a cat. It is now thought that we have here a hunting cat trained for this purpose; the old idea was that the cat was a marauder. Some Egyptian pictures represent kingfishers or wild duck defending their nests by pouncing down on animals climbing the papyrus stems in quest of eggs or nestlings. Here a "Pharaoh's rat" (ichneumon) with rounded ears and a long thick tail is trailing the cat. A branch on which hangs a simply drawn and colored flower is bending under its weight. The leafage of the background is rendered in a very light wash, obviously intended to throw into relief the animals. The cunning of the cat and the sly approach of the ichneumon are skillfully suggested. One of the most striking qualities of the Egyptian artist is his knack of synthesizing the essential traits of his subjects and thus creating, with the simplest of means a perfect balance between aesthetic beauty and his visual responses. On the technical side, we may note that the thickness of the impasto shows that in the detail of the rat the painter superimposed various colors one on the other; in the oblique light prevailing in this tomb, the papyrus stem is seen to stand out in relief across the animal's body. This, like the cat's, was first blocked in as a patch of color, then circumscribed with a black contour-line defining its form.

Even the most critical beholder can hardly fail to be delighted by the paintings of animals in Menna's tomb. On the righthand wall of the first chamber (several scenes of which we have so far left unmentioned) are the traditional representations of offerings to the gods. The detail of the man carrying a pink antelope has a particularly charming naturalism and vivacity. Drawn into a circle, the animal forms a sort of stole round the man's shoulders; he is hardly more than a boy and his fondness for the little animal can be seen in the tender care with which he holds it by its neck and fragile legs, crossed upon his chest. We feel that the painter has put his whole heart into the depiction of the two and sought to bring out, especially in the expression of their eyes, the pathos of the scene: the innocence of the graceful victim led to the sacrifice, the remorse felt by the youth so obviously hating the duty imposed on him. Delicate color, tranquil

line, the charming ingenuousness of the forms of the boy and the antelope—all contribute to the atmosphere of simple human feeling that imbues this little scene. The red in the flesh-tints, lighter than usual, harmonizes admirably with the pink of the antelope's coat, both hues blending upon the pale grey background. In the upper lefthand corner a single papyrus flower—relic of a bouquet brought by some other servant—does duty for a landscape setting.

The subject here is the preparation of the table of offerings to the gods. On the wall devoted to scenes of country life, we are shown Menna receiving the produce of his estate. While symbolic in intent this group of scenes acts as a sort of résumé of all the pictures in the tomb. In the lowest tier are baskets of figs and grapes on a green mat, with three red terracotta winejars on the left. Above are eggs and young birds in their nests, dishes of food, tresses of flax or papyrus, two handsome fish. The effect is that of a beautifully composed still life, an arrangement of red, blue, green, pink and blue-grey on a near-white ground. This is a work which, had the notion of the framed picture been current in those days, might have graced the dining-room of some wealthy art-loving Egyptian. We have already compared the Theban necropolis to an enormous picture gallery, and surely such works as this are worthy of a place "on the line" in even the most selective art-museum. The transparency of the pigments produces the effect of a watercolor and in the original this effect is accentuated by the small dimensions of the scene. Also one cannot fail to be struck by the finely balanced composition, the stronger colors being placed towards the bottom of the picture and serving as a sort of base for the superstructure of lighter tones. Noteworthy, too, is the pink of the bodies of the fledglings, scared at being taken away from their natural surroundings and their mother; it exactly reproduces the texture of the light, fluffy down of very young birds. Small models of such objects have been found in tombs— especially in the treasure of Tutankhamen; they were intended to be taken with him by the dead man into the hereafter as souvenirs of his earthly life. The more material- istic aspect of this practice was the idea that it enabled him to enjoy good fare eternally; thus the eggs, chicks and other edibles were artifacts giving concrete form to a religious belief. Along with the fish laid on a small ceremonial mat, they link up this sequence with the fishing scene in the second chamber, where the same fish reappear in the center of the composition. Here, however, they are standing on their tails, the reason being that Menna (who figures on the right) has harpooned them and is hauling them out of the water. The artist has employed a perspective device of a wonderfully decorative order. The water rises with the fish, forming a sort of dome around them, in which the blue zigzags are arrested by pink triangles, stylized versions of papyrus roots. Soft- green papyrus stems form the background of the picture already described: of birds struck with a boomerang, the cat and the ichneumon. In our illustration the ends of the boats, which are made of papyrus stems, can be seen, and also an incident taking place in the water below, a baby crocodile starting to devour a fish as big as himself. Lotus leaves and flowers, spread out like waterlilies, charmingly diversify the landscape. Two species of fishes are differentiated by slight variations in the shape of their snouts;

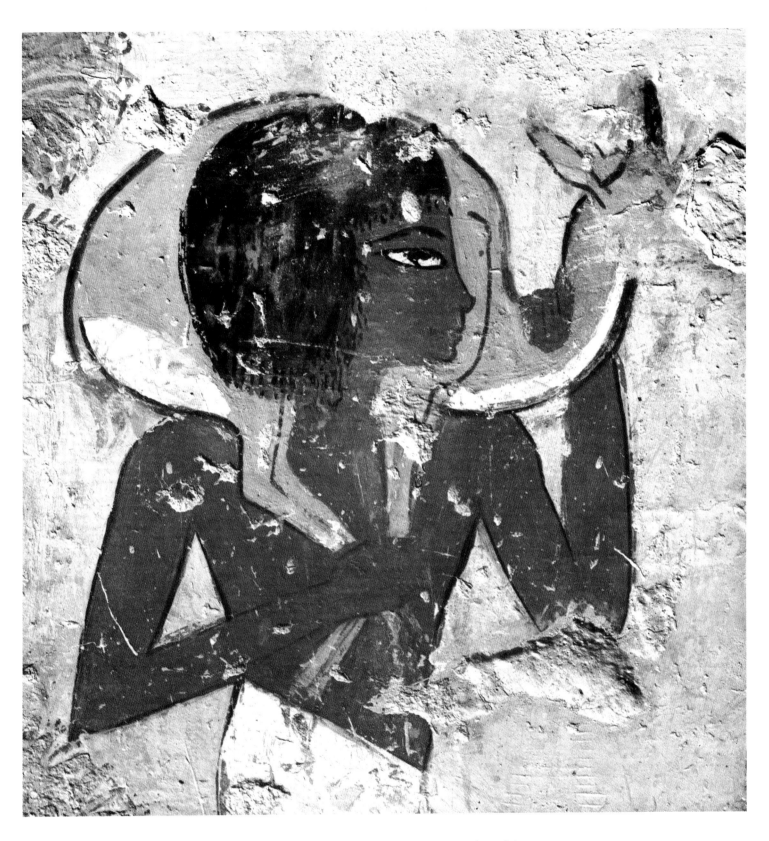

MAN CARRYING AN ANTELOPE. TOMB OF MENNA (NO. 69), THEBES.

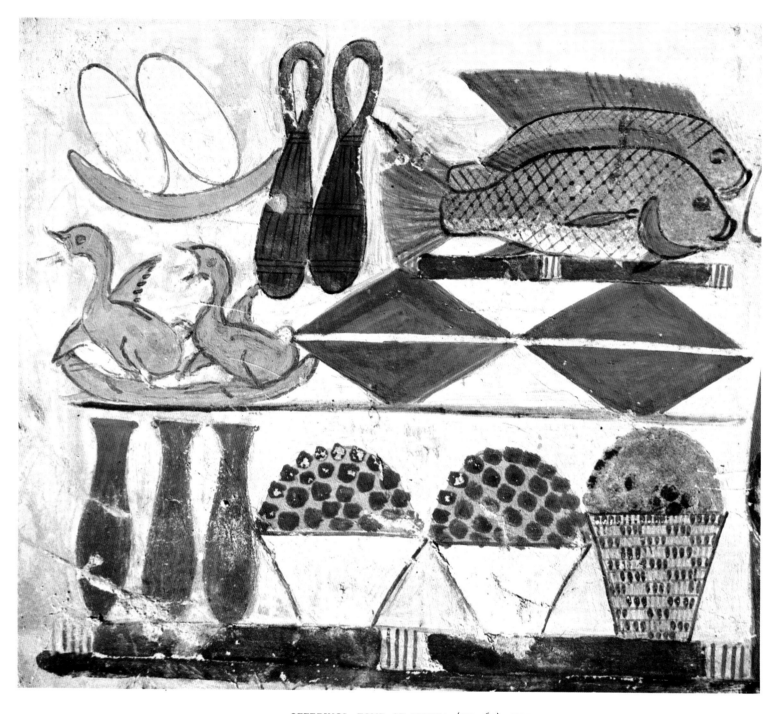

OFFERINGS. TOMB OF MENNA (NO. 69), THEBES.

it has been suggested that these represent the two best varieties of edible fish found in the Nile. This, too, has a symbolic purpose; at once to celebrate the dead man's skill as a fisherman and to ensure that in the next world he will eat nothing but the best. We must never lose sight of the fact that the choice of motifs in Egyptian pictures, even in those which seem to have no connection with religious subjects, is always

HUNTING AND FISHING, DETAIL: FISH. TOMB OF MENNA (NO. 69), THEBES.

guided by ritual considerations. Thus as regards the scenes of fowling and fishing, it should be remembered that similar scenes figure in temples, where the heaven-born Pharaoh, in virtue of his priestly function, captures the animals to be sacrificed on the altar. Likewise within the precincts of the temple the king made the symbolic gesture of netting water-birds on pools specially constructed for this purpose. The representation in the tomb of similar acts being performed by ordinary mortals for their own advantage is one of many instances of the democratization of the ritual. As for the artistic merit of such scenes, it depends on the personal talent of the painter whether he achieves an original or merely stereotyped interpretation; after all the same is true of the innumerable pictures of the Madonna made from Byzantine times to the Renaissance, each of which reflects the personality of its maker.

Of the many scenes of hunting in the marshes or on the Nile, those in Menna's tomb are certainly the most successful. There is much poetic charm in a detail on the extreme left of the hunting scene. A young girl carrying lotuses and ducks is turning away to gaze at the river-bank, as though she wanted to avoid seeing the wholesale slaughter that keen sportsman, her father, is engaged in. In the attitude of this attractive girl, as in that of her young sister bending to pluck a flower in the river, there is a pensive calm, agreeably contrasting with the violent action of the central scene. This is certainly a calculated effect, and it is not the first time we have had occasion to draw attention to procedures of this kind in Egyptian art. The portrait of the great man himself has been mutilated, some superstitious vandal having destroyed the face, and the same fate has befallen the figure of the little kneeling girl. Happily the charming detail we reproduce is undamaged. That the artist devoted loving care to it is evidenced by the numerous retouchings, and the net result of all these pentimenti is a delightful little face, whimsically roguish. The left elbow being too angular, he corrected it, but the original drawing now shows through. On the arms are smudges, indicative no doubt of hasty execution, but also bringing out effectively the hue of the girl's sun-tanned skin and the soft curves of flesh. The girl's attitude is interesting, her body being shown in profile up to the shoulders, then given a sudden twist, so that the head is facing backwards. Such twists are characteristic of the technique of "folded-over" planes practiced by Egyptian artists, often to the happiest effect. Indeed are not our modern painters, who at long last have broken with the disciplines of academic perspective, nearer to the Egyptians than were the classicizing decorators of Pompeii? This figure is another proof of the fact that the truly inspired work of art is ageless, it never "dates." Noteworthy, too, are the delightfully simple colors—brownish-pink, yellow, blue-green, black and much white—, the smoothly flowing line and the artist's avoidance of any over-emphasis.

Another young girl by the same hand—in the first chamber of the tomb—is complementary to the "diptych" we have formed by juxtaposing the two pictures. She is one of a procession of offering-bearers covering several rows in the lowest of which, on the left, is the charming pink antelope. Above are youths and girls carrying bouquets. This girl, the most attractive member of a group of maidens, is carrying lotuses and

grapes. Damaged though it is, this work has lost nothing of its elegance. The green pigment employed having disintegrated on contact with the air, the stucco ground has flaked away in places. Hence the disappearance of the flowers and some parts of the jewelry on the girl's hair, ears, neck and arms. On the light grey wall the big black mass of hair, which has grown paler with the years, admirably sets off a young face painted in the brownish pink, suntan hue that the "Menna" painter always uses for women's flesh-tints. The fading of the color has imparted to this portrait a mellowness, a quiet dignity, ranking it amongst the most attractive specimens of Theban painting.

To conclude our survey of the tomb of Menna we add the portrait of a lady at the end of the sequence of offering-bearers in which is the young girl described above. Here we find the same stylistic qualities and the same scheme of colors, but this work has a far more potent appeal. This is not due, as might seem, to its larger dimensions, for even when photographically reduced to the size of our other plates, it loses nothing of its impressiveness. Nor does the relative maturity of the face as compared with those of the young girls account for this. What strikes us most about the figure is an over-all compositional balance rarely achieved in Egyptian art; moreover the artist has exercised an exceptional restraint in his choice of colors and his treatment of the jewelry. True the black of the hair has lost its intensity, yet even when freshly painted it cannot have produced the effect of a top-heavy, compact mass, since the artist had the happy idea of breaking the monotony of uniform vertical lines by detaching two strands and letting them glide round a big gold earring on to the lady's shoulder. The rows of pearls composing the necklace are shown in low-keyed colors, moss-rose pink predominating. There is the same delicacy of coloring in the bandeau round the woman's hair and the lotus flower above her forehead. But it is in his handling of the face itself that the artist excels himself. All is depicted with a fine economy of means; the rounded nose, the fleshy lips, the chin suggesting a plump cheek and above all the glowing eye are indicated discreetly, without insistence. Nevertheless there is something in this portrait that makes us feel it is not so impersonal as so many other portraits of deceased couples. In temples and royal hypogea we can easily recognize the faces of the various Pharaohs; evidently the sculptors worked from the living model and then stylized it. Why not assume that in the Theban tombs the best painters sometimes made real portraits, idealized no doubt, of their patrons? In any case this portrait in the Menna tomb has too much lifelikeness to be dismissed as merely conventional; indeed we are more inclined to see in it the painter's conception of the woman of his dreams. The anonymity of the artists of the remote past should not blind us to the fact that they were flesh-and-blood men who loved and suffered and enjoyed themselves, in short men with feelings of their own, and that they must have often sought to give expression to those feelings. The hieratic dignity religious custom imposed on gestures as depicted in the tombs could not wholly suppress the artist's personality. Indeed no great artist lets himself be thus inhibited; the more stringent the control, the greater the tension we sense in his art. And the works from Menna's tomb here reproduced are vibrant with life, instinct with the genius of the man who made them.

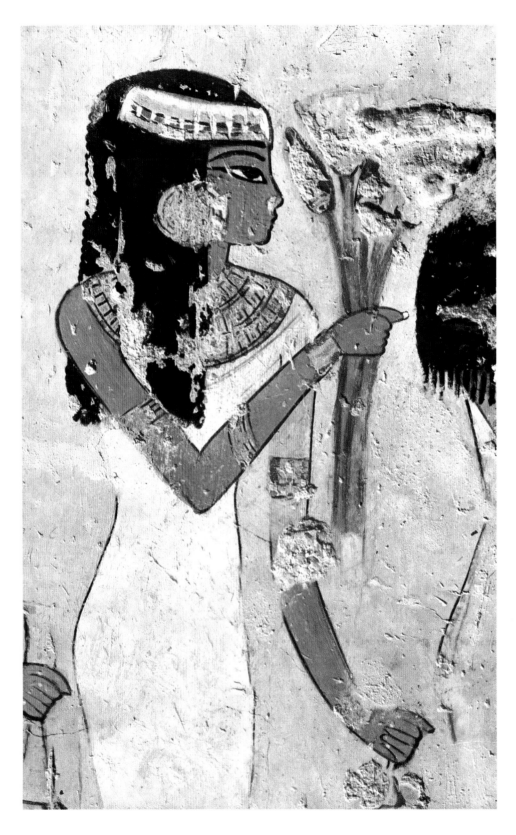

GIRL CARRYING LOTUSES. TOMB OF MENNA (NO. 69), THEBES.

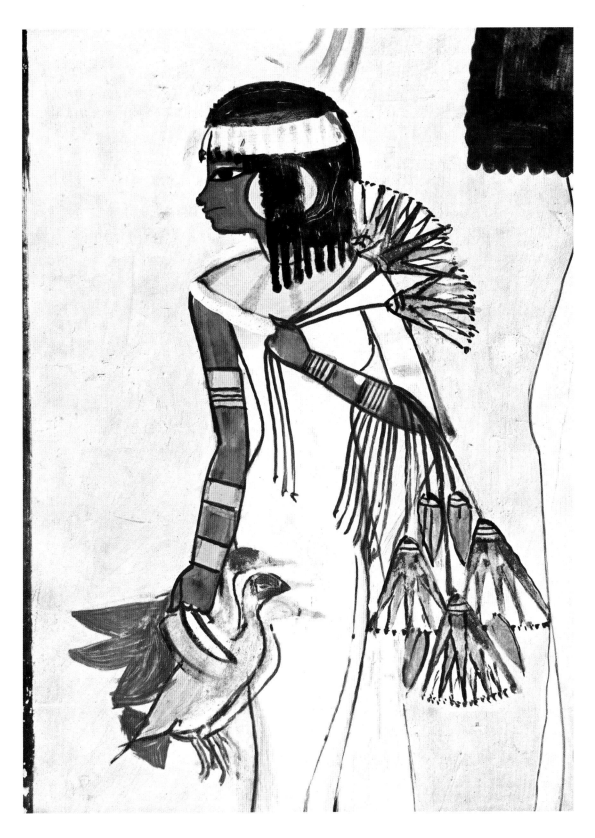

HUNTING AND FISHING, DETAIL: THE HUNTER'S DAUGHTER. TOMB OF MENNA (NO. 69), THEBES.

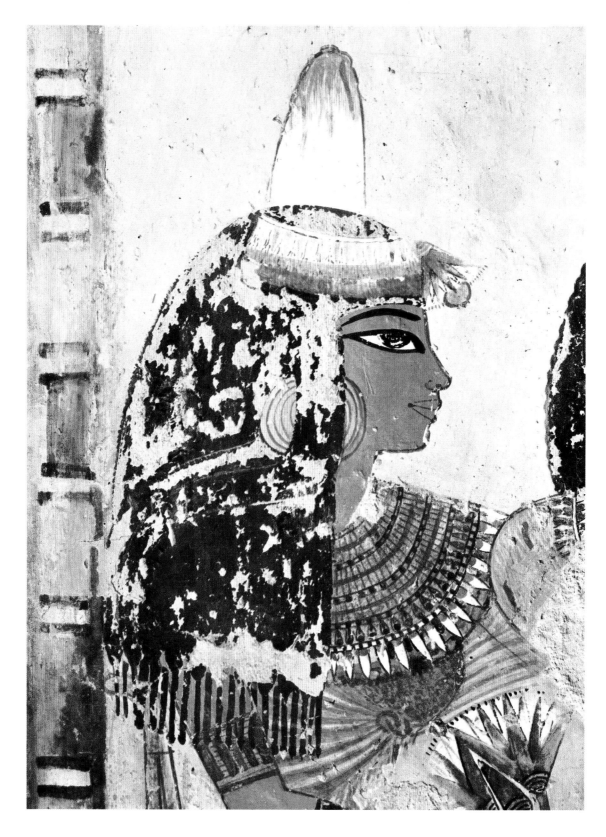

PORTRAIT OF A LADY. TOMB OF MENNA (NO. 69), THEBES.

94

This is a point on which we venture to lay stress, for it is our conviction that students of Egyptian painting would do well henceforth to approach it from a new angle. True, there is no denying that each successive period witnessed a general change in the artists' handling of stock themes; but it is no less obvious that each individual artist had a style peculiar to himself. There has been a tendency to overlook this fact, which can be verified only by visiting the tombs and studying the pictures on the spot. The reason why it has hitherto escaped the notice of so many Egyptologists is that they usually work at home in their studies, in Europe or America, and base their appraisals on photographic reproductions in black and white. As regards Egyptian painting such methods are, to say the least, misleading. To some extent this handicap is obviated by color reproductions—provided these are absolutely faithful. Above all it is needful that the texture, tactile values and exact colors of each picture should be reproduced. This in fact is what we have aimed at in the present volume, though well aware of the technical difficulties involved. It is hoped, however, that, thanks to the details to which so prominent a place is given, the reader will feel as we do that each tomb bears the imprint of a well-marked personality.

This is strikingly evident in the tomb of Thanuny (No. 74), to which we now turn. THANUNY Thanuny was an "army scribe" in the reign of Tuthmosis IV and, appropriately enough, his funerary chapel is adorned with scenes relating to recruiting. The five Nubian mercenaries advancing at the double are typical. Here we have not the delicate crafts-manship of the artist who worked in Menna's tomb or his softly modulated, transparent hues. Warm colors and masses in movement are this painter's speciality. He little cares if the profiles of some of the men are submerged by their neighbors' hair, and this in fact lends animation to the group. This artist has used only three colors through-out the picture: red ochre, pure or diluted, for the plump bodies; black for the hair and some details of garments; white for the much abbreviated loincloths. These sturdy, bucolic recruits to the Pharaoh's army still wear what are presumably their tribal attributes: leopards' tails attached to their belts and knees. A long, netlike garment, reinforced at the seat by a strip of cloth or leather, covers the upper part of their legs. The device on the standard carried by the last man stresses their pugnacity; it represents two wrestlers at grips. Outlines are drawn only where indispensable and this very lack of definition, tending as it does to amalgamate the group with the blue-grey back-ground, intensifies the vitality of the composition as a whole. Most striking is the standard-bearer. With his resolute face, stiff hair and bulging muscles, he would obviously be a dangerous opponent, and an army of such men well-nigh invincible. This is exactly what Thanuny wished to convey, and for the same propagandist reasons he makes a point of showing us that the Egyptian army was well looked after and its foreign legion generously fed.

Evidence of this is given in the other panel which shows, on several registers, fat cattle being led in to feed the troops. Unfortunately these scenes are damaged or smeared with dirt in many places, as this tomb was dwelt in some time in the past.

The restorers employed by the Antiquities Department have merely stopped the holes with cement and not as yet embarked on the highly delicate task of cleaning. The scene that comes out best is that of a herdsman leading a black-and-white cow, followed by other animals. The effect of the fat red bull with a glaring eye, bulging chine, blue horns with tufts of hair standing up between them, upon the azure-blue wall is almost startling.

The pink horse with a reddish-brown mane in the lower register (likewise in a bad state of preservation) is surely the supreme masterpiece of all Egyptian art, on a par with the horses of the Parthenon frieze which it preceded by a millennium. Pricking its ears, whinnying, the mettlesome animal is chafing with impatience to be yoked to the chariot and to gallop into the fray. Here the masterly drawing brings out to perfection the dilated nostrils, panting mouth, flashing eye and quivering withers; the whole body, even the curves of mane and breast, is vibrant with tempestuous life. Most amazing of all is the effect of the strange, unrealistic pink on a blue ground.

Beyond all doubt this painter was more, far more than a mere artisan and if the refined society of the XVIIIth Dynasty failed to do honor to the great artists in their midst, so much the worse for them! We would prefer to think that Thanuny, "army scribe," and his painter, "scribe of contours"—the hieroglyphic designation of the artist—were on an equal footing and the glorious pictures we have described were a tribute to their friendship. Otherwise we could hardly account for a painter's putting

CATTLE. TOMB OF THANUNY (NO. 74), THEBES.

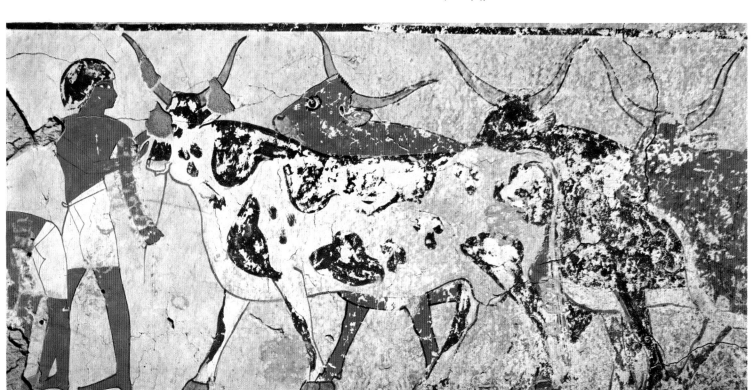

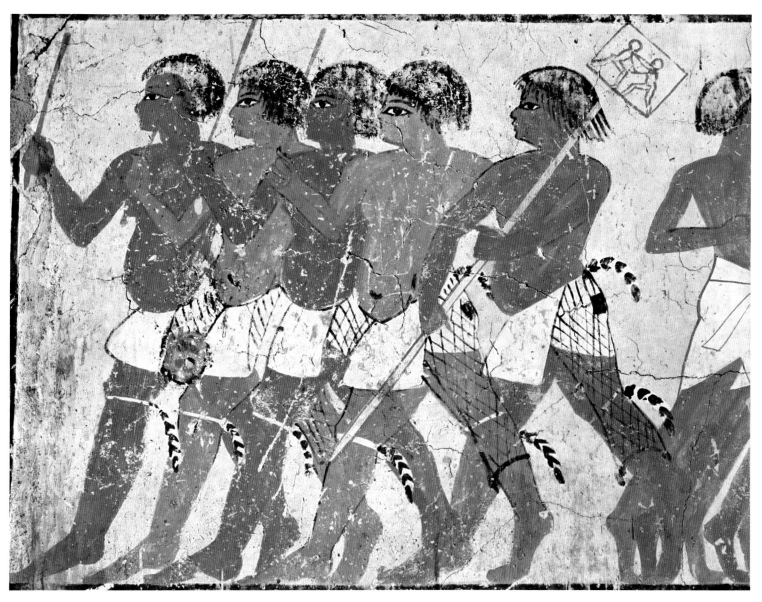

NUBIAN MERCENARIES. TOMB OF THANUNY (NO. 74), THEBES.

so much of himself into his creations. Presumably an eminent artist or master-craftsman supervised the decoration of many of the tombs. Why then all too often do the paintings in them seem insipid, and why so rarely do we feel the presence of the same hand in two different tombs? And why, on the other hand, are there brilliant exceptions such as this: deeply moving works in which we sense the power of genius?

In the Theban necropolis are several hundred hypogea, each with its own character-istics even when the subjects are stereotyped. Among those of the reign of Tuthmosis IV we would draw attention to two tombs which are so similar in style that none can fail to recognize the hand of the same artist, and a very great one. He has the knack

HAREMHAB

of simplifying line and color to such a point that with a few significant brushstrokes he tells everything about the expression of a face or a moving body; we might almost call him the first Impressionist. Like Thanuny the owners of both tombs were army men: Haremhab and Nebamun. We shall now describe the chief scenes on the walls of their chapels, with special reference to those here reproduced and their thematic and aesthetic qualities.

There are two decorated chambers in the tomb of Haremhab (No. 78). In the first are scenes of banqueting, offerings, recruiting, a parade of foreign tributaries before the Pharaoh; in the second the funeral procession with the usual bands of mourners, and scenes of fowling and fishing in the marshlands.

BULL'S HEAD. TOMB OF THANUNY (NO. 74), THEBES.

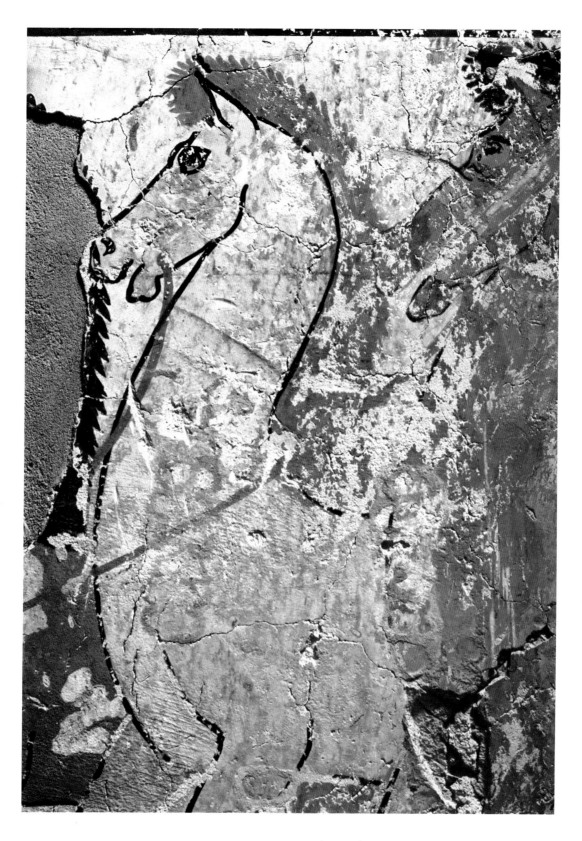

HORSE. TOMB OF THANUNY (NO. 74), THEBES.

So frequent is the theme of mourning women in Egyptian tombs that it would soon become wearisome, were it not handled in so many different ways. Here, for example, the two sets of female mourners are quite dissimilar. The two women heading the group in front of the men dragging the sarcophagus are placed back to back and schematically treated, so that the women's raised arms and greying hair surrounded by white head-bands make a symmetrical pattern. The lower part of the scene was sketchily treated, with a spontaneity far more expressive than if the artist had lingered over details. Even the conventional mourner's gesture, though repeated many times

FUNERAL PROCESSION. TOMB OF HAREMHAB (NO. 78), THEBES.

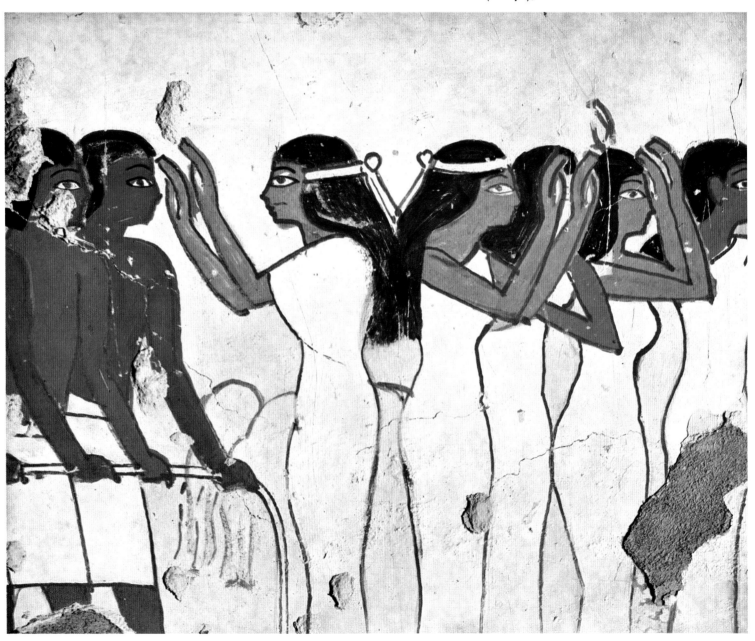

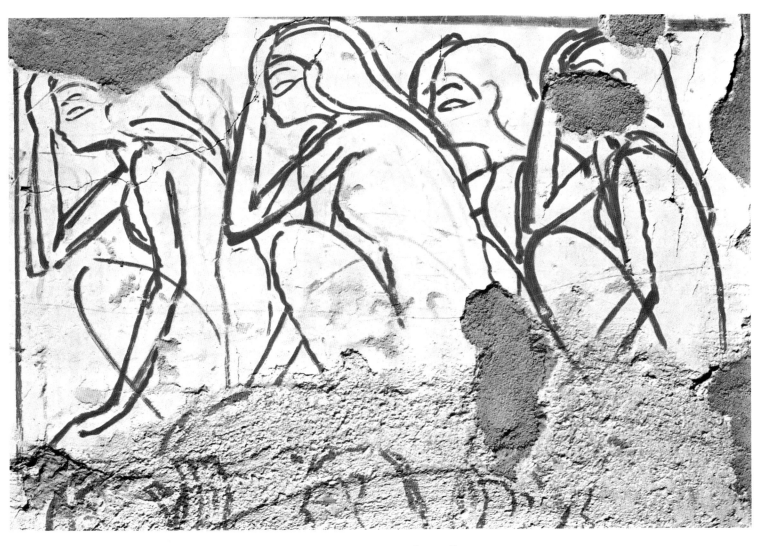

FEMALE MOURNERS. TOMB OF HAREMHAB (NO. 78), THEBES.

over, does not produce an effect of monotony, for the women are beating their fore-heads with their right and left hands alternately. Occasional thinnings of the strokes show that here the color on the painter's brush was running out, but this did not prevent him from going ahead with his design, and even his revokes and hesitations add lively touches. Even the slight wavering of the line, notably in the drawing of the second woman, is effective, suggesting as it does the movement of the pleated tunics that came into fashion under the New Kingdom. We may well be thankful for the almost miraculous preservation of works of this order, testifying to the genius of a very great, if nameless artist who lived over three thousand years ago.

No painter has better succeeded in expressing so much with so few lines. We find the same fine spareness of means, combined with the same wealth of inspiration, whether he is depicting human beings, animals or landscape. One of the most striking examples is in the first chamber: the blind singer, painted in a warm yellow ochre with brown

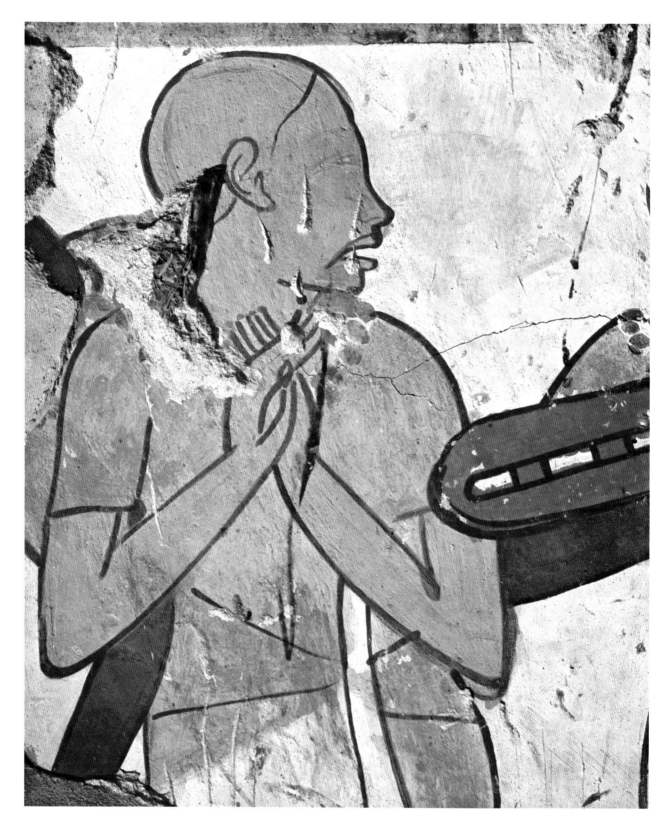

THE BLIND SINGER. TOMB OF HAREMHAB (NO. 78), THEBES.

outlines. The obliterated eye, melancholy lips and locked hands tell more than words or gestures of the tragic lot of this blind singer who has to feign delight and can visualize the splendors of the banquet only with the inner eye of his imagination.

Turning to the tiny locust in the fowling scene of the second chamber, we find that the painter has devoted no less loving care to the depiction of this humble insect perched on a huge, stylized papyrus blossom. Its pinkish yellow hue, more vivid on the wings than on the body, is not merely naturalistic, but also produces an effect of volume, borne out by the parallel half circles drawn on the tail. Each detail is wonderfully true to life: the insect's head, huge eye, antennae, legs. Less than five inches long, the locust is no more than a tiny fragment of a scene covering the entire wall, but the artist has drawn attention to it by leaving a wide empty space all around it, with the result that almost automatically our gaze comes to rest on this diminutive insect, which becomes, if momentarily, the focal point of the picture.

LOCUST. TOMB OF HAREMHAB (NO. 78), THEBES.

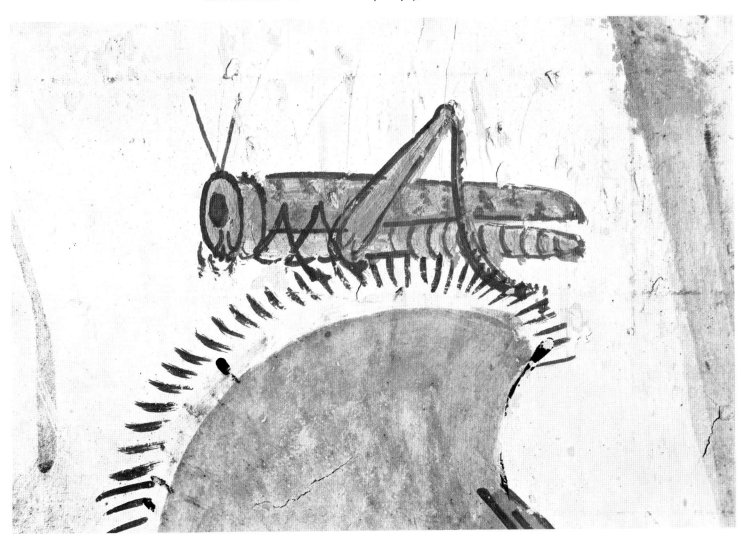

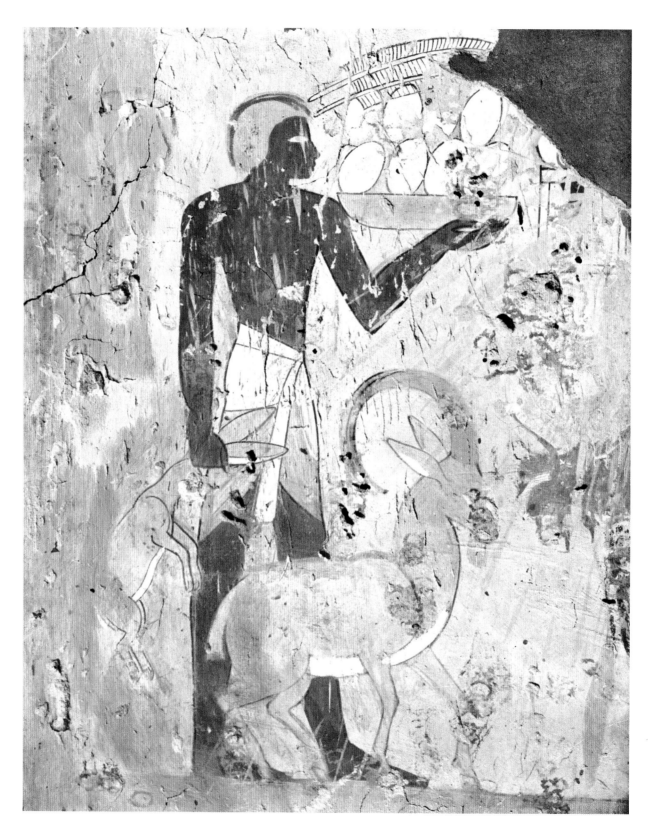

OFFERING-BEARER AND IBEX. TOMB OF HAREMHAB (NO. 78), THEBES.

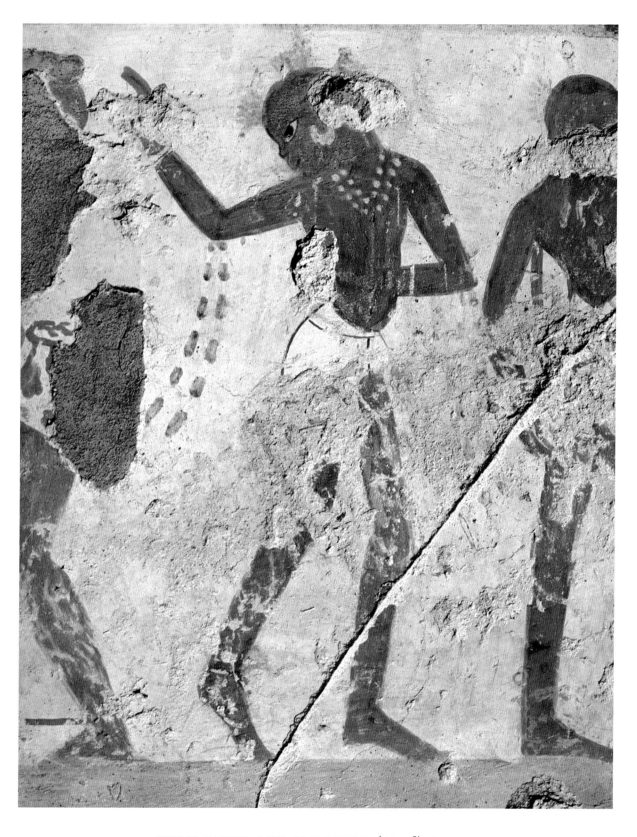

NUBIAN DANCER. TOMB OF HAREMHAB (NO. 78), THEBES.

We are tempted to linger over this composition not so much for its over-all effect as for its many charming details. The birds, for instance, flying with wide-spread wings stylized into a few red and blue specks, add touches of gaiety to the landscape. Two pigeons on the left, perched on green papyrus stems sheathed in pink leaves, may be regarded by the sentimentalist as a poetic reminder of the joys of married love. A dove sitting on her eggs is cooing—one can tell this from the bulging throat— while the male bird, on another branch, keeps guard over the nest. The colors are appropriate to this idyllic little scene: pink on blue-grey. For as we have so often pointed out, the Egyptian artist gives free play to his feelings when depicting animal life; one can sense his joy at being released for once from the restraints of the "official" iconography.

GRAPE-PICKING. TOMB OF NEBAMUN (NO. 90), THEBES.

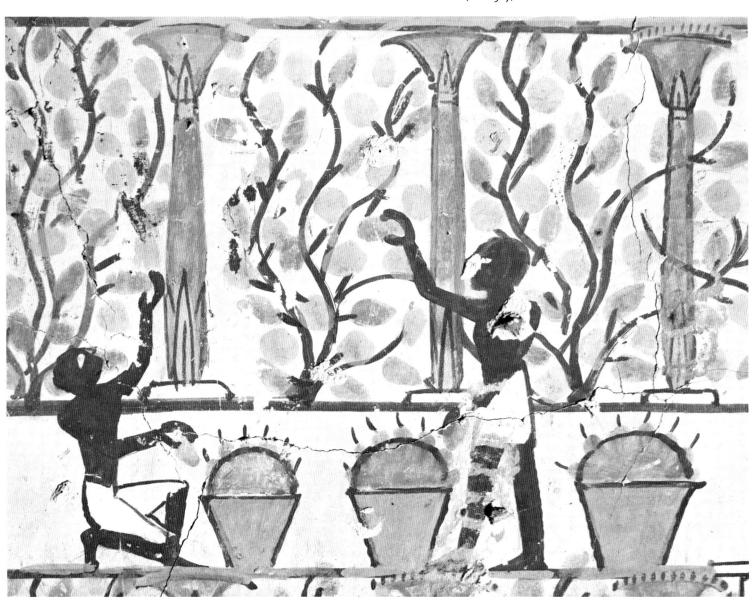

The group of pelicans under the fowling scene is a masterpiece of sensibility and insight into the animal mind. As is right and proper, the father pelican walks in front, but he is turning back to cast a grave, protective glance on his wife and offspring. The mother follows meekly, her head bowed, her beak tucked in with an air of humble deference. Beside her walk three youngsters, little more than fledglings; the painter has well brought out the downy softness of their plumage. In front are two baskets of eggs covered with grass; the makings of the next brood presumably. Behind, a kneeling trapper is calling the birds, using his hand to vary the timbre of his call. An uncouth figure, untidy and ill-shaven, this man is treated impressionistically, and the same is true of the fishermen bending forward to draw in their nets (on the same wall)—red masses on a blue ground. The movement of these figures is finely rhythmic, full of vigor.

That from the wealth of interesting material on this one wall we have singled out the locust for reproduction is due to the fact of its being the most original of all the details. However two pictures in the first chamber are more typical of the style prevailing in the tomb of Haremhab. One represents the traditional offering-bearer, but here the composition is architecturally ordered. The man has a dignified bearing and is carrying a desert hare by its ears with his right hand; on his left shoulder is a dish of eggs and ostrich feathers. The head was left unfinished, but there is much verve in the drawing of the profile, especially in the stroke outlining the man's hair. The diagonal formed by his left forearm and the hare divides the picture into two triangles balancing each other—a carefully thought-out device which has led the artist to elongate the man's legs unnaturally so as to make room for a lithe but strongly built ibex at his feet. In contrast with the vertical of the standing figure, a sweeping curve starting from the tip of the animal's horns encircles its neck and belly, then swinging back terminates at its shoulder blades. The flexion of the legs and the poise of head and ears suggest a timid creature shut in an imaginary cage and on the brink of leaping out of it—much the same nervous tension, in fact, that we detected in the pink horse of Thanuny's tomb. As well as linear there are color contrasts; the flesh-tints have dulled, but they must have been originally bright red. The ibex, on the other hand, is colored a delicate brownish pink hardly distinguishable from the ground. Nevertheless three-dimensional form is suggested by the white band of its belly and the subtle gradation of tones on its back and haunches. Though it has fared badly with the years, this is one of the finest paintings of the xviiith Dynasty.

Its pendant, so to speak, is the Nubian dancer. Notable in this figure is an extreme simplicity of line and color; nevertheless the man's movements are admirably conveyed. The poise of his head, the rhythmic motion of the arms, the fluttering steps and swing of the body typical of Negro dancing are well observed and the same is true of such details as the tufts of hair on the man's shaven crown, the huge earring, the necklace of big beads, the leopards' tails hung from his elbows, the short white loincloth under a long transparent skirt. Here once again we cannot fail to be impressed by the Egyptian painter's gift of combining fidelity to visual facts with a discreet avoidance of any meretricious realism.

So similar is the technique in the tomb of Nebamun (No. 90) that the visitor is apt to confuse the two tombs, despite differences in the subjects treated. Though this painter left his imprint on every scene he painted, he was too great and original an artist to repeat himself. Nebamun's chapel is small, unfinished, and has been wantonly damaged in several places. Thus some of its, stylistically speaking, most typical elements are almost obliterated; for example the woman—shown for once in the way full face—who figured in a group of female musicians. Obviously this painter had a highly independent personality and was determined to break away from the beaten track of academic conventions.

The women in his "concert" scenes wear the long, pleated garments then in fashion (to which reference has already been made) and also have a sort of yellow shawl flung round their shoulders. This costume is sometimes seen in other tombs but its rendering here, in fluid, well-placed touches, is distinctive of this painter and demonstrates his exceptional sureness of hand and eye. Characteristic in fact of the Master of the Tomb of Nebamun is his predilection for synthetic form. On the wall left of the entrance the hand of a girl tendering a golden cup to her parents has escaped destruction; the pink fingers clasping its rounded surface are a miracle of purity and grace, a little poem in line and color bearing the authentic stamp of genius.

Let us now turn to the two scenes here reproduced. One depicts the grape-gathering. Under a vine-arbor upheld by elegant columns shaped like papyrus-stems with flower capitals, two men, one standing, the other kneeling, are picking the grapes and throwing them into baskets placed on the ground. Their gestures are pictographic; the figures, red-brown masses traversed by white loincloths; the heads, round balls with an open space reserved for the eye and a spike to suggest the nose; the hands clutching the grapes, like claws, the fingers being left undifferentiated; the bunches of grapes, blue ovals with red tails. Despite this extreme simplification, the general effect is strikingly vivacious. There are other interesting details in this sequence, such as scenes of wine-pressing, butchers at work, animals being branded with red-hot irons.

At the top of the wall are foreigners presenting the produce of their countries. We are shown, behind a white horse, a Cretan bringing gold; only a sketch but more expressive than the finished picture would have been. Perhaps indeed the artist never meant to "finish" it. For the figure is brilliantly convincing as it stands; a tuft of hair projecting on his forehead, a beard hanging from his chin—what more was needed to suggest this exotic tribute-bearer? Here we see one of the idiosyncrasies of the artist who decorated the tombs of Nebamun and Haremhab: his habit of depicting faces, bodies and hands in profile like shadows cast upon a wall.

We have already described him as an Impressionist *avant la lettre*; he suggests more than he represents, schematizes lines and forms, stylizes even his colors. While he obviously has a partiality for yellow, his favorite color-scheme is blue, white and red. We find it everywhere: in the birds of the fowling scene in Haremhab's tomb and likewise in Nebamun's, in the scene of the wine-pressing and that of the tribute-bearer, in which, preceding the Cretan, is an Asiatic leading a horse and, on the next register,

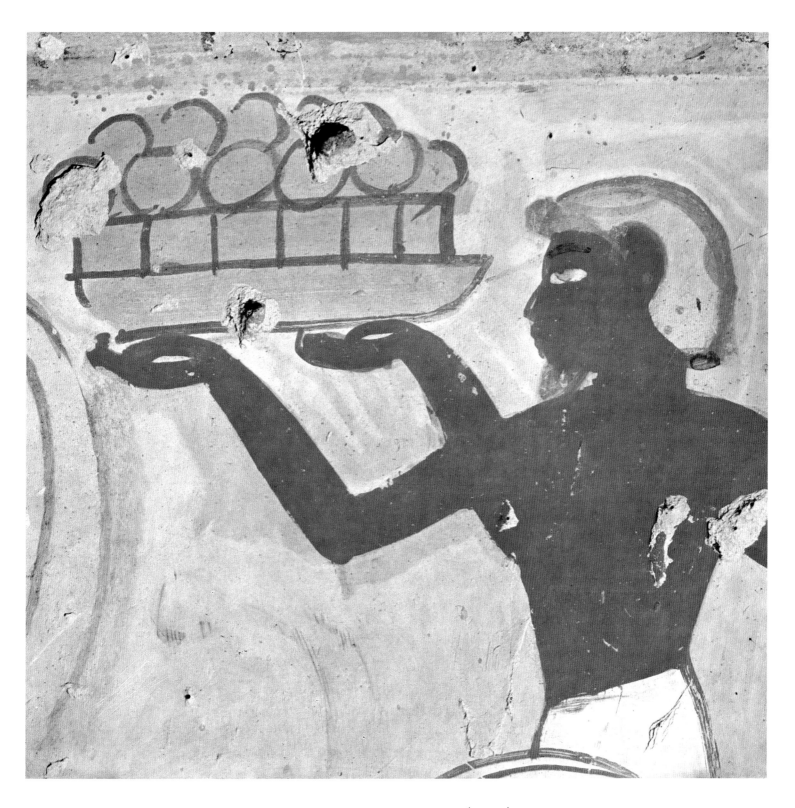

CRETAN TRIBUTARY. TOMB OF NEBAMUN (NO. 90), THEBES.

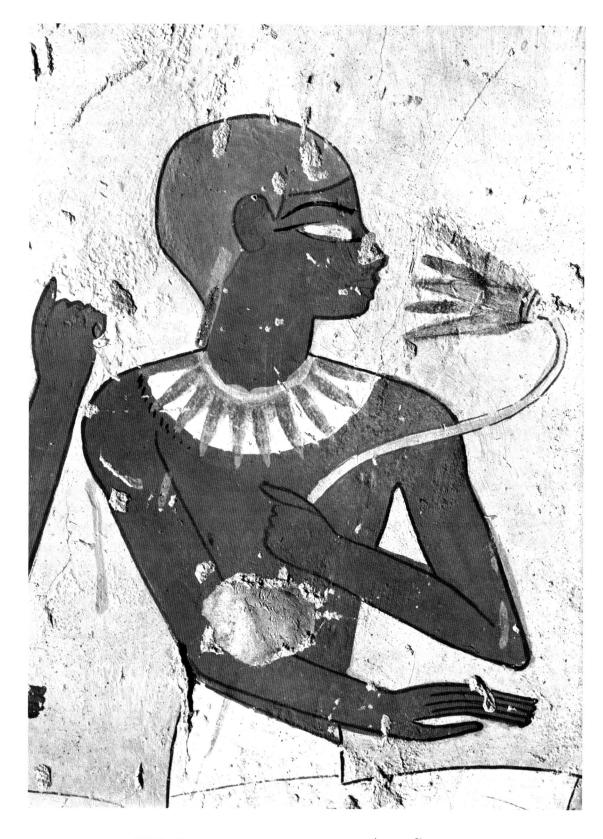

GUEST AT A BANQUET. TOMB OF NEBSENY (NO. 108), THEBES.

another Asiatic carrying a huge vase. Conspicuous in the work of all Egyptian artists is their masterly draftsmanship; but whereas with most of them line is paramount, clean-cut like that of the Japanese or the Gothic illuminators, this artist designed with a broad brush, never drew an outline unless it was needed to isolate a figure or a detail, and gave little thought to the "cleanness" or "finish" of his work, or to the regularity of his brushstrokes; he trusted, and rightly trusted, to the promptings of his inspiration. Thus he is the most original, least tradition-bound painter of the entire xviiith Dynasty—if proof be needed we have only to compare his work with that of his contemporaries.

The tomb of Nebseny (No. 108), which contains some charming paintings, brings us back to the more normal Theban style. It is a small single-chamber tomb, in poor condition and unfinished. Thus the scenes on the back wall were left in the rough; with a few summarily drawn silhouettes to indicate the positions of persons taking part in a funeral ceremony, and three or four horizontal guide-lines to fix their various heights. On two fully painted walls are scenes of offerings to the deceased, butchers, a banquet, musicians. Under the chair in which Nebseny's wife is seated is a monkey nibbling dates; its fur and outlines are now so faint as to be hardly visible. This fading has mitigated the harshness of the women's flesh-tints: yellow ochre stressed by black wigs with red and blue ornaments. So expressive are the plump, agile hands of the male harpist at the banquet that we almost fancy we can see them moving; his face has been scored out by some vandal. Behind him are the guests in two rows, the men seated, the ladies squatting on a mat. Though of the same period, the figures are quite different from those in the tombs of Nebamun and Haremhab. This painter is more concerned with design, and up to a point more academic, and his figures have a somewhat hieratic dignity, due to a lack of imagination and a failure to diversify their attitudes. None the less on close inspection we find a subtle distinction between his treatment of the men and the women; the former have an air of haughtiness, whereas the women's heads are slightly drooping. The profile and poise of one of the women guests are particularly effective, but we do not reproduce this figure as some incompetent restorer has spoilt the colors. She is turning to talk to the woman beside her, raising her hand as if to stroke her friend's shoulder. The tiny nose and mouth have the charm of early girlhood and the twist of her shoulders has caused the tunic to slip, revealing a young, tip-tilted breast which she exposes without the least false shame. The yellow dress, pink skin and blue headband on a pearl-grey ground form a delightful harmony of half-tints. More striking, however, is another woman's figure on the extreme left; with its tender colors, delicate line and graceful dignity, it is a fine example of Egyptian art under Tuthmosis IV. The male guests, with their red ochre flesh-tints, form a patch of warmer color. In the figure we illustrate, the confident draftsmanship in the design of the head, the ear, the black curve of the eyebrow and the preternaturally long fingers are typical of the Nebseny artist. The symbolic lotus the man is sniffing and his lotus collar provide the usual blue-green variations of the prevailing monochrome.

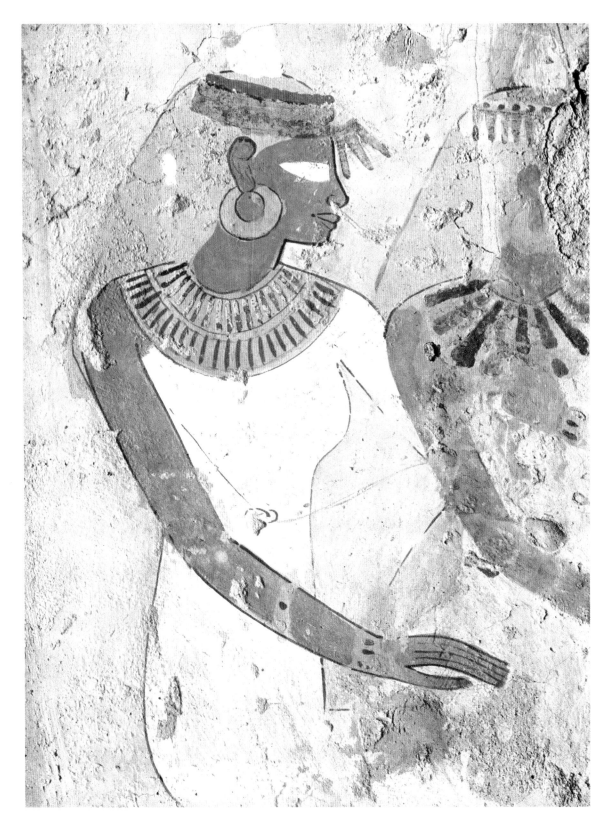

LADY AT A BANQUET. TOMB OF NEBSENY (NO. 108), THEBES.

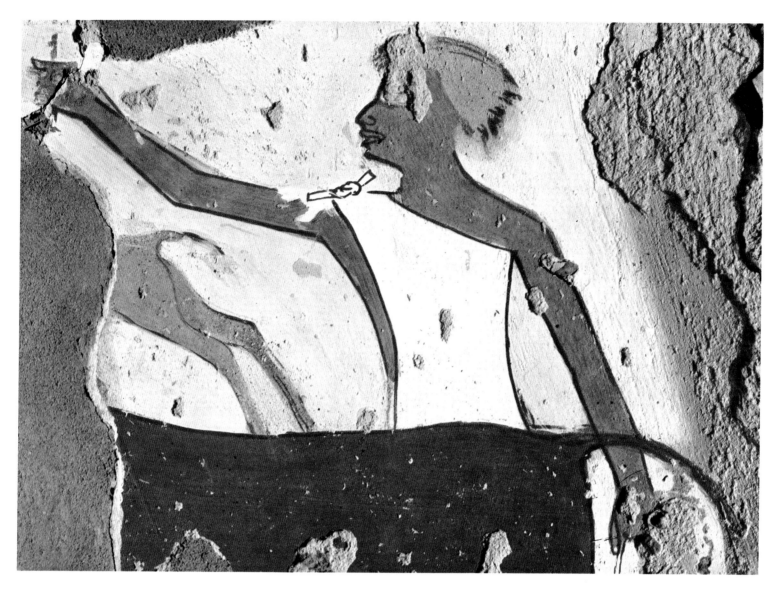

COWHERD. TOMB OF THENUNA (NO. 76), THEBES.

We conclude our account of the mid-xviiith Dynasty style with a picture from
the tomb (No. 76) of Thenuna, the king's fan-bearer. One wall depicts gold vases
presented to the Pharaoh; another, cattle. The herdsman at the top of this panel,
treated in the impressionist style of the scenes in Haremhab's and Nebamun's tombs,
foreshadows that taste for picturesque effect which became general under the xixth
Dynasty. Unfortunately most of the animals are sadly mutilated; but we have a charming
glimpse of a blue calf capering away, with a red bull in the foreground. The herdsman
—brown ochre with red outlines—has angular features, straggling hair and a white
tunic looped and knotted on his right shoulder; he is carrying a small basket in his
left hand, while with his right he brandishes a stick. Despite the destruction of his eye,
this fragment gives a good idea of the rather slapdash liveliness of the scene as a whole.

THE TREND TOWARDS ACADEMICISM
IN IMPERIAL EGYPT

A new era, rich in achievement, opened with the reign of Amenophis III (1411-1375 B.C.). A period of stability within the Empire, it also witnessed the codification of all previous rules of art in a precise, well-ordered canon. Beauty now took orders from the thinking mind, the result being a calculated equipoise of proportions, volumes, lines and colors. Thus the last traces of lyrical effusion now gave place to scientific rationalism and craftsmanship took the lead of inspiration. In the life of any form of art these are signs of maturity, and the works produced under Amenophis III in the fields of architecture, sculpture and painting may, like those of the IVth and Vth Dynasties, be properly described as classical.

FUNERAL PROCESSION. TOMB OF RAMOSE (NO. 55), THEBES.

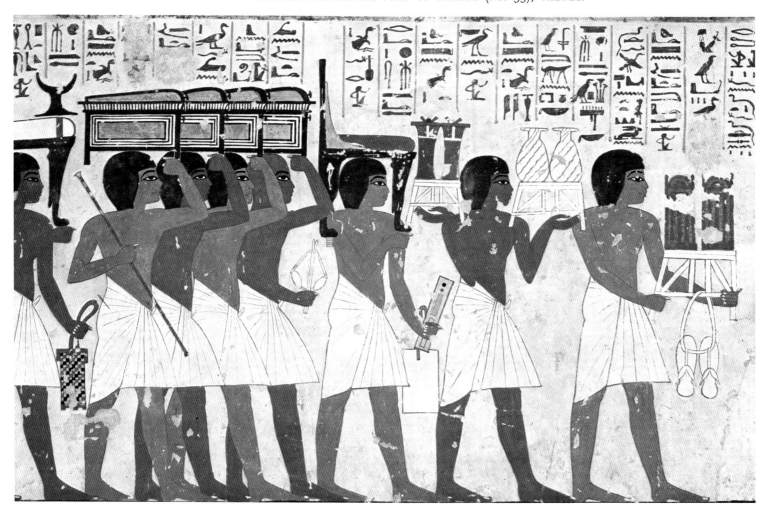

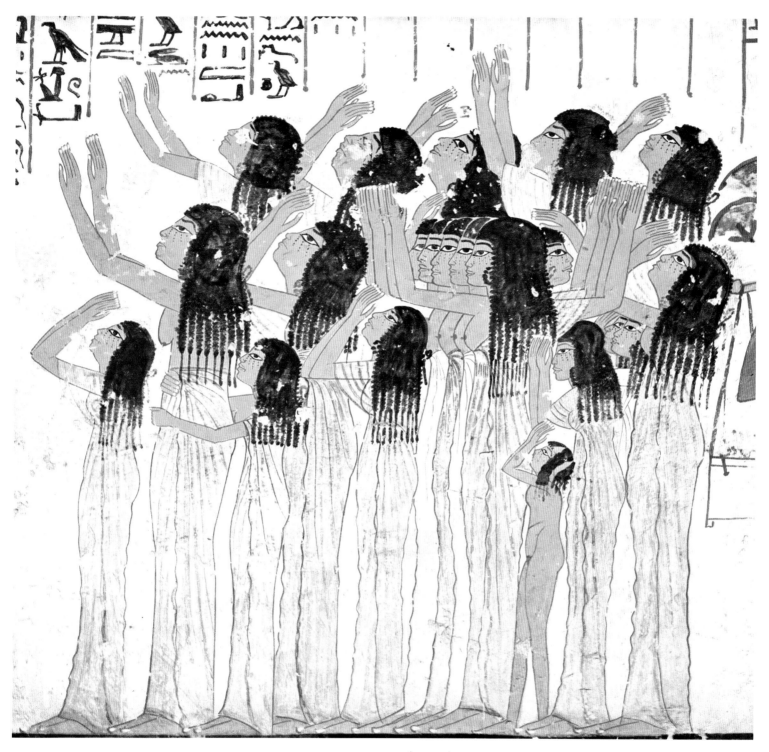

FEMALE MOURNERS. TOMB OF RAMOSE (NO. 55), THEBES.

Before, however, this classicism had had time to settle down into an academic system, that ruthless romantic, King Akhenaten (1375-1358 B.C.) abruptly intervened. Son of King Amenophis III and a very beautiful Asiatic lady, quixotic champion of

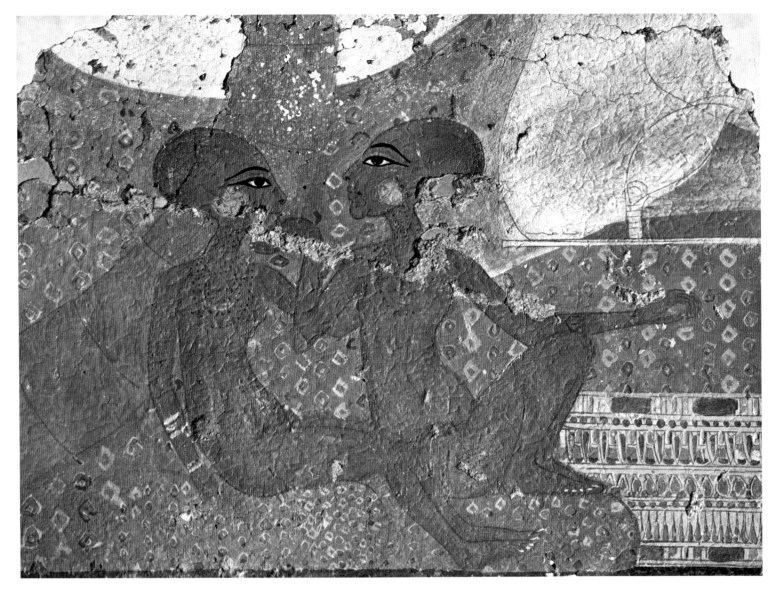

THE DAUGHTERS OF AKHENATEN. PAINTING FROM EL-AMARNA.
ASHMOLEAN MUSEUM, OXFORD.

a new faith and a new order, this Pharaoh launched a novel but short-lived art, anti-traditionalist through and through. But though frankly revolutionary to begin with, the so-called Amarna style gradually developed conventions of its own and by the time of Tutankhamen (1358-1350 B.C.) had degenerated into a mannerism that, while elegantly sophisticated, sometimes inclined to mawkishness.

A reaction against these unpropitious tendencies set in at the end of the XVIIIth and the beginning of the XIXth Dynasty, but in their efforts to return to the classicism of the great age of Amenophis III, the painters of this period cultivated a purely academic refinement that little by little prepared the way for the Ramesside style, inheritor of the advances made during the two centuries we have been considering.

After this brief survey of the historical background, we may now turn to specific works of art, beginning with a picture in the tomb of Ramose (No. 55), vizier and governor of Thebes under Amenophis III and Amenophis IV. This tomb is famed above all for its reliefs, most exquisite of all Egyptian works in this field, technical virtuosity in the modeling being combined with perfect balance in the proportions of the figures. Indeed, no art could go farther in this direction without lapsing into pedantry. It must be remembered that the moving spirit at the time, a man who did as much to promote the grandeur of the kingdom as the Pharaoh himself, was Amenhotep the Sage, also known as "the son of the Nile" (Hapu), either because Hapu was really his father's name or with the object of deifying him in his lifetime by affiliating him to the river to which Egypt owes her being. Minister and architect to Amenophis III, he supervised the building of the temple of Amun at Luxor and his royal master's mortuary temple, of which only the two so-called Colossi of Memnon have survived, and probably the vast "domain of pleasure" in the desert with its palaces and lake. Finally he built for himself a temple in which it is recorded that at the king's jubilee he was seated on a golden throne facing the Pharaoh. It is not surprising that a culture which ranked its wise men equal to the gods should have sponsored works of art immortal of their kind. The tomb of Ramose is of particular interest because it illustrates the transition from the classical art of the xviiith Dynasty to that of the "heretical" monarch Amenophis IV. One wall, which is unfinished, or was purposely left uncarved and merely painted, depicts the funeral procession, and it is at the foot of this wall that the passage leading to the sepulchral chamber starts. We reproduce a fragment of the funeral procession, showing the furniture-bearers accompanying the catafalque (figuring in the upper register). Painted alternately in red ochre and brown, these men give the impression not of a medley but of ordered diversity, each being treated as an independent, self-sufficient unit. The variety of shapes and colors in the objects they carry lends animation to the scene, but this is kept within due bounds; vases, sandals, boxes, a chair, scribes' tablets are depicted precisely but without excessive minuteness. Whereas the three front figures are spaced out, those behind are bunched together, so as to form a mass, and the parallelism of their movements creates a rhythmic unity. A curious point is that only in the case of the first and fourth furniture-bearers are both arms shown, those between them having only one arm each, the other arm being supposedly hidden by his neighbor. The sandals that the fourth man is carrying pressed sole to sole serve to bridge the gap between him and the man in front, and no less adroit is the placing of the slanting staff. Obviously this artist gave careful thought to his composition. The wide spacing of the men who head the procession is likewise deliberate; on the right was the serried group of female mourners greeting its arrival, and some air was needed between the two compact groups.

More than all the other scenes in this tomb, that of the female mourners illustrates the classical trend of the art of the period. At first sight we may get the impression of figures in disordered movement; on closer inspection we see that each pose, each gesture is carefully calculated. The arrangement of the heads in three tiers and the line

of profiles in the center create the feeling of a dense throng, while in the contrasting movements of the outstretched arms, flung back or raised skywards, we have an eloquent expression of uncontrollable grief. Yet the faces themselves, except for the tears trickling down the cheeks, are curiously impassive. Unlike the arms, bodies are static, uniformly parallel, though the artist has broken the monotony of the long flowing garments by adding a small nude figure. Upon the white ground are only three colors: black for the wigs (whose massiveness is relieved by pendent tresses), a delicate yellow for the women's skin, pale blue for their garments. They form a compact, architecturally ordered mass, within which a curiously swirling rhythm is imparted to the somewhat hieratic graphism. It will be noticed moreover that there is a marked difference of style between the figures in the tomb of Ramose and those of the mid-XVIIIth Dynasty; they are at once less elongated and more austere.

BATTLE SCENE: TUTANKHAMEN FIGHTING THE SYRIANS. DECORATED COFFER. CAIRO MUSEUM.

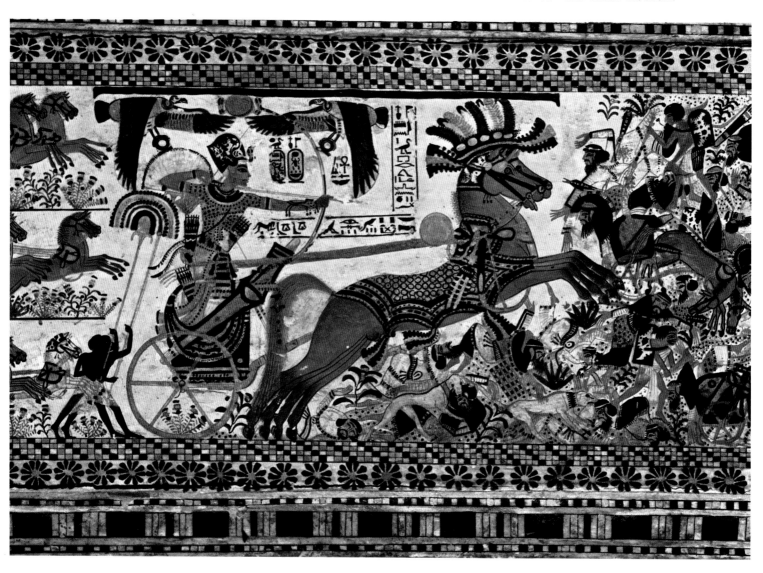

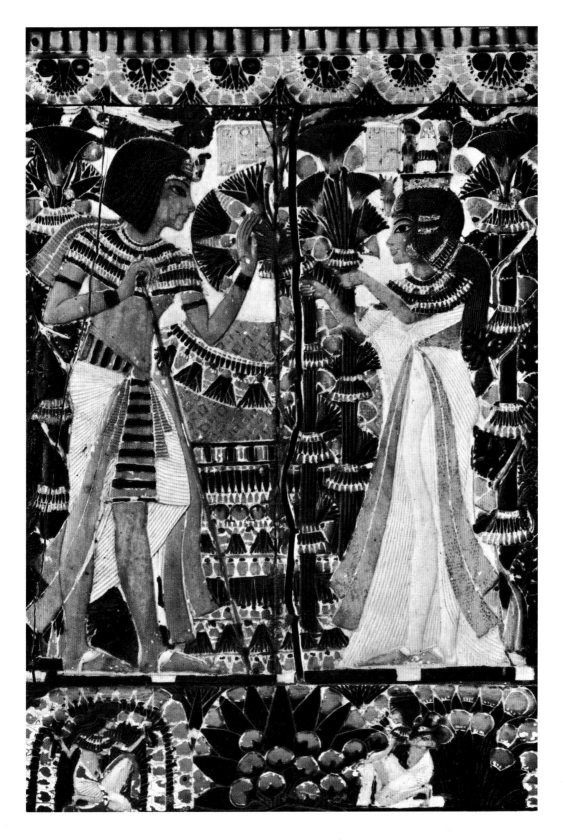

LID OF AN IVORY BOX FROM TUTANKHAMEN'S TOMB. CAIRO MUSEUM.

One can hardly believe that this same generation of artists created the Amenophis IV-Akhenaten style. A fragment excavated at El-Amarna, capital of the heretical Pharaoh, and now in the Ashmolean Museum, Oxford, shows Akhenaten's two young daughters seated on embroidered cushions at their parents' feet. The elder girl is turning to her little sister to stroke her chin. The general effect is altogether charming despite the curious proportions of the nude bodies, with their over-slender lower legs, inflated thighs, elongated skulls, receding foreheads and immense eyes. One feels that they are so to speak hothouse plants, children who have been kept far too much indoors. Some have thought to see here the cranial malformation found in certain primitive races or else a deliberate uglification, for mystical reasons, so as to stress the contrast between human and divine beauty. More probably, however, the eccentricities we find in portraits of the king, his pretty wife Nefertiti and their children are simply mannerisms of the Amarna style, for they became so generalized that even the members of the royal court were portrayed in a similar way. In the tomb of Ramose are portraits of the vizier himself made before and after the Amarna revolution. His pleasant, gracefully molded features become in the later version gaunt and angular; after being an upstanding, dignified figure, dowered seemingly with eternal youth, he has abruptly turned into an almost doddering old man, humbly sniffing the ground in front of the king's balcony. The artist's all but exclusive use of red ochre in the picture of the royal children heightens the baroque effect of this sole surviving fragment of what was originally a family group. For touches of other colors are few and far between: black for the arched eyebrows, almond eyes and the hair plastered down on the ovoid skulls; white in the pointed nails; blue in the design of the rugs and cushions. In short we have here an intriguing blend of naturalism and a somewhat mannered lusciousness. In the ruins of the palace of El-Amarna other paintings, on walls or pavements have been discovered. At once naturalistic and decorative, they depict birds and animals in papyrus thickets; unfortunately all are badly damaged.

Ephemeral though they were, the revolutionary innovations of Amarna art left their mark, and their repercussions extended to the Ramesside period.

Tutankhamen's short reign witnessed the first mild stirrings of a reactionary movement. Son-in-law and perhaps illegitimate son of Amenophis IV, the young invalid king returned to the former capital, where Amun and his priests still retained their power. Thus there was a reversion to the Theban style, without, however, any slavish imitation of the art preceding the Amarna interlude. On the contrary, one sees attempts to reconcile the classical canon with the more moderate aspects of the Amarna innovations. The works of art found in the famous Tomb of Tutankhamen, the only royal tomb that by some happy chance escaped the attentions of marauders, illustrate this attempted synthesis. The only mural paintings in this tomb were those on the four walls of the sepulchral chamber, big figures on a yellow ground, obviously hastily brushed in. They depict the funeral procession, the rite of "the opening of the mouth," the Goddess of the Sky welcoming the Pharaoh and the adoration of "the Ship of the Sun."

NEGRO TRIBUTARIES. TOMB OF HUY (NO. 40), THEBES.

Our colorplate shows a detail of the painted coffer now in the Cairo Museum. On the convex lid and the four sides are scenes of hunting and warfare. The wood was given a thin coat of gesso which, despite all precautions and periodical restorations, tends to flake away. Marvelous examples of naturalistic animal-painting and ranking among the supreme masterpieces of oriental art are two yellow lions: a male roaring with pain and fury and a dying lioness. The chariot we reproduce figures in a battle-scene: a subject banned in the days of the pacifist king Akhenaten, but in high favor under the new régime—though that poor consumptive Tutankhamen had hardly strength enough to drag himself about the palace gardens. Against the ivory-yellow ground the pair of huge red horses with their decorative plumes and streamers, black and yellow caparisons, are trampling down the defeated Syrians. Chaotic as is the scene, the foreign faces are treated with a miniature-like precision and no less striking is the realism of their expressions of pain or terror. The ornamental frames—rosettes,

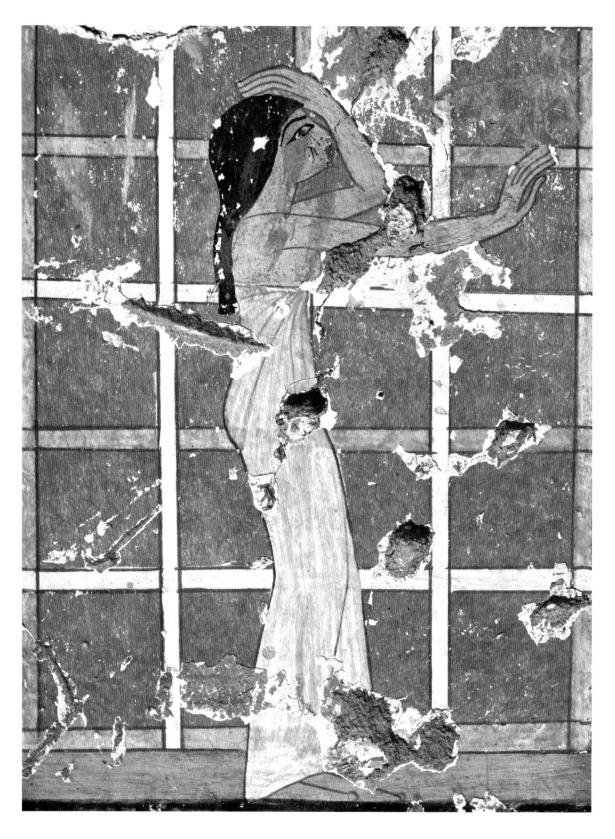

MOURNER AND CATAFALQUE. TOMB OF NEBAMUN AND IPUKY (NO. 181), THEBES.

diapers, multicolored bands—have a rich decorative effect, and so have the symbolic elements above the picture: the firmament, the sun and sacred vultures. The Pharaoh is majestic power incarnate; alone in the body of the chariot he at once guides the horse by reins strapped round his waist and brandishes the bow with which he is wreaking havoc on the foe. Bundles of arrows hang from his belt, a quiver is fastened to the chariot. The painter makes us feel the lightness of this vehicle, which the Asiatics themselves had, to their cost, introduced into Egypt. Behind the warrior king are two Negro fan-bearers, then squadrons of Egyptian cavalry charging across a landscape of quaintly stylized bushes. The ardor of the fray is well conveyed by the galloping horses, a massive diagonal slashing through the tangled mass of combatants, and also by the exceptional warmth of the scheme of colors in which reds and yellows, set off by black, predominate.

On the lid of the famous decorated box from Tutankhamen's tomb we find the same harmony of black and red, but here picked out with gold and on an ivory ground. The atmosphere of this little scene, which takes place in a garden, is more suited to the extreme youth of the boy king and his attractive wife. There is a lower scene showing the queen picking the flowers, which in the upper one she offers, made up in huge bouquets, to her husband, who leans forward on his staff to take them. All around are lotuses and papyrus plants. This artist abhorred empty spaces; nevertheless the two figures stand out so naturally that one hardly notices the overcrowding of the setting. The gracefully balanced gestures show a return to classical reticence and have not the almost embarrassing naturalism of the steles on similar subjects that Akhenaten presented to his courtiers. The relative fragility of the ivory ground contributed to the effect this artist aimed at, greater delicacy in the modeling being called for than if the support had been of stone or wood. Hence the prevalence of soft curves, adapted to the languid grace of the two young peoples' attitudes, the somewhat mannered elegance of their smiles. The queen is perhaps one of the two small girls in the Oxford family group, but she has grown up, matured—like the "new art" inaugurated by her father—and her head has now a normal shape, she has lost her look of childish innocence. But her figure has the same voluptuous softness—symbolic, perhaps, of the *far niente* of the oriental lady of high estate. Without regaining the austere balance of the great periods, the art of Tutankhamen's day had rid itself of many of the eccentricities and audacities of the previous reign.

The only tomb contemporary with Tutankhamen's is that of Huy (No. 40), viceroy HUY of Nubia. Almost all the pictures relate to the activities of this high official; we are shown the Pharaoh delegating the government of the South to Huy, and the latter organizing the administration of these distant lands and supervising the dispatch of treasure to his royal master. There are scenes of boats and Negroes bringing gold, rare and precious objects and exotic animals to Thebes. One of the most typical amongst the less damaged scenes is that of a band of Negroes carrying gold, followed by a giraffe dappled with patches of brown and red. The men's white garments, pleated in the Egyptian manner, stand out against a pale grey ground and racial peculiarities are

cleverly portrayed: thick lips, flat noses, cropped hair topped with a plume. But the execution was obviously hasty and the loam-and-straw foundation has been much damaged. Noticeable in this tomb is the disproportion between the men's short bodies and their big heads. Still odder is the way in which the giraffe has been reduced in height so as to fit into the panel. On the other hand the linework is remarkably accurate and paucity of color is more than compensated for by the originality of the figure-drawing, the liveliness of some anecdotal details and the artist's persistent endeavors to break away from the art of Amenophis IV. Nevertheless Huy served under both reigns and there are definite reminiscences of the Amarna style in the picture of his investiture, in which several Egyptians, differentiated by the alternation of brown and yellow, are shown bowing to the Pharaoh.

CALF. TOMB OF NEBAMUN AND IPUKY (NO. 181), THEBES.

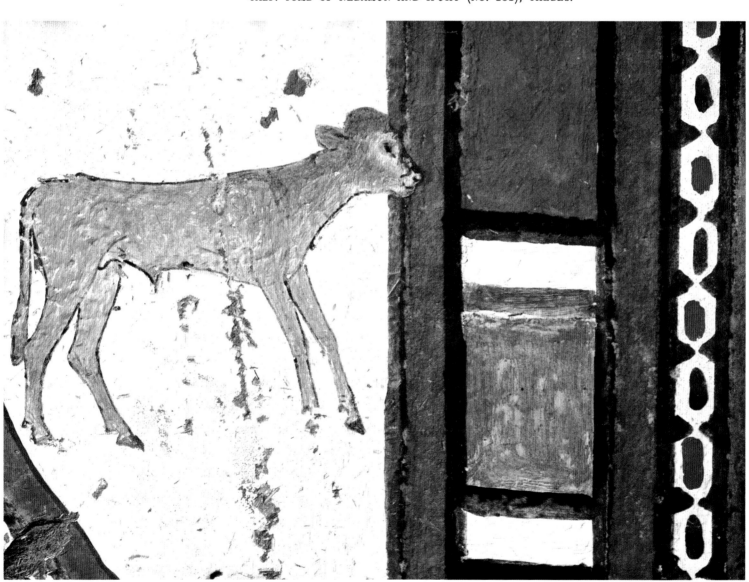

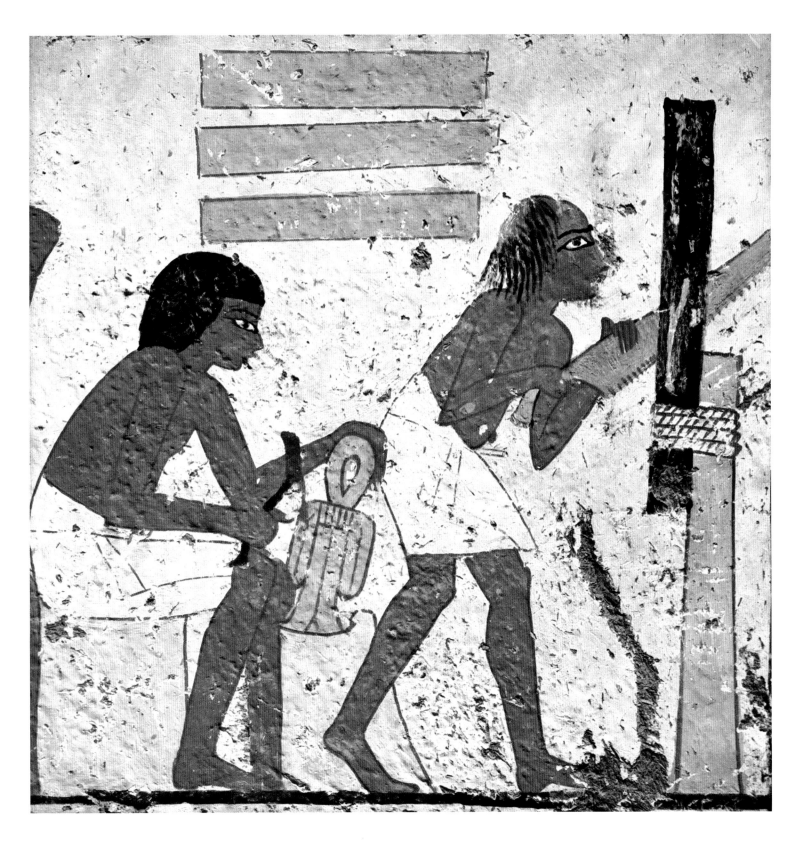

CARPENTERS AT WORK. TOMB OF NEBAMUN AND IPUKY (NO. 181), THEBES.

The reactionary movement sponsored by the champions of traditional Theban art did not take full effect until the end of the XVIIIth Dynasty and the beginning of the XIXth, that is to say during the second half of the 14th century B.C., from the reign of Haremhab to that of Sethos I. One of the most revealing tombs is that of two sculptors, Nebamun and Ipuky (No. 181); it has the interest of all transitional works, at once summing up past achievement and pointing to the future. Some of the figures have an academic quality in which the technical accomplishment of the Theban artists, fruit of a century's experience, makes itself felt; whereas others have the vivacity which was to be the speciality of the Ramesside painters. In all the scenes that have escaped the odious attentions of iconoclasts we can feel a delightful freshness of inspiration, the presence of a highly imaginative mind. The walls were surfaced with clay to which a coat of white was applied to serve as a foundation, the result being an exceptional luminosity, which is enhanced by the happy circumstance that in many places the colors have kept their pristine brightness. Owing to exigencies of space we confine ourselves to a summary description of the scenes. In the first chamber, left of the entrance, are three panels depicting a banquet, the pilgrimage to Abydos, the funeral procession, the ceremonies outside the tomb; on the right are scenes of craftsmen at work, and on the back wall we are shown the dead man worshipping the gods of the Other World. The second chamber, starting-point of the shaft leading to the underground sepulchral chamber, is unfinished, there are only the beginnings of what was to be a scene of musicians and dancers.

A curious detail of the funeral procession is that in front of the cows drawing the sledge on which is placed the catafalque a calf is scampering about at liberty. The small animal—in shaded grey with black outlines and a patch of red below the tail—is at once boldly rendered and wholly lifelike. And, what is quite exceptional, its head overlaps the decorative band—in stripes of red, yellow, blue and green, with intervening tracts of white— that frames the pictures on this wall. One has an impression that the calf is wondering if he should try to jump the obstacle which has loomed up in front of him; his front legs are in the act of rising, while his back legs are stationary. This playful little calf adds a touch of humor to the otherwise lugubrious scene of the catafalque on its sledge escorted by shrilly lamenting mourners. One of the women, dressed in grey, keeps close to the sarcophagus; perhaps, as inscriptions seem to indicate, she is the dead man's daughter. Beating her head with her left hand, she stretches her right arm towards the priests as if to beg them halt their progress to the grave, the end of all. The fine restraint of her gesture is reminiscent of the great period of New Kingdom painting; whereas the execution, color-scheme and rough-and-ready preparation of the wall foreshadow the Ramesside epoch.

These tendencies are even more apparent in the scenes of artisans at work: goldsmiths, cabinet-makers, gold-weighers and ceramists. Most energetic of all is the old carpenter sawing an ebony log tied to a pillar. Someone has deliberately destroyed his nose, but the scanty, bristling hair, shaggy brows, gaping mouth and bearded chin produce the impression of a rather stupid type of man, the sort who is given rough

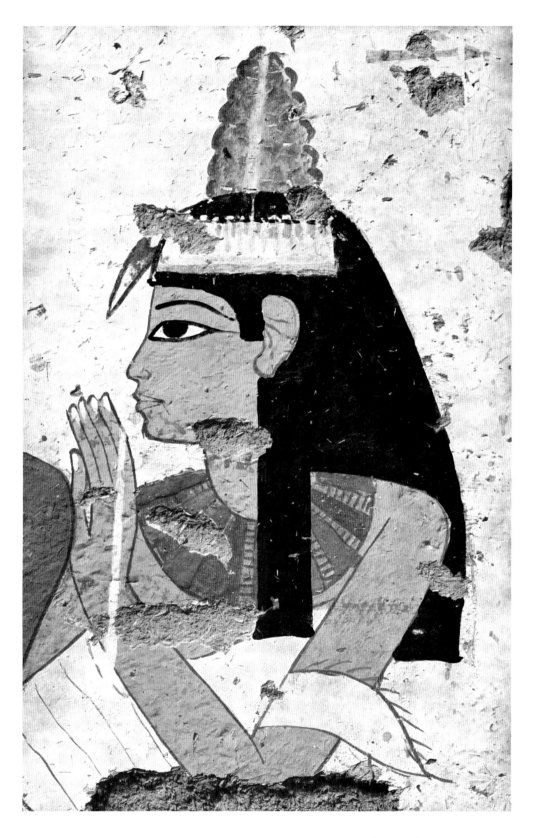

PORTRAIT OF A LADY. TOMB OF NEBAMUN AND IPUKY (NO. 181), THEBES.

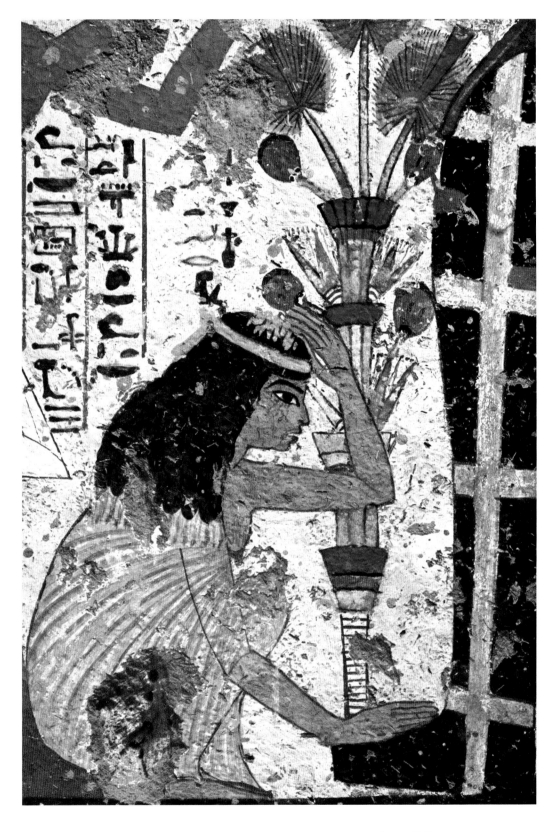

WIDOW IN MOURNING. TOMB OF NEBAMUN AND IPUKY (NO. 181), THEBES.

128

jobs that call for no great skill. The man beside him is engaged on a task requiring deftness of hand; he is making an ornament, symbolic and decorative at once, for a shrine in gilded wood. Here we see that propensity for genre scenes which developed more and more in xixth Dynasty art. However, details such as these, with their tempered realism and their verve, have an interest that is not merely anecdotal.

Quite different are the portraits of deceased married couples and effigies of gods; these have an almost academic gravity. The portrait of a lady with a cone of scented unguent on her hair might be ascribed to a much earlier period but for certain peculiarities showing it is a xixth Dynasty work: precise realism and clearly indicated tonal values in the cone of scent; the lady's dress, too, with its flounces and a fringed corner of it drawn over her arm is in the new fashion. But most "modern" of all is the drawing of the profile—the pointed little nose and cleancut lips (with a tiny extra line added to suggest the presence of a dimple); it is as crisp, incisive as the stone-cut line in the reliefs. Even the gaze has not the melting softness we observed in the portrait of a lady in Menna's tomb. In fact a comparison of these two portraits, made a hundred years apart, is enlightening. The earlier is vibrant with life because it is a reflection of the personality of its maker; he has put his soul into it. The later painter, in deference to canons of the past, renounces self-expression, and the portrait is conventional, even a little archaistic—not only because of the hard outlines, the stylization of the wig and collar, the yellow flesh-tints. Technically, no doubt, it is flawless; emotionally it leaves us cold.

Indeed the artist himself must have been conscious of the chilling effect of the very perfection of his line; for when he is no longer dealing with official portraits and expected to parade his skill, he becomes quite human and aims at expression more than at virtuosity. In one of the more lyrically rendered scenes on the wall devoted to the funeral ceremony we see the man's anthropoid coffin, standing at the entrance of the tomb, being sprinkled with lustral water. This is the moment when a priest will lift it and carry it away to its last resting-place. The widow is crouching at the foot of the sarcophagus. Haggard with weeping, her face convulsed with grief, a breast bared in token of bereavement, she is pouring dust on her hair. She has laid her other hand on the foot of the coffin, as if imploring the priest to let her keep in touch a little longer with the loved one whom the gods have thought fit to take from her. Here the artist has felt freer, permits himself to be of his own time and gives play to his obvious fondness for realistic touches. And how far removed from classical sobriety is his rendering of the woman's anguished face and sunburnt skin, the grey dress pleated but transparent through which shows the pinkness of an arm, the flaccid breast and the disordered hair straggling across her shoulder!

The same is true of the whole group of female mourners on the funerary boat. When we compare them with the dignified women figuring in Ramose's tomb we can see how much ground has been covered within two or three generations. Here we have a frantic throng of paid mourners, of wrinkled harridans hired to impress and startle the populace with their screams of feigned distress—for in the East rich folk can never

die in peace! The composition here is striking; so too would be the color, were it not that this part of the scene, placed too near the ground, is coated with the dust of ages. Moreover, readers will note in our reproductions of scenes from the tomb of Nebamun and Ipuky how fragile is the painted surface and in how many places the clay foundation shows through. Indeed a mere breath often suffices to dislodge the brittle layer of color. The placidity of the men seated on the cabin containing the mummy makes an effective contrast with the hysterical gesturings of the women, though it should be noted that the latter, too, are grouped so as to form a smoothly flowing curve leading the eye towards the prow of the boat. Well conceived, too, is the open space between them and the man holding a rope, and, just beyond, the papyrus flower fixed to the boat's stem, a patch of green offsetting the pink mass of the flesh-tints. The slight blurring of the colors adds to the charm of this detail, last of our illustrations of that transitional phase between the XVIIIth and XIXth Dynasties which ushered in the new art of the Ramesside epoch.

FUNERARY BOAT, DETAIL. TOMB OF NEBAMUN AND IPUKY (NO. 181), THEBES.

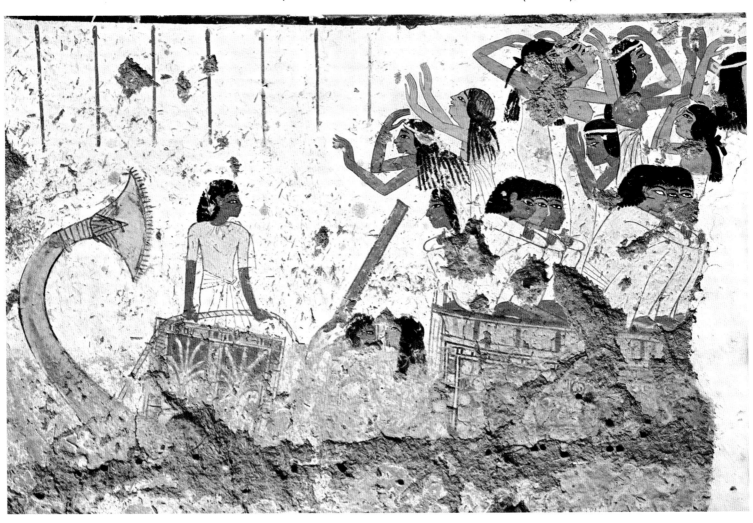

THE RAMESSIDE PERIOD:
CULT OF THE PICTURESQUE

So much of our space has been devoted to the xviiith Dynasty alone that it may seem inequitable to condense the two centuries of Ramesside art into a single chapter. Our reason is not that this was artistically an unproductive period; but the fact cannot be blinked that during the decline of the New Kingdom the Egyptian painters fell in line with the increasingly bourgeois spirit of the age. Commerce and successful warfare had made Egypt inordinately wealthy, her great men lived in conditions of the utmost luxury and their tombs, too, now acquired a "new rich" air. Not only were they huge, but they often contained gigantic statues of the dead man, carved in the rock face, while reliefs, pictures and texts so prolix as to discourage even the most indefatigable transcriber covered hundreds of square yards upon the inner walls. Dealing with hackneyed subjects, endlessly repetitive, these pictures quickly weary the beholder. For Egypt had lost all sense of measure and her art was entering on a phase of decadence. Nevertheless, in the enormous output of this period, some few works stand out of the ruck, and prove that, even in an age of drab conventionalism, some great artists gave expression to their personalities. We see this not so much in the decorations of the big hypogea—obviously the work of teams of craftsmen—as in the small chapels where individual painters ventured to indulge in fantasy. The term is not too strong; we have already seen that, though Egyptian art aspired to be impersonal, there were always artists who gave rein to their imagination. And I have little doubt that if archaeologists were to study the Ramesside period more thoroughly, they would discover many genuinely original works of the highest merit.

While alive to the perils of over-simplification in such matters, we may say that the main differences between the paintings of the xixth and xxth Dynasties (13th and 12th centuries B.C.) and those of the xviiith Dynasty (15th and 14th centuries B.C.) —periods of approximately the same duration—were as follows. During the later period the use of a thin coat of stucco as a ground for the pictures was superseded by that of a puddled clay foundation, which was of a reddish hue in certain tombs. The painting did not take well on this rough surface, with the result that many pictures have disappeared, the wafer-thin coat of watercolor paint having been largely absorbed by the dry clay and all traces of it having crumbled away. When plaster was added, this was with a view to cutting out the picture in relief before painting it, plaster being easier to incise than the limestone wall. In short the line of least resistance; and this was the besetting sin of the Ramesside artists, a tendency to scamp their work. True, this made for spontaneity as regards the drawing, but once he was satisfied with his outlines the painter took little trouble over the colors and either simplified them to the point of stylization or else indulged in an orgy of garish hues. Strident colors —red, blue, vivid green on a yellow ground—are frequent in the tombs of the rich

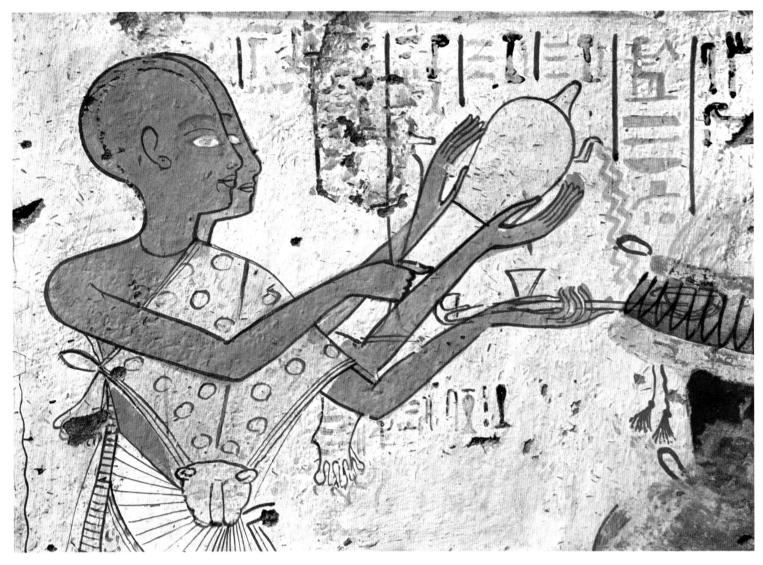

PRIESTS OFFICIATING AT A FUNERAL. TOMB OF USERHET (NO. 51), THEBES.

middle class, and though undoubtedly impressive, the big figures lack the grave nobility of xviiith Dynasty portraits. When visiting the Theban tombs in their chronological order one has an impression of moving from a world of robust country squires into one of class-conscious aristocrats. The "low life" scenes, on the other hand, are agreeably vivacious; the artists obviously put their heart into them. However in their eagerness to achieve variety and picturesqueness at all costs they tended towards a certain cheapness of effect, unlike the masters of the previous century who even in richly comic details always eschewed vulgarity. We realize why this was so when we see the minor place accorded to the genre scenes in some Ramesside tombs. Being restricted more and more to the depiction of religious and funerary themes—mythological and cosmological allegories, ceremonial rites or enlarged miniatures from the sacred texts—these artists gradually lost their painterly sensibility by dint of concentrating on symbolic

imagery. So impersonal was the choice of themes that even when the artist Amenwahsu painted his tomb (No. 111) with his own hand (we have his word for it) his work was quite insipid. The scenes of poor folks' daily toil and those of sport—hunting, fowling, fishing—treated with such gusto in the previous period are all too often replaced by endless processions of gods and spirits, or relatives and friends of the deceased, as well as innumerable altars, offering-tables and the like. Naturally enough these Ramesside painters were sometimes moved to liven up the sumptuously decorated walls of their rich patrons with humorous touches. But we find these chiefly in smaller tombs.

These remarks do not altogether hold good for the beginning of the xixth Dynasty —the reign of Sethos I and the early years of that of Ramesses II (around 1300 B.C.)— when the artistic conceptions of the last phase of xviiith Dynasty art still were operative, the result being a blend of academic refinement and "modernism." Two famous tombs of the period act as a connecting link between the art of the tomb of Nebamun and Ipuky and the new "picturesque" style.

Both were priests' tombs and naturally religious themes predominate. The first is that of Amenmose (No. 19); unfortunately its walls and fissured roof seem likely to collapse at any moment. The scenes were painted on a thin coat of stucco applied directly to the rock-face and its azure-blue hue recalls the procedures in favor at the beginning of the New Kingdom. In the figures that have survived are reminiscences, notably as regards the shape of the heads and the careful execution, of the exquisite reliefs in the temples of Sethos I at Thebes and Abydos.

The other tomb, that of Userhet (No. 51), is more Ramesside, and the walls are USERHET of whitewashed clay. The priests officiating at the funeral have shaven, elongated heads somewhat in the Amarna manner; but here foreheads are high, forming a straight line with the nose. Their arms are slender, their fingers tapered and there is something effeminate in their gestures as they pour lustral water and burn incense before the flower-wreathed offerings made to the dead. Though careless in places, the drawing is remarkably self-confident. The hand holding the censer from which greyish-pink flames are issuing and the vase showing up across a priest's arm are more expressive than if they had been meticulously retouched. Particularly graceful is the arabesque formed by the curves of the front man's neck, shoulders, stylized hands and the panther-skin tied round his chest; indeed this artist's constant quest of fluent line almost amounts to a mannerism. The simplified design of profiles, ears and noses, gives the picture a fine spareness at which the painter certainly aimed, as is confirmed by his almost uniform use of the same color, a brownish red more or less diluted. There is however a new, essentially Ramesside touch: an indication of the eyelid.

Kneeling at the feet of the priests (this scene recurs on several registers) are the female mourners, grouped in a triangle that balances the pyramid of richly colored offerings. Notable is the pictographic treatment of these figures, all in stylized lines, a counterpoint of gestures timed to the rhythm of their lamentations. A slight pouting of the lower lip, an occasional tear, betoken their grief. One woman is flinging herself

forward, another throwing up her arms and beating her forehead, the third clasping her head in a frenzy of despair, and all these movements are conveyed with an eloquent simplicity, a minimum of lines and colors. The white dresses, brown skin and black hair—funereal hues—contrast with the gaudy colors of the garlands, in which attempts at shading can be seen in the red and blue.

Elsewhere, using the same color-scheme, the painter has composed what well might be a tapestry cartoon, the subject being a sycamore tree covering the whole wall with its blue branches, green leafage shading off into rust-red, and pink fruit at which grey sparrows are pecking. There are no empty spaces. Seated in the shade of the sacred tree, the dead man, his wife and mother are holding richly decorated cups and the sycamore goddess, rising from a small pool, is pouring water into them. (The faces of the two women have undergone some mutilation at a recent date.) At another T-shaped pool souls in the form of birds with human heads are drinking. In this delightfully poetic scene we have a vision of the Garden of Paradise, as glimpsed through Egyptian eyes. It may be compared with another version of the same theme treated sketchwise in the royal tomb of Tuthmosis III, reproduced above. This artist's virtuosity is evident in the exquisite brushwork, and no less striking is his fine attention to detail. Surely a Flemish Primitive would not have disowned the precision of the clean-cut profiles of these two Egyptian ladies, the fringes, bandeaux and gaily colored necklaces, the tassels of the cords around their hair, the bangles and vases in precious metals, the subtle tracery of folds in the transparent dresses, the slim fingers and even the inscription of the ladies' names on their forearms. Every touch is meaningful: the speck of shadow on the chin; the black dot of a dimple beside the mouth; the different hues of the faces, the further one being paler; rounded cheeks suggested by the same tonal variations of the pink as those in the sycamore fruit of the background; the thin line of the upper eyelid and the nose-wing (of the second face), which a slip of the brush has placed in the black patch of the nostril. An almost pedantic concern for linear perfection, perhaps—yet there is nothing finicking in the richly decorative color orchestration, the dignified gestures, the way the black mass of the wigs tells out against the yellow wall where an eye-filling profusion of green, pink, red and blue is counterbalanced by the restful, delicately shaded white of the flowing dresses, made of the fine linen favored by the Egyptians. Here, in fact, we have a vision of the legendary splendors of the "silken East."

The appetite for somewhat ostentatious opulence characteristic of XIXth Dynasty art made itself felt in all parts of the kingdom, and innumerable—often spectacular—vestiges of the monuments of the period can still be seen in every part of Egypt and Nubia. Those of the reign of Sethos I (1312-1298 B.C.) combine artistic quality with sumptuous effect. Others, grandiose but already tending to pretentiousness, were the work of that indefatigable builder Ramesses II (1298-1235 B.C.). The hypogeum of Sethos I in the Valley of the Kings is typical of the spirit of the age at its best. Hollowed out in the mountainside to a depth of nearly a hundred yards, its corridors and chambers are lined with painted reliefs which justly rank among the highest achievements of Egyptian art.

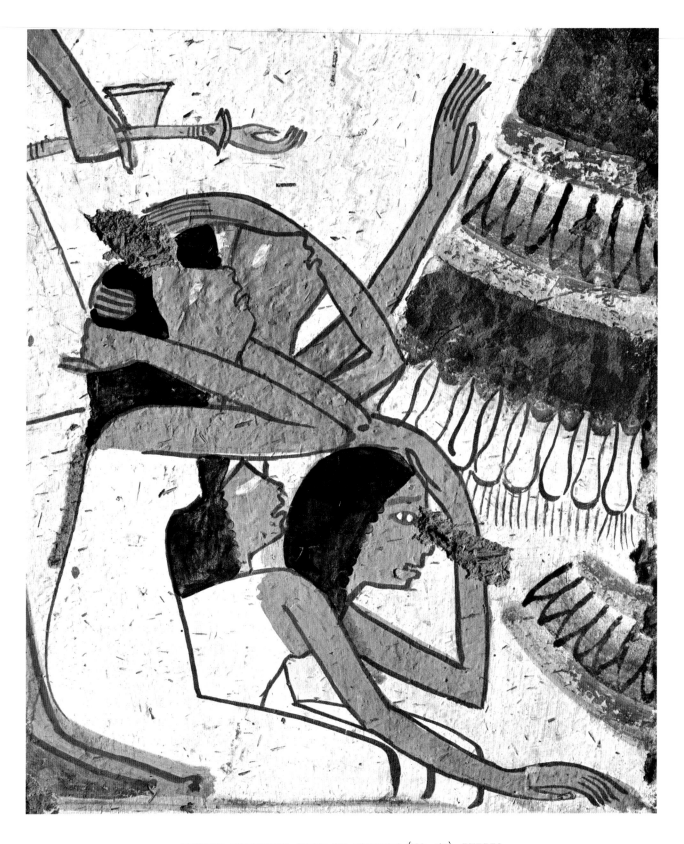

FEMALE MOURNERS. TOMB OF USERHET (NO. 51), THEBES.

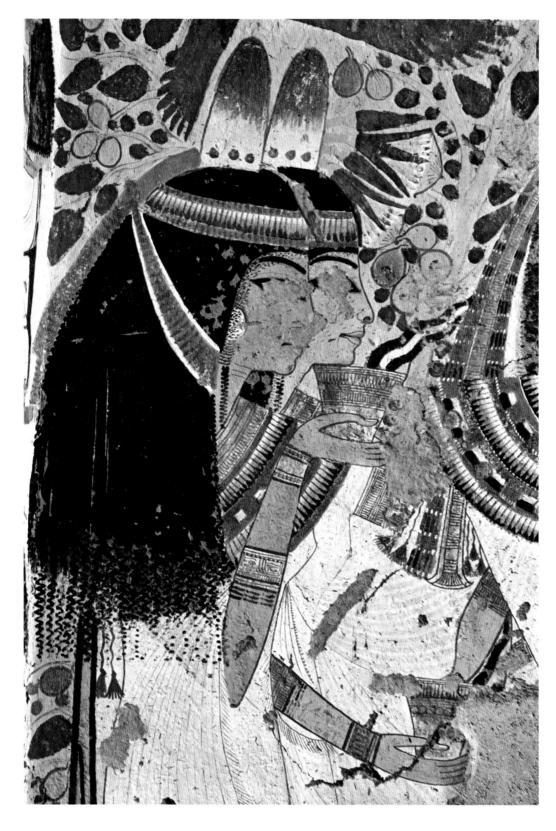

LADIES IN THE SHADE OF THE SYCAMORE. TOMB OF USERHET (NO. 51), THEBES.

DETAIL OF THE SYCAMORE TREE. TOMB OF USERHET (NO. 51), THEBES.

Another magnificent tomb is that of Nefertari, wife of Ramesses II, in the Valley of the Queens. Unfortunately instead of working directly on the limestone the artists dressed it with a coat of plaster which they then carved and painted. Attacked by damp, it is gradually disintegrating and will soon have crumbled into dust.

The first chamber is adorned with writings and illustrations from the Book of the Dead. One of the finest of the latter is a blue heron twenty-seven inches high; the aerial delicacy of the color on the white ground and the stateliness of the heron's pose make it stand out from the other figures done in various shades of red: lions poised between earth and sky, falcons simulating Isis and Nephthys watching over Osiris' body, and the like. Notable for its wealth of color and its charming subject, a picture beside the door shows the queen seated in a diminutive building, her feet on a red mat. She is playing chess by herself—or, more accurately, a game the Egyptians called *senet*, rather like draughts, whose rules have been discovered. Such, evidently, was the Egyptian's conception of the joys of the after-life and its eternal leisure—but we may venture to doubt if a lady of today would include perpetual games of patience in her idea of heavenly bliss! The picture surface has been varnished, perhaps to ensure its outlasting the other pictures in the tomb. Hence an exceptional luster that makes the colors warmer, notably the red ochre of the flesh-tints; indeed the general effect of this picture, framed in green, crowded with hieroglyphs of diverse colors and patterned with lines of black, is of quite exceptional brilliancy.

All the pictures in the second chamber, the descending passage and the burial chamber itself relate to the journey to the future life. Everywhere are inscriptions informing us that the great queen, "mistress of Egypt and the whole earth," is being escorted to the kingdom of the dead by the gods themselves. At each stage of the journey she encounters some divine being, celestial or of the netherworld, seated on a throne within a shrine. The roof is spangled with yellow stars on a blue ground, suggesting her ultimate ascent into the night-sky. Meanwhile, however, the queen advances into the depths of the mountain where the goddess Truth, daughter of Re, first of the gods, her wings extended, is waiting at the end of the ramp to take into her arms the royal new-comer. Thus sanctified, Nefertari enters Eternity in all the splendor of her earthly life: gold, silver and enamel jewelry framing her lovely face, garments of fine linen floating round her graceful body, a red girdle clasping the slim waist; and, it would seem, touches of kohl prolonging her big almond eyes and setting off the soft pink of her cheeks. Features, bearing, gestures—Nefertari is every inch a queen.

In the tombs of commoners belonging to the same period, we often find aesthetic mediocrity offset by an engaging if slightly vulgar gusto. Not that they do not sometimes contain figures as finely conceived as Nefertari's; some of those in Userhet's tomb (No. 51), as we have seen, are superb. But usually the figures lack distinction; the painters concentrate on details of a Breughelian order. A detailed account of the many famous monuments of the period would take us too far afield and be wearisome for our readers, so we shall mention only some of the artistically most significant productions, beginning with the tomb of Dehutemheb (No. 45).

Dehutemheb took over a chapel built under the XVIIIth Dynasty for a man named Dehuti, whom perhaps he believed to have been one of his ancestors. As we have seen, he did not destroy his predecessor's work but merely rejuvenated it; that is, he dressed the ancient figures in the style of his own day, retouched (and spoilt) certain passages, filled up spaces on the walls that had been left empty or unfinished, and gave the names of members of his family to figures hitherto unspecified. His only drastic change was the obliteration of a scene of ritual offerings covering an entire wall and its replacement by a scene in keeping with his own ideas. In places one can see the "palimpsest." The new style is generally inferior, but to ensure the over-all harmony, Dehutemheb had the good sense to retain the grey-blue ground, though it had gone out of use in the Ramesside period. The inscriptions, however, are written on a yellow ground.

One small detail claims attention: two female mourners accompanying the sarco-phagus the men are carrying in the funeral scene. Like the rest of the picture, these women are depicted sketchwise, but such was obviously the artist's intention. Summary as is the drawing, every line is eloquent: uplifted arms, sad eyes, hair streaming down the back, tears on the women's cheeks, half-opened dresses. Nothing is superfluous, no color is employed. A synthetic art, in short; intellectual, near-abstract.

In the tomb of the priest Panehsy (No. 16) the ground is a neutral grey, the walls are roughly dressed with a clay foundation, the ceilings low and uneven. Little care has been taken over the structure of the tomb or its decorations, which are mostly on religious themes. A double register, however, is allotted to some agreeably vivacious scenes of work in the fields. The best preserved and most picturesque detail is the representation of a donkey carrying a huge load of wheat and being whacked into reluctant motion by a fellah, while on the left another peasant is busy cutting wheat. The animal is braying in protest, and the angry gleam in its eye is well suggested. True, the line is slovenly and the color dull—but we must not ask too much of a humorist!

At Deir el-Medinah, that part of the Theban necropolis in which the workmen, artisans and decorators employed on New Kingdom tombs lived and were buried, hasty work was the order of the day; the clay foundation was often carelessly prepared and the painting, on a yellow ground, exceptionally fragile. Many as yet unpublished tombs are crumbling to dust under our eyes. Some of the best scenes in that of the sculptor Ipy (No. 217) have collapsed, but fortunately illustrations of them were published before this happened. Amongst these was the grape-gathering scene which was copied and reproduced some years ago by Mrs Nina M. Davies. Pictures showing the workshops in which catafalques, statues and ritual objects were made occupy a whole wall; hosts of little details give us an insight into the lives of those humble workers to whom we owe the masterpieces of Egyptian art. Ipy saw to it that nothing was left out and we can not only watch the workers at their tasks but also get an idea of the way they were treated by their employers. A civilization so refined and well-organized as that of Egypt under the Pharaohs could not disregard the welfare of its skilled workers,

THE QUEEN PLAYING CHESS. TOMB OF NEFERTARI IN THE VALLEY OF THE QUEENS, THEBES.

however humble their estate. Even the accidents to which they were liable are illustrated. We are shown a big mallet falling on a man's foot, an oculist applying a salve to the eye of a man who steadies himself by clinging to a shrine in process of manufacture, and, above this, two men, one lying down while the other holds his arm, evidently trying to "reduce" a dislocated shoulder.

Three details on other walls (all are in a dilapidated state) call for mention. First, a pastoral scene—rare, perhaps unique, in Egyptian iconography—in which we see a herdsman playing the flute while he tends his goats, a bundle hanging from a peculiarly shaped stick resting on his shoulder. An unpretentious little vignette, but endowed with a poetic charm of its own due both to the subject and to the accents of red, blue and green which are added to it by the vases in the register above. The artist displays much gusto in a scene of fishing in the Nile. On the bank two men are hauling in big nets filled to repletion. A small boy is keeping a sharp look-out on the fish that are squeezing through the meshes, and deftly catching them on the wing as they jump out. Further on are two workmen quarrelling. One, a southerner with fuzzy hair, snub nose and negroid lips, seems much excited, while his mate, whose greying hair and aquiline nose suggest the northerner, hears him out with true nordic stolidity. The composition of this little "slice of life" is simplicity itself: two red masses edged with black on a yellow ground.

On the lowest register a blue strip patterned with black zigzag lines represents the river; two small wooden fishing-boats are moving about amongst the lotuses. The fishermen are using drag-nets and while three men ply their paddles in a steady rhythm a standing man, with a fair complexion, shouts instructions to them. Here the color-scheme is based on red and blue. Highly simplified as is the drawing, the idea of movement is well conveyed. A curious point in Ramesside figure drawing is that the bottom of the neck is indicated by a curved line which one would suppose to be the collar of a tunic were not the torso naked.

The Deir el-Medinah tombs are generally two-storied. A small chamber topped by SENNUDEM a pyramid in unbaked bricks built in the hillside serves as the funerary chapel to which the public have access. From it straight or spiral flights of steps lead down to the vaulted tomb chamber adorned with pictures relating to the after-life. The best preserved and most richly colored burial chamber is that of Sennudem (No. 1), dating most probably to the end of the XIXth or to the XXth Dynasty. The walls are covered almost to ground level with religious scenes showing the dead man and his wife encountering a long series of gods, goddesses and spirits of the underworld. Though as works of art these pictures have no great value, they are dramatic illustrations of the Egyptian cosmogony. We see Re springing forth at dawn from the mountain in the East whence he is born, this idea being given concrete form by the breasts and arms of a woman holding the solar disk above a barren valley. Having reached the zenith, the sun god takes his seat between his "double horizon," upheld by two lions. Next he makes ready for his journey through the night, beset with obstacles he will duly overcome; a cat slicing off a snake's head symbolizes his victory over the powers of darkness. On the vault Re is depicted sailing in his boat, while Sennudem, after opening the door between this world and the next, likewise makes his way into the nether regions and does homage to the deities who welcome him into their company. A fairy-like figure, the goddess of the sky appears from a sycamore which has assumed semi-human form and with almost maternal sollicitude

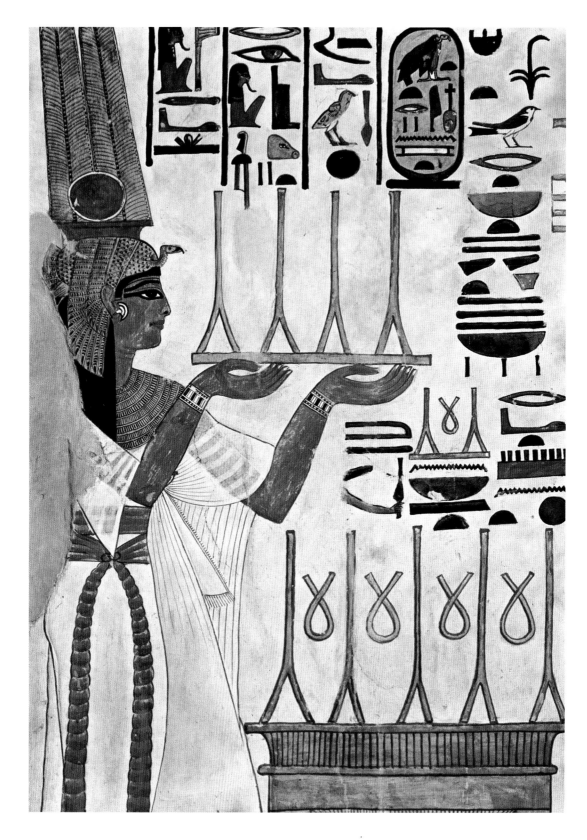

THE QUEEN OFFERING FINE LINEN TO THE GOD. TOMB OF NEFERTARI IN THE VALLEY OF THE QUEENS, THEBES.

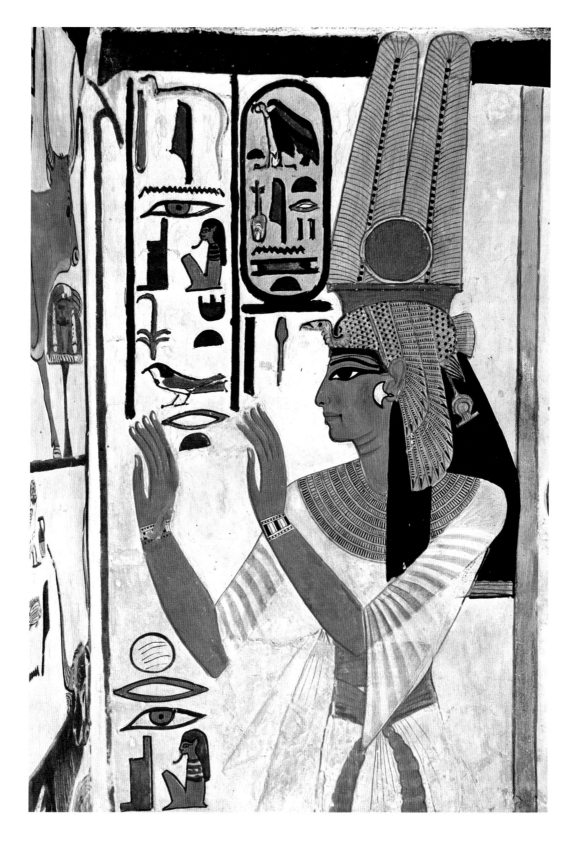

THE QUEEN WORSHIPPING. TOMB OF NEFERTARI IN THE VALLEY OF THE QUEENS, THEBES.

THE CARRYING OF THE CATAFALQUE, DETAIL. TOMB OF DEHUTEMHEB (NO. 45), THEBES.

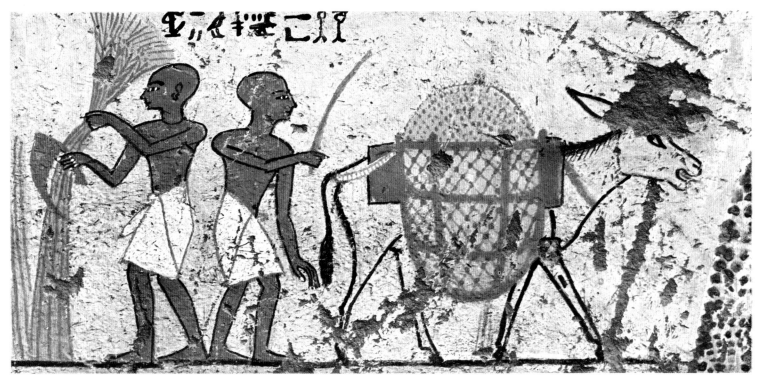

DONKEY AND PEASANTS. TOMB OF PANEHSY (NO. 16), THEBES.

proffers bread and water to the dead man and his wife who have broken through the roof of the tomb and floated up to meet her. The decorations on the walls commemorate the myth of Osiris, the god with whom every virtuous man becomes united and identified after death. Led by jackal-headed Anubis, Sennudem undergoes his trial before Osiris, a grim figure, green-skinned, swathed in his mummy-cloths; only his hands are visible holding the emblems of Egyptian kingship crossed upon his shoulders. On his head is a tiara crowned with the sun. The god of the dead stands under a decorated baldachin which with its uraeus-snakes, many-colored cornice and floral pilasters recalls that of the Pharaohs. Unlike all the other scenes in the burial chamber, which have yellow grounds, this representation of the god of the dead, the first picture to meet the visitor's eye when he enters the tomb, is painted on a white ground. So strident are the colors of the offerings heaped up before him that the general effect is almost garish. Further on we are shown Anubis, the dead man's escort, embalming the body of Osiris and, facing this scene, the mummy being watched over by Isis and Nephthys who have assumed for the nonce the form of falcons.

The eastern wall is entirely devoted to a depiction of "the Garden of Ialu," abode of the blessed dead. Above it is the sun god worshipped by blue dog-headed figures. The Egyptian paradise was a floating island, full of the loveliest flowers and well stocked with fruit-trees: sycamore, doum and date palms. The dead couple were expected to justify their presence there by helping in the upkeep of this celestial domain and we see them ploughing, sowing, reaping flax, cutting wheat and gathering in the sheaves. The day's

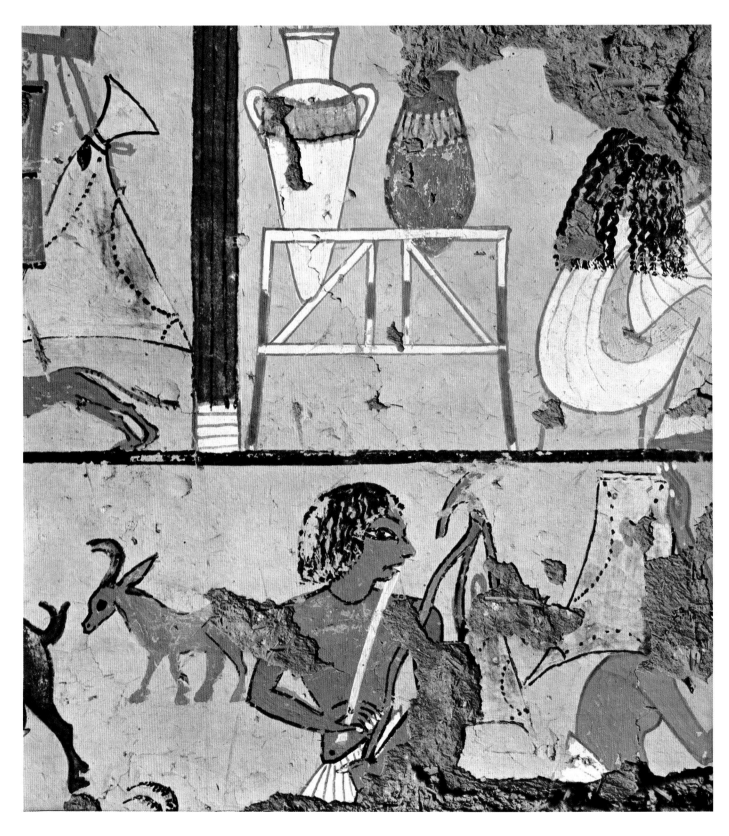

HERDSMAN. TOMB OF IPY (NO. 217), THEBES.

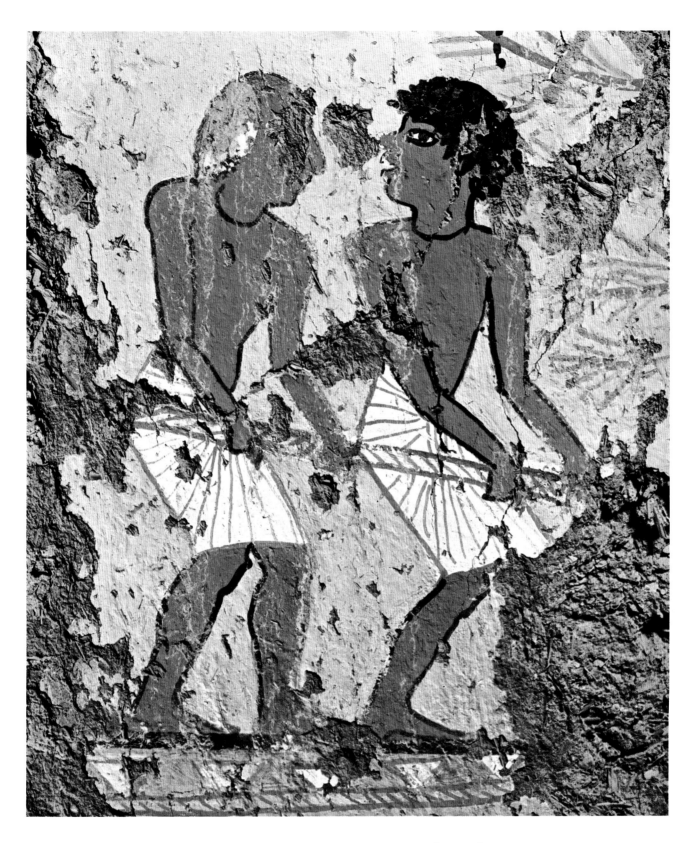

FISHING WITH DRAG-NETS, DETAIL. TOMB OF IPY (NO. 217), THEBES.

work done, Sennudem and his wife repair to the Isle of the Blessed and kneel before the lords of the universe: Re, Osiris, Ptah. Behind the gods, a young man paddling a papyrus-boat turns to inspect the new-comers. He is a son of the dead man and having died at an early age has entered into bliss before them. The forthrightness of these scenes and their excellent state of preservation make us momentarily forget the mediocrity of the style. Limitations of space have forced the painter to flatten out his figures; coarse brushwork and lack of vigor in the line (notably in the ploughing scene) are offset to some extent by the general effect of the ensemble: a vast yellow rectangle framed in a blue band of water indicated by the usual wave pattern (the celestial Nile), within which are disposed tier on tier a field of red wheat, another of green flax, then the orchard with trees painted alternately green and brown with black stripes, and finally the flower garden with its fan-shaped bushes painted green, red and blue.

FISHING BOAT. TOMB OF IPY (NO. 217), THEBES.

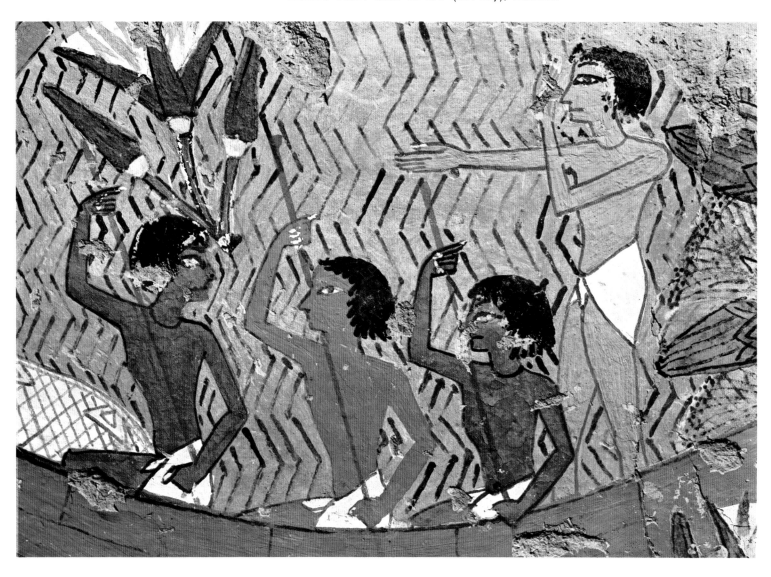

The lowest register of the south wall is a sort of family album, crowded with brothers and sisters and other relations of the deceased. To include them all within the limited space available the painter had to pack them tightly, sometimes in rather awkward positions. The portrait of Sennudem's daughter standing under her mother's chair is a sorry revelation of the decadence of Egyptian painting at the close of the Ramesside era. The artist has scamped his work; the wall-surface is rough, the color crude, unshaded, the drawing perfunctory, and the quaintly comical effect of the small girl's face may well have been unintended. True, Sennudem was a quite unimportant person, an artisan, even perhaps an unskilled workman; he is described as a "servant of the Necropolis." But when we turn to the sumptuous tombs of the Pharaohs and princes of the xxth Dynasty things are scarcely better. As might be expected the decorations in the tombs of some of the sons of Ramesses III in the Valley of the Queens are carefully, almost too carefully executed; but how cold and dead the style is! No longer was the Egyptian artist capable of infusing into his work the breath of life;

he repeated himself, wasted his energy on feats of futile virtuosity, and when, in works allowing him a freer hand, he aimed at humorous effects, lapsed into vulgarity. One feels in fact that he had nothing more to say.

It seems almost incredible that after degenerating to such an extent Pharaonic art should have lingered on for more than a thousand years; yet so it was. Such was the power of religious tradition and conservatism in this extraordinary race that thrice in those centuries of decadence efforts were made to arrest the process of decay. The last of these "renaissances"—it took place in the 4th century before Christ—produced some excellent imitations of the great periods and even a few works of genuine originality. But though many indications of this new lease of life can be seen in the sculpture and architecture of this time, we find nothing of the sort in the field of painting. It would seem that the painter's only function in this late period was that of coloring the reliefs in tombs and temples. And perhaps it was better so; better to accept a servile role than to strive vainly for an impossible rejuvenation.

CONCLUSION

While aware of the risk of making generalizations after a survey so hasty of so wide a field, we believe that the chronological account of Egyptian painting given in the foregoing pages makes it clear that, though spanning an exceptionally long period of time, its evolution took the normal course; that is to say it passed through three successive phases: of growth, maturity and decline. So far as can be judged, its "great age" synchronized with the XVIIIth Dynasty. Possibly, however, we might come to a different conclusion had enough Old and Middle Kingdom works survived to give us as clear an idea of the painting of those periods as we have of that of the New Kingdom. But the art historian is bound to base his opinion on the material at his disposal. Though the works of art discussed in this volume fall within a relatively short period (about two centuries), they illustrate what seems to be a universal rule governing the course of art in all climates and ages. Traditionalist to start with, New Kingdom art gradually discarded the conventions of the past, became more flexible, more eye-flattering, and ended up by formulating an aesthetic of its own which, without reverting to the austere grandeur of the so-called Golden Age, had an elegant sobriety combined with delicate compositional balance. Then abruptly came a phase of feverish unrest and lyrical extravagance, from which, however, New Kingdom art was quick to recover; but only to lapse into a baroque mannerism which soon crystallized into an academic art devoid of all vitality. Having achieved this technical perfection, conscious that they had reached a dead-end, and finding no means of escape, the Egyptian artists tended to lose faith in their vocation, this skepticism being reflected in a laxity of line and color as startling as it was unprecedented.

After three thousand years' oblivion Egyptian art has come into its own, thanks to our modern eclecticism and emancipation from the canons of Greek art. By a happy

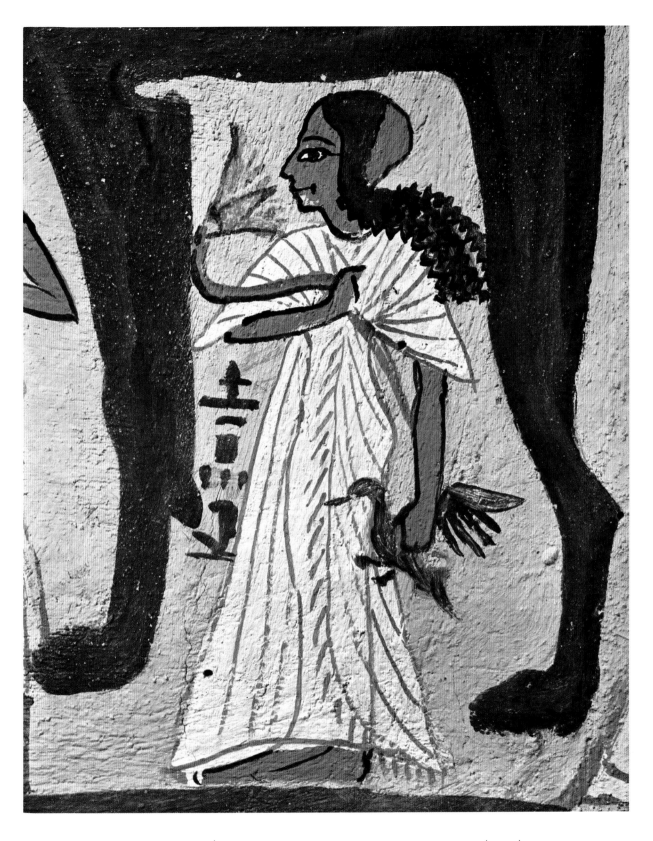

PORTRAIT OF SENNUDEM'S DAUGHTER. BURIAL CHAMBER OF SENNUDEM (NO. I), THEBES.

chance many of the painted tombs which during the early period of the Christian era were occupied by troglodytes—hermits to begin with, then Kurna peasants—have survived the ravages of time and men, and from them we get a vivid picture of Egyptian social life under the Pharaohs. In view of the obvious association of Theban art with the Egyptian hieroglyphic script, we are justified in approaching it almost from the angle of the graphologist, and this in fact is the most rewarding method of approach. For though we know nothing of the actual lives of the people depicted in the tombs, we learn much of their psychology from these pictures. Did the Egyptians hope that some day they would be "discovered" in this way? They invented a secret code which only initiates could decipher; their writing, architecture and plastic arts were governed by inflexible conventions based on a deep religious faith. Why then, one wonders, do these mural paintings so rarely transport us into the realm of mysticism? For their appeal is human rather than spiritual, and the impersonality aimed at by the Egyptian artist was merely a mask assumed to hide his native sensibility. If these pictures move us, it is because they are so unmistakably the work of men who had emotions, hopes and fears like ours. For all their piety the Egyptians enjoyed life and could not bear to think of being deprived in the next world of the amenities of their earthly existences. The mortuary chapels testify to their constant obsession with the mystery of the here-after, and their tombs are not the mausolea of heroes but last abodes of mortals athirst for immortality.

CHRONOLOGICAL TABLE

BIBLIOGRAPHY

INDEX OF NAMES AND SUBJECTS

LIST OF COLORPLATES

CHRONOLOGICAL TABLE

WITH A LIST OF THE CHIEF KINGS OF ANCIENT EGYPT AND THE PAINTINGS REFERRED TO IN THE TEXT

ARCHAIC PERIOD

Ist and IInd DYNASTIES (ca. 3200-2800 B.C.)	Menes	Wall painting in a tomb at Hierakonpolis, now in Cairo Museum.

OLD KINGDOM

IIIrd DYNASTY (ca. 2800-2720)	Zoser	
IVth DYNASTY (ca. 2720-2560)	Sneferu Kheops Dedefre Khephren Mykerinos Shepseskaf	Mastaba of Itet at Meidum, whose best fragments are preserved in Cairo Museum: geese painted on a coat of stucco, a scene of fowling with nets and work in the fields executed in color-pastes incrusted in the limestone. *A style sober and austere, already academic.*
Vth DYNASTY (ca. 2560-2420)	Userkaf Sahure Neferirkara Niuserre Unas	Mastabas at Sakkara, particularly the tomb of Ti with its "Herd of Cattle fording a Canal," a painted bas-relief. *Classical style of a period regarded as the Golden Age of Pharaonic art.*
VIth DYNASTY (ca. 2420-2270)	Tety Pepy I Merenre Pepy II	Tomb of Ptahiruk at Sakkara with scenes of the butcher's trade painted on the limestone. *An uncouth style symptomatic of troubled times; composition, however, is still skillful, and lay-out almost mathematically precise.*

FIRST INTERMEDIARY PERIOD

VIIth-Xth DYNASTIES (ca. 2270-2100)	

MIDDLE KINGDOM

XIth DYNASTY (ca. 2100-2000)	Antef I-III Mentuhotep I-V	
XIIth DYNASTY (ca. 2000-1785)	Amenemhet I Senusret I Amenemhet II Senusret II-III Amenemhet III-IV	Nomarchs' hypogea at Beni Hasan, tomb of Antefoker (No. 60) at Thebes with a scene of ritual dancers. *Noticeable stiffness in the style, but a fine sense of rhythm and composition.*
XIIIth DYNASTY (ca. 1785-1700)	Sebekhotep Khenjer	

HYKSOS PERIOD

XIVth-XVIth DYNASTIES (ca. 1700-1580)	
XVIIth DYNASTY (ca. 1680?-1580)	Sekenenre Kamose

XVIIIth DYNASTY

Ahmose
(ca. 1580-1555 B.C.)

Amenophis I
(ca. 1555-1530)

Tuthmosis I
(ca. 1530-1520)

Tuthmosis II and
Hatshepsut
(ca. 1520-1480)

Tuthmosis III
(ca. 1501-1448)

Painted bas-reliefs in the temple of Queen Hatshepsut at Deir el-Bahri: *a classical style in imitation of Old Kingdom art.* Outline paintings in the tomb of Tuthmosis III in the Valley of the Kings, *deriving their style from the illustrations in funerary papyrus scrolls.* Tombs of Ineni, Senmut, Nebamun, Wah, Amenemhet (sacrificial bull, gazelle, musicians, a hippopotamus hunt in the papyrus thickets), Amenemheb (hyena hunt), Menkheperresonb (Asiatic tributaries, craftsmen at work), Minnakht (mourners, funeral ceremonies), Rekhmire (bricklayers, banqueting, very varied iconography), Amenuser (foreign tributaries) and Tomb No. 261 (offerings to the dead couple)—all tombs hollowed out of the Theban mountains. *Archaizing style of painting, carrying on the traditions of Middle Kingdom art, occasionally harking back to Old Kingdom art: hieratic severity, symmetry, pure opaque tones on a pale blue ground.*

Amenophis II
(1448-1422)

Tuthmosis IV
(1422-1411)

The great age of Theban painting: tombs of Sennufer (grape-vine decoration on the ceiling), Kenamun (hunting scene in the desert with ibex and youths carrying arrows, banqueting, ritual scenes, offerings, mandola player, the young king on his nurse's lap), Userhet (hunting in the desert and swamps, funeral ceremonies, offerings, cattle, paying homage to the pharaoh, inspection of supplies, barbers at work out-of-doors, grape-picking and wine-pressing), Dehuti (banqueting), Deserkarasonb (butchers, work in the fields, banqueting), Nakht (banquet with three women musicians and a blind harpist, fowling and fishing, grape-picking, wine-pressing. work in the fields and harvesting, picking flax, a worker quenching his thirst), Menna (all the various operations in the cultivation of wheat with a host of picturesque details, processions of offering-bearers, funeral ceremonies, hunting and fishing, the pilgrimage to Abydos, portraits of Menna and his wife), Thanuny (recruiting scenes with Nubian mercenaries, cattle, horses), Haremhab (banqueting, offerings, recruiting, foreign tributaries, funeral procession, fowling and fishing, with outstanding details of groups of mourners, a blind singer, a locust, a pair of pigeons, a family of pelicans, an offering-bearer, a Nubian dancer), Nebamun (musicians and dancers, grape-picking, foreigners), Nebseny (guests at a banquet), Thenuna (gold vases, cattle, herdsman). *A graceful style, freer sense of composition, livelier scenes, finer shades of color, with light, transparent glazes on a blue-grey ground.*

Amenophis III
(1411-1375)

Tomb of Ramose (funeral procession). *A style of sober elegance, harmonious proportions, classical equilibrium.*

Amenophis IV-
Akhenaten
(1375-1358)

Paintings in the palaces of El-Amarna. *Sudden lyrical effusion in Egyptian art; the early extravagance of the Amarna style gradually settled down to saner standards.*

Tutankhamen
(1358-1350)

Wall paintings and treasure (painted coffers) in the royal tomb of Tutankhamen in the Valley of the Kings, and the tomb of Huy. *Mannered style.*

Haremhab
(1350-1315)

Tomb of Nebamun and Ipuky (portraits, mourners, craftsmen). *Transition style between XVIIIth Dynasty and Ramesside Period, mingling of reactionary academicism with the trend towards picturesque genre scenes.*

XIXth DYNASTY	Sethos I (1312-1298 B.C.) Ramesses II (1298-1235)	Tombs of Amenmose, Userhet (priests, mourners, sycamore scene), Queen Nefertari (Book of the Dead, journey to the Other World), Dehutemheb (funeral procession, ritual scenes), Panehsy (religious scenes, work in the fields with the detail of a loaded donkey), Ipy (craftsmen at work, pastoral scenes). *Lingering traces of the Amarna revolution particularly in the shapes given heads, increasing signs of careless execution, but with considerable virtuosity in rendering features, bright colors indicative of the ostentation and sumptuous living of the imperial period, fondness for the picturesque in genre scenes, use of yellow grounds.*
XXth DYNASTY (1200-1085)	Ramesses III-XI	Workmen's tombs at Deir el-Medina: Sennudem and others. *Slackness of style marking the decline, despite many lively touches.*

LATE PERIOD

XXIst DYNASTY (1085-950)	Hrihor Psusennes I-II
XXIInd-XXIIIrd DYNASTIES (950-730)	Sheshonk I-V Osorkon I-IV Takelothis I-III
XXIVth DYNASTY (730-715)	Tefnakht Bocchoris
XXVth DYNASTY (715-656)	Ethiopian Occupation
XXVIth DYNASTY (663-525)	Psammeticho I-III Necho Apries Amasis
XXVIIth DYNASTY (525-404)	Persian Domination
XXVIIIth DYNASTY (404-398)	Amyrtaeus
XXIXth DYNASTY (398-378)	Achoris
XXXth DYNASTY (378-341)	Nectanebes I Tachos Nectanebes II
Second Persian Domination (341-333)	

GRAECO-ROMAN PERIOD

Conquest of Egypt by Alexander the Great (332-323) Ptolemaic Period, or Lagid Dynasty (323-30) Roman Occupation of Egypt (30 B.C.-395 A.D.)	Painted tombs at various places, notably in the necropolis of Hermopolis and at Alexandria, mummy portraits. *Death agony of Pharaonic art despite several attempts to renew its traditions.*

BIBLIOGRAPHY

BAUD, Marcelle. *Les dessins ébauchés de la nécropole thébaine* (au temps du Nouvel Empire). Mémoires de l'Institut français d'Archéologie orientale du Caire, Vol. LXIII, Cairo 1935.

BISSING, F.W. von, and REACH, Max. *Bericht über die malerische Technik der Hawata Fresken im Museum von Kairo*, Annales du Service des Antiquités de l'Egypte, Vol. VII, 1906, p. 64-70.

BLACKMAN, Aylward M. *The Rock Tombs of Meir*, vols. I-VI, Archaeological Survey of Egypt. The Egypt Exploration Fund (afterwards Society), London 1914-1953.

CARTER, Howard. *The Tomb of Tut-ankh-Amen*, vols. I-III, London, Cassell, 1923-1933.

DAVIES, Nina M., with the editorial assistance of Sir Alan H. Gardiner. *Ancient Egyptian Paintings*, vols. I-II. Plates, vol. III. Descriptive Text. Chicago, The University of Chicago Press, 1936.

DAVIES, Nina M. *Egyptian Paintings*. London, Penguin Books, 1954.

DAVIES, Nina M., and GARDINER, Alan H. *La peinture égyptienne ancienne*. Preface and adaptation by Albert Champdor. Paris, Albert Guillot, 1953-1954.

DAVIES, Norman de Garis. The Metropolitan Museum of Art, Robb de Peyster Tytus Memorial Series:
 I. *The Tomb of Nakht at Thebes*. New York, 1917.
 II-III. *The Tomb of Puyemrê at Thebes*. New York, 1922-1923.
 IV. *The Tomb of Two Sculptors at Thebes*. New York, 1925.
 V. *Two Ramesside Tombs at Thebes*. New York, 1927.

DAVIES, Norman de Garis. *The Tomb of Ken-Amûn at Thebes*, 2 vols. New York, The Metropolitan Museum of Art, 1933.

DAVIES, Norman de Garis. *The Tomb of Nefer-hotep at Thebes*, 2 vols. New York, The Metropolitan Museum of Art, 1933.

DAVIES, Norman de Garis. *Paintings from the Tomb of Rekh-mi-Rē at Thebes*. New York, The Metropolitan Museum of Art, 1935. — *The Tomb of Rekh-mi-Rē at Thebes*, vols. I-II. New York, 1943.

DAVIES, Norman de Garis. Mond Excavations at Thebes:
 I. *The Tomb of the Vizier Ramose*. London, The Egypt Exploration Society, 1941.
 II. *Seven Private Tombs at Kurnah*. London, 1948.

DAVIES, Norman de Garis. *Five Theban Tombs*. Archaeological Survey of Egypt. London, The Egypt Exploration Fund, 1913.

DAVIES, Norman de Garis, and GARDINER, Alan H. The Egypt Exploration Society, Theban Tombs Series:
 I. *The Tomb of Amenemhet* (No. 82). London, 1915.
 II. *The Tomb of Antefoker, Vizier of Sesostris I, and of his Wife, Senet (No. 60)*. London, 1920.
 III. *The Tombs of Two Officials of Tuthmosis the Fourth (Nos. 75 and 90)*. London, 1923.
 IV. *The Tomb of Huy, Viceroy of Nubia in the Reign of Tut-ankhamun (No. 40)*. London, 1926.
 V. *The Tombs of Menkheperrasonb, Amenmose and Another (Nos. 86, 112, 42, 226)*. London, 1933.

FARINA, Giulio. *La Pittura egiziana*. Milan, Fratelli Treves, 1929.

FOX, Penelope. *Tutankhamun's Treasure*. Oxford University Press, 1951.

FRANKFORT, H. *The Mural Painting of El-Amarneh*. F. G. Newton Memorial Volume. London, The Egypt Exploration Society, 1929.

KLEBS, Luise. *Die Reliefs des alten Reiches* (2980-2475 v. Chr.). Material zur ägyptischen Kulturgeschichte. Heidelberg, C. Winter, 1915.

KLEBS, Luise, *Die Reliefs und Malereien des mittleren Reiches* (VII. - XVII. Dynastie, ca. 2475-1580 v. Chr.). Heidelberg, 1922.

KLEBS, Luise. *Die Reliefs und Malereien des neuen Reiches* (XVIII. - XX. Dynastie, ca. 1580-1100 v. Chr.), Teil I: *Szenen aus dem Leben des Volkes*, Heidelberg, 1934.

LHOTE, André, and HASSIA. *Les chefs-d'œuvre de la peinture égyptienne*. Preface by Jacques Vandier. Paris, Hachette, 1954.

LUCAS, A. *Ancient Egyptian Materials and Industries*, Third Edition. London, E. Arnold, 1948.

NEWBERRY, Percy E. *Beni Hasan*, I-IV. Archaeological Survey of Egypt. London, The Egypt Exploration Fund, 1893-1900.

PORTER, Bertha, and Moss, Rosalind L. B. *Topographical Bibliography of Ancient Egyptian Hieroglyphic Texts, Reliefs and Paintings*:
 I. *The Theban Necropolis*. Oxford, Clarendon Press, 1927.
 II. *Theban Temples*. Oxford, 1929.
 III. *Memphis*. Oxford, 1931.
 IV. *Lower and Middle Egypt*. Oxford, 1934.
 V. *Upper Egypt: Sites*. Oxford, 1937.
 VI. *Upper Egypt: Chief Temples*. Oxford, 1939.

SCHIAPARELLI, E. *Relazione sui lavori della Missione archeologica italiana in Egitto*. (Anni 1903-1920). Vol. I: *Esplorazione della « Valle delle Regine » nella necropoli di Tebe*. Turin, R. Museo di Antichità [1923].

SMITH, William Stevenson. *A History of Egyptian Sculpture and Painting in the Old Kingdom*, Second Edition. Boston, Museum of Fine Arts, 1949.

STEINDORFF, Georg, and WOLF, Walther. *Die Thebanische Gräberwelt*. Leipziger ägyptologische Studien, Heft 4. Glückstadt-Hamburg, J. J. Augustin, 1936.

STOPPELAËRE, Alexandre. *Dégradations et restaurations des peintures murales égyptiennes*. Annales du Service des Antiquités de l'Egypte, Vol. XL, 1940, p. 941-968, pl. CXXXVII - CXLVI.

WEGNER, Max. *Stilentwickelung der thebanischen Beamtengräber*, Mitteilungen des Deutschen Instituts für ägyptische Altertumskunde in Kairo, Vol. IV, 1933, p. 38-164, pl. III-XXIX.

WRESZINSKI, Walter. *Atlas zur altägyptischen Kulturgeschichte*, I. Leipzig, J. C. Hinrichs, 1923.

INDEX OF NAMES AND SUBJECTS

THE COLORPLATES

PUBLISHED MAY 1978

PRINTED BY
IMPRIMERIES RÉUNIES SA
LAUSANNE

The photographs made in Egypt are the work of Claudio Emmer, Venice
The colorplates were engraved by Aberegg and Steiner, Bern

PRINTED IN SWITZERLAND